2000

pattern combinations

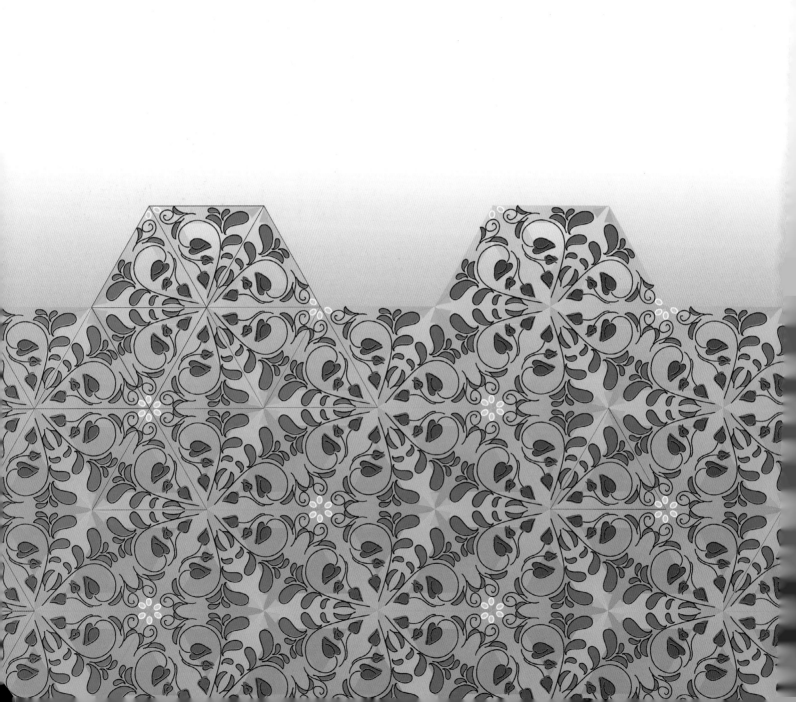

2000
pattern combinations
for graphic, textile and craft designers

Jane Callender

BATSFORD

In memory of my most beloved parents,
Dorothy and Norman Callender.

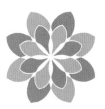
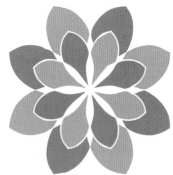

First published in the United Kingdom in 2011 by
Batsford
10 Southcombe Street
London W14 0RA

An imprint of Anova Books Company Ltd

ISBN-13: 9781849940078

A CIP catalogue record for this book is available from the British Library.

20 19 18 17 16 15 14 13 12 11
10 9 8 7 6 5 4 3 2 1

Printed by Toppan Leefung Printers Ltd, China
Reproduction by Rival Colour Ltd, UK

This book can be ordered direct from the publisher at the website:
www.anovabooks.com, or try your local bookshop.

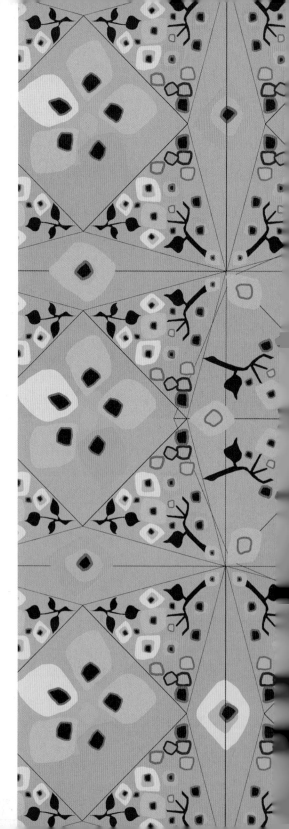

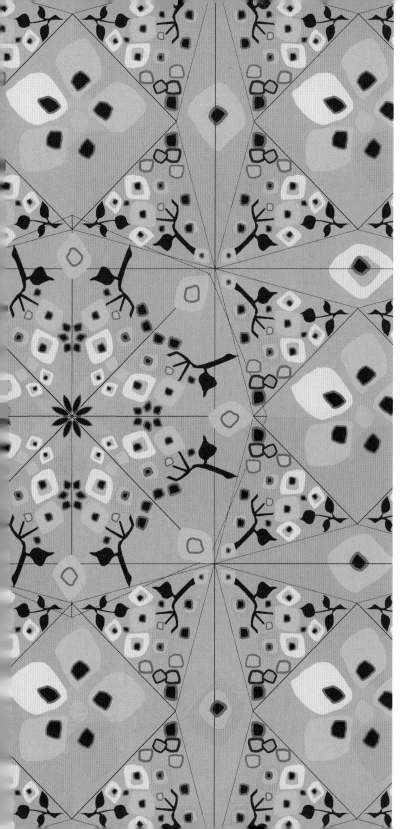

Contents

Introduction

Pattern can be as expressive as music, as transient as breeze, or as stern as granite; it can lift the spirit or take it to a more sombre place. It has become a fascination for me over the years, providing a sound discipline for my stitched shibori work.

We encounter pattern design on different surfaces on a daily basis. Even smooth white sheeting has pattern, the organisation of warp and weft threads in a plain weave, more easily seen in basketry, is pattern born out of construction. For pattern designers, never before has there been such a vast selection of techniques, enticing media and materials to work with or so many diverse sources for inspiration. With current weaving, transfer and printing technology, patterns can be interpreted in a myriad of different ways and applied to any number of surfaces.

Pattern is created by the repetitive placement of a motif or design in a systematic way. The pattern maker uses geometric grids to ensure the placements are methodically accurate, which in turn allows the pattern to flow without interruption or disturbance of rhythm. This regularity of placement is known as the 'repeat', and a pattern can be 'put into repeat' in a number of ways. On a two-dimensional surface, pattern can be regarded as potentially limitless. Man alone produces infinite pattern;

pattern in nature, while offering infinite inspiration, is restricted to shape and form. After all, fish scales alter in size and are tailored to suit the fish!

The most popular shapes for grids are the square and triangle and many options arise when these are used in combination. The scale and ogee offer alternatives, and all provide the armature or skeleton into which motifs and designs can be placed. Using grids may seem like a restrictive process but they are liberating for the pattern maker. The main consideration is the surface on to which the pattern is eventually to be placed; for example, the tile size or fabric width – is it for fashion or furnishing? The pattern needs to be made 'fit for purpose', in other words, absolutely suited for its intended use with scale, colour, motif design and layout all working together to enhance the product. Buyers, when choosing designs, more often than not request that they are presented 'in repeat' and in various colourways.

This collection demonstrates many aspects of patterning and offers more than just patterns to copy. Using the easy-to-follow, step-by-step illustrations and guidelines readers can start setting up patterns of their own choice. A story board is included on the practical steps involved in putting a design into repeat. Many options crop up in the varying themes, each focussing on a different

aspect of the repeat. As a design is developed the process is outlined and changes discussed en route. It shows how complex patterns can evolve from simple beginnings.

Specific headings such as brick repeat; rotation repeats and so on, are not used except in the introductory chapters 1–4. Rather all these variations are encountered under a pattern's name. Thus in 'The Duck' repeat formats, development schemes, colourways and scale will be found as the pattern unfolds on the page. One would assume that 'The Duck' would bring forth endless patterns of ducks, but as tweaks and amendments are made, the emergence of a 1940s pastel geometric style pattern is not such a surprise after all.

This book is about placement of line and shape rather than mark making, or the quality of marks. All the patterns have been created on the computer in an attempt to create neutrality and to disconnect from any specific style. I hope that the reader will interpret line and the infill of shape in a personal way. Thus a line may become a hand-stitched line in the eyes of an embroiderer or an inscribed mark by the ceramicist; a shape as leather appliqué or as paint applied through a stencil. Certain patterns bring woven textures to mind; others evoke engraved glass. I have included a chapter on shibori

as, though this technique is very different, it benefits from pre-planning with pattern making principles. Even here pattern drafts are open to interpretation.

This pattern collection is a lexicon on which a designer, in whatever discipline, can draw for their own particular purpose and intended surface. I hope that students embarking on a career in design and pattern making will find it a useful text book and that it will inspire and be a point of reference for those wishing to decorate any number of different surfaces. What unites us is a love of, and delight in, the enduring and enriching quality of pattern, the desire to discover their hidden correlation and a need to express our own unique vision.

Right: 'Trellis' shows stitched *miru* shibori circles with lace flower inserts, dyed in indigo and iron rust on cotton.

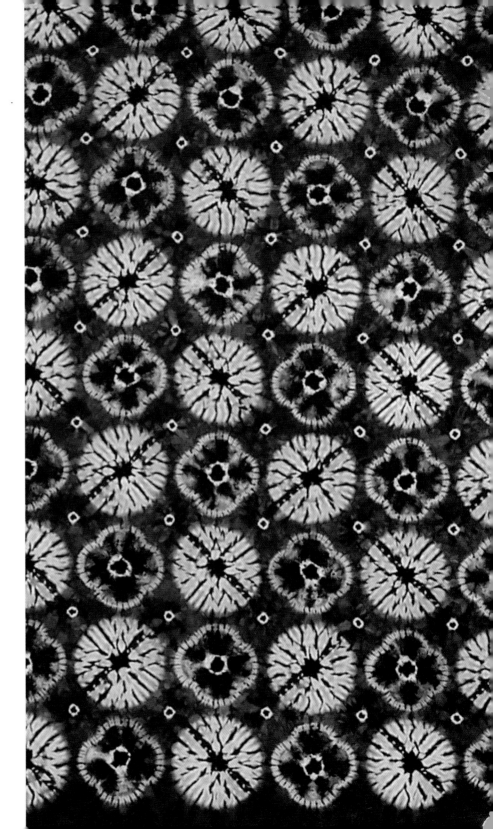

Tiles, tessellations and grids

Tiles and tessellations are the stabilizing anchor for pattern, the 'regular and repeating development of ornamentation across the plane'. The word 'tessellate' is derived from the Ionic Greek word *tesseres*, meaning four, and the first tilings such as pavings and mosaics, were indeed made up of squares.

The square, equilateral triangle and the hexagon are all polygons – many-sided shapes – and tessellations made up from them are known as regular tilings because each repeated shape can be adjacently placed without leaving a gap.

For a full appreciation of geometry, every minute taken to engage with simple hand-drafting construction exercises is well worth the time and is an excellent way to understand pattern development. Armed with a pencil, sharpener, ruler and compass, begin to draw line and shape carefully and deliberately. You will be embarking on a wonderful journey to unfold ancient truths.

Regular tiling variations

One shape repeated covers the plane entirely, without leaving any gaps.

Square.

Regular tiling.

Half drop.

Brick repeat.

Diamond.

Triangle.

Hexagon.

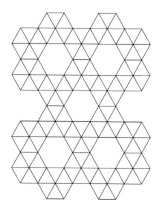

Semi-regular tilings

These are made up of one or more polygons but requires each junction to be the same. That is to say that each meeting point or vertex should be constant with the others in the tiling. There are eight semi-regular tilings.

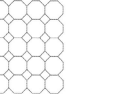

Octagon.

Dodecagon.

Combination tilings

In this group we find demi-regular tilings of which there are 20. Within their combinations lie the astounding patterns of Islamic surface decoration, designs in Celtic art and the flowing meanderings of William Morris's floral patterns.

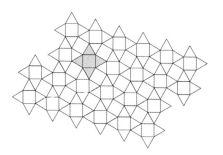

The circle

From the circle essential forms can be constructed with just a pencil, straight edge and compass. In sacred geometry the circle symbolises heaven and eternity, beautiful in its completeness.

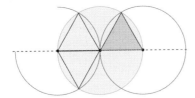

Using a rule, draw a horizontal line. With the compass point on the line draw a circle. With the same radius place the compass point where the drawn circle cuts the line. An equilateral triangle can be found.

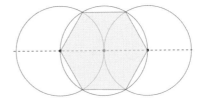

Repeat on the other side and a hexagon can be found.

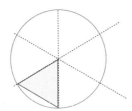

Divide 360 degrees, the circumference of a circle, by six, the number of points of the hexagon, using a protractor, and mark these points precisely. (it doesn't matter if these points are outside the circle).

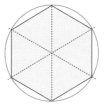

Draw lines connecting these outer points which pass through the centre of the circle. From these construction lines equilateral triangles and hexagons can be found.

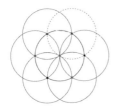

Draw a circle. With the same radius, place the compass point on the circle's circumference and draw another circle, ensuring the arc travels through the central point of the first circle. Where the arc crosses the circumference marks the central point of the third circle. Continue around the first circle, plotting six more circles.

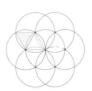 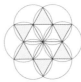 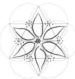

Now isolate all the different shapes that this yields. Triangles, hexagon, the Star of David, and various formats for basing florets upon, will reveal themselves. It is useful to have a few drawn up in a dark ink – placed under layout paper these will help when it comes to plotting out shapes freehand.

The ogee

The ogee is made up of double curves – concave and convex curves flow together to form an elongated 'S' shape. Very popular in medieval times, it was used in architectural arches and mouldings. It also forms a very useful mesh for setting up patterns as it can be repeated without breaks or gaps.

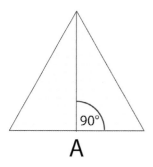

1. Start with an equilateral triangle. Mark a point half the width of the baseline 'A' and set your compass the same.

2. With the compass point at A, draw in a half circle.

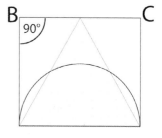

3. Plot out a rectangle (all right angles with 90 degree corners) which contains the three points of the triangle. Mark the top two corners as B and C.

4. With the compass at the same setting as step 1, place the point at B and draw in the quarter circles – repeat at C.

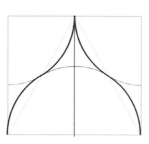

5. Trace over the ogee shape twice. Include the central line and baseline as these ensure accurate placement later.

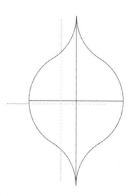

6. Bring the two halves together, placing the verticals and horizontals on previously drawn lines and trace to give one shape.

Now you have constructed the ogee shape it can be used simply to hold a design or to be a part of it. A grid of rectangles will help you keep the mesh lined up accurately.

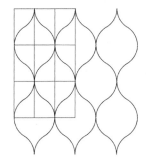

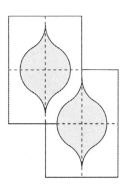
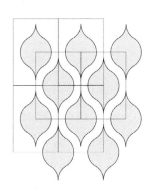
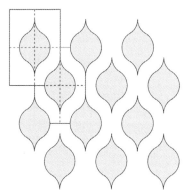

Setting the shape centrally in a rectangle will give options as to how tight or loose the mesh will be. It also gives space in which to design a border detail. Work the first row. Place the second halfway along and halfway down.

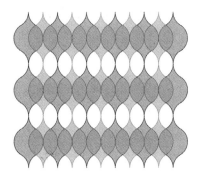
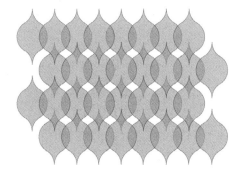
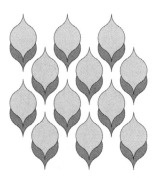

By superimposing identical formats on top of each other using translucent colour, wonderful options appear.

The scale or scallop

This common motif, used to infill shapes, gives a highly decorative effect. Also a wonderful shape to use as a basis for plant growth.

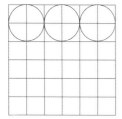

1. Using a compass draw three circles on a grid.

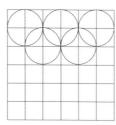

2. Then draw two more directly in between and one step of the grid down.

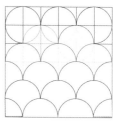

3. The build-up of shapes suggests another pattern but as unwanted arches are blocked out the scale emerges.

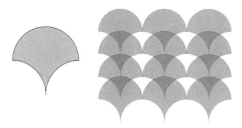

4. Trace off the scale shape.

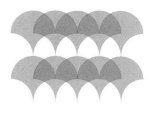

5. The scale can be used to create pattern; with translucent settings, overprinting allows the colour beneath to show through...

6. ...or it can be used as a container unit for other motifs – or indeed a combination of both.

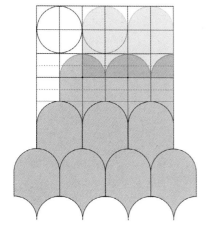

7. By setting the second row further down the grid, the sides of the scale are lengthened.

Moving the square

The square

 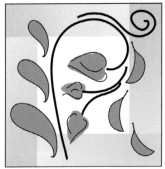

Changes in the rhythm and flow of a pattern are not only the result of how squares containing the same design are positioned next to each other in slide or drop repeats, but also depend on how the contained elements relate to each other in rotation or reflected placements. These changes can be quite subtle or immediately recognizable and there are many options that include combinations of both. These juxtapositions are always worth exploring as they can spark off new appraisals of a design, a new motif to link the pattern together more successfully, or an idea that can lead to a new design completely – perhaps a border or a one-off piece.

It is possible to a certain extent to visualize some of these manoeuvres, especially for rudimentary elements, but with a complex design or with combination formats it is impossible to see quite where motifs will lie and how they will connect. So in order for the varying placements to be more readily identified I have given the square (the most commonly used unit of repeat) coloured borders. As some placements may look the same, the border has a gradient colour to help identify how the square has been moved. The blue is more dominant for sighting to make it easier to spot the move. I have added a floral here and there, which has been drawn specifically to identify moves and rotations. Florals will be looked at in greater detail later. Even so, the number of different patterns to emerge with the simple colour coding of the square itself is remarkable.

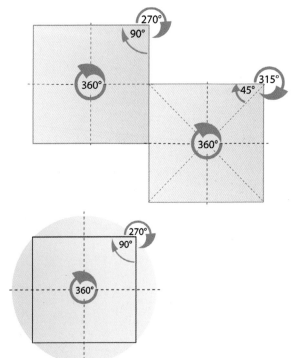

Here are some angles which are particularly useful to the pattern designer.

Block repeats

The movable units of the grid, the 'squares' containing the
motif or design, are placed next to each other 'squarely' – both
horizontally and vertically without reflection or rotation – for the
block or step repeat. This is the most straightforward repeating
sequence. Other straightforward grids could contain squares
that have been rotated or reflected.

Block repeat.

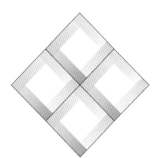

Rotated 45 degrees.

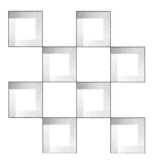

Leave out every other square to open
the design and emphasize diagonals.

Brick repeat or slide repeat

Rather than being placed directly underneath, the square is
moved along a half measurement. This measurement can be as
you choose, such as a quarter, three quarters or a distance that
suits the design you have created to bring out the desired effect
in the pattern.

Half-drop repeat

As the name suggests, the square is moved down half a square.
Again, this measurement can be adjusted to ensure the most
successful pattern outcome. The diamond format is also used
to effect a drop pattern.

Rotation repeats

Here, the left square is kept static and the right square rotated.

In this series of repeats the square is rotated, before it is placed to form a duo or pair, which is then repeated.

Rotation repeats offer three options if working in a clockwise direction, or two clockwise and one anti-clockwise.

One turn ... and then to original.

Two turns ... and then to original.

Three turns ... and then to original.

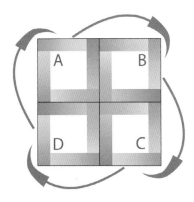
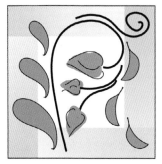
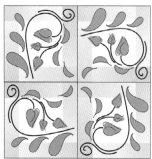

Rotation can also be worked to create a repeating 'block' of four. The original square A is rotated and placed as B, which is then rotated and placed as C – then C to D. The floral design has been added again.

The new unit of four is repeated 'squarely' without reflection or rotation. Here the tiny floral 'spiral' motif marks a diamond shape.

The square is placed in a half-brick repeat. The spiral shape now reads as a diagonal.

Combination repeats

Rotated squares can be combined with brick and half-drop repeats. The rotated square is paired up with the original square. The duo is then repeated underneath but moved on half a square – or a distance that benefits the design.

This example shows one rotation combined with a brick repeat.

This example shows two rotations combined with a brick repeat.

Rotation with half drop

These rotations can also be combined with the half drop.

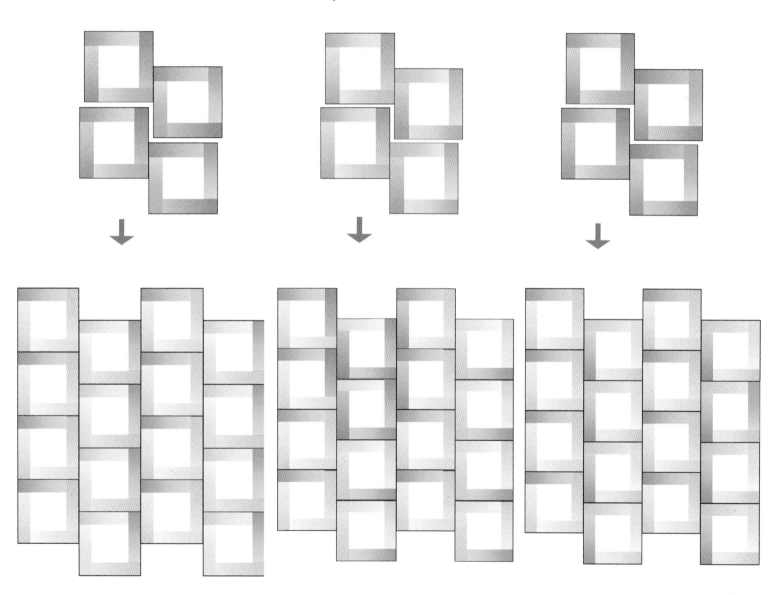

One rotation combined with a half drop.

Two rotations with a half drop gives a noticeable stripe.

Three rotations with a half drop.

Mirrored or reflected repeats

When the square is reflected as in a mirror or 'flipped over', the result is a 'reflected symmetry'. Large designs using this format took up the entire width of the fabric and at one time were called 'turn over' designs. Again, these can be worked in combination with other placement formats.

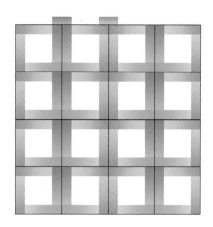

Many mirrored combinations create successful borders. When these pairs are placed directly underneath each other, they form continuous tan and purple stripes broken by the blue and green (above right).

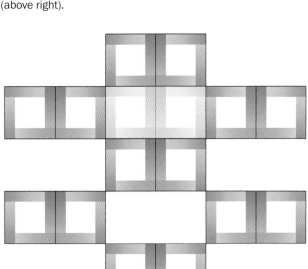

Here, space is left between the pairs.

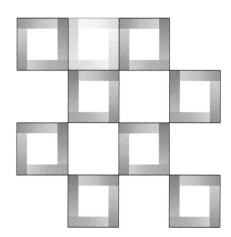

In this example the mirrored square is omitted, leaving a space. Another way to work the repeat sequence is to mirror the rows alternately.

Mirrored with half drop

There are two ways to explore these mirror repeats. The first way is to keep the pair together and then make the half-drop placement.

Alternatively, make the half drop first before the pair is put into repeat.

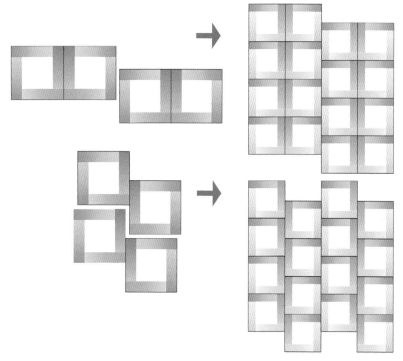

Mirrored with brick repeat

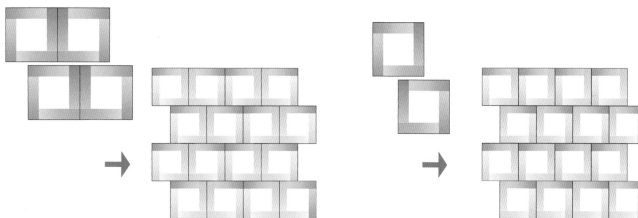

The same applies here. Keep the pair together for the repeat...

...or make the reflection and then place the second image underneath but halfway along. In essence, you are simply reflecting alternate rows...

Four-square reflection

When each square is mirrored in turn the result is 'complete reflected symmetry'. These blocks are then placed squarely next to each other. I have introduced the floral design again so you can see what happens with the curved lines and relate that back to how the square is being used.

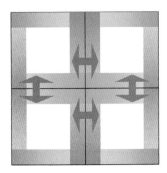

Because the line turns back on itself within the repeating unit the pattern remains closed, and in this instance a way of progression appears blocked. But the design could be tweaked to open it out so that it flows more successfully, as in the placements below, and give it a delicate, fresher look. Even with this symmetrical grouping, rotations, brick and half-drop repeats can be worked to reveal other juxtapositions, which in turn offer varied links and 'flow throughs'.

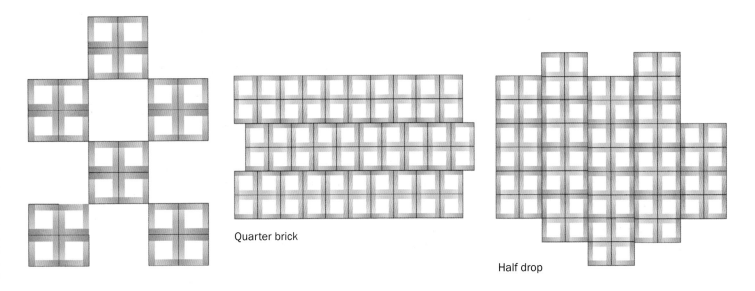

Quarter brick

Half drop

Reflected symmetry with rotation

Here the mirrored block of four is rotated once and placed directly next to the first group of four. A row is built up.

The rows are placed directly underneath one another. This results in continuous stripes of tan and green in alternate columns. The circled elements do not appear in the pattern to the right.

In this rotation example the pair of blocks is moved a full block along, breaking up the continuous vertical stripes of tan and green. The pattern blocks alternate...

...and here the pair of blocks is moved along a half width to make a half brick repeat...

These small, subtle placements and changes make all the difference in how the final pattern will read and depend on the design chosen. They can inspire different ways to link the flow of the design.

...and here, in a custom brick repeat, the pair has been moved a 'smidge', slightly changing the pattern of vertical stripes.

Scale combinations

Combinations of any of the previous formats can be used and in this instance I have chosen a four-square rotation. They have been placed with a full space between, in which I have set an adjusted motif at a larger scale. To the original design I have added some more petals and tendrils, colour and a splash of brightness with the yellow.

The 'block' look is apparent. The design could extend beyond the boundaries of the square grid in order for the pattern to flow more successfully. This will be looked at in greater detail with other designs.

There is opportunity at every stage to tweak designs and often when pushing a pattern through the various options some elements can seem superfluous while others dominate or may suggest a completely new approach. Often deleting a motif can be the way forward.

Spaces can suggest alternatives while the organization of existing elements can create new motifs, such as the floral sprig below.

Changes and adaptations

The new floral sprig has been rotated to form a four-square repeating unit. Here it has been placed at a quarter drop. Some interesting link throughs are appearing, which could be developed.

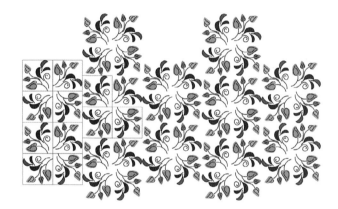

The colour of the line work has been changed in this example and the detail removed from the tulip heads. There is a combination of scales. The square has been rotated 45 degrees.

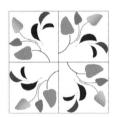

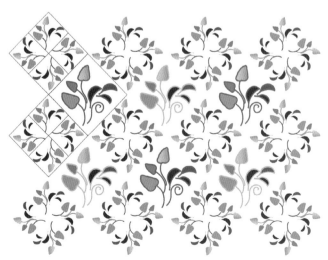

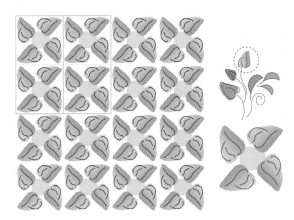

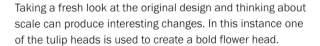

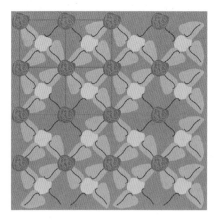

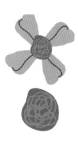

Taking a fresh look at the original design and thinking about scale can produce interesting changes. In this instance one of the tulip heads is used to create a bold flower head.

Removing detail and using unsaturated colours close in tonal value gives this simple pattern a softer look. While the additional dots create a new flower head, petals have been removed to leave spaces.

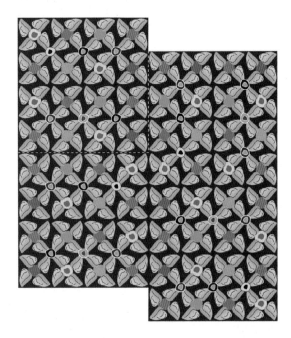

The square can still be rotated, reflected and given a custom drop at any stage to create a pattern – as here – where one repeating unit's placement has been altered. This mixes up the sequence of dots, rendering it unpredictable, and the informality of the flower heads reads more as a texture on the darker background. Here, there is tonal contrast. Even now this can be used as the repeating unit as shown above right.

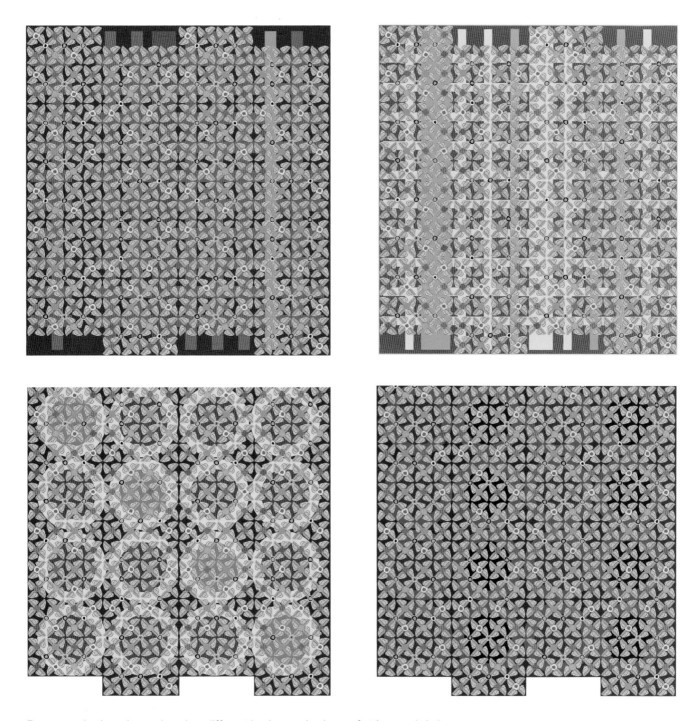

Four examples have been placed on different background colours of stripes and circles.

Moving the triangle

When joined to each other, equilateral triangles form a regular tiling or tessellation, which makes for another grid on which a pattern can be constructed. An equilateral triangle has sides of equal lengths and equal angles, at 60 degrees.

Triangles are extremely versatile – when they contain a motif and are placed to form a hexagon, wonderfully complex roundels appear. When several hexagons are massed together there is a sense of Islamic design, rich in geometric pattern sequences. With the options of rotations and reflections when moving the

triangle, several different roundels or florets can be made by using just one motif, and this is explored in this section.

Triangles can be divided up into two right-angled triangles and offer many varied repeat opportunities. They can be combined with the square to create further structures for pattern. The triangle is altogether a very useful shape to keep in mind.

The following pages contain some rotations and reflections. Later the floral motif is more fully included.

The wide borders retain the colour gradient, which I hope will help identify the placements. The floral sprig motif will be added at a later stage, adapted from the square design to fit the triangle.

Reflection

When the triangle is reflected, or mirrored, the gradients on the coloured bars match up. A dotted line will be added to help identify the reflection placement. Working on the horizontal, once A has been reflected to form B, it needs to be rotated 60 degrees to join B. Ultimately, it will be the contained image that gives the pattern.

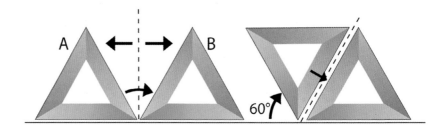

Rotation

To bring about the maximum number of pattern options, like the square, the triangle needs to be rotated before being placed. Anything to do with rotation relates to the circle and its central point, no matter how far away the circumference line is. And this means measurements of degrees. To bring each side – blue, purple and tan – sitting on the horizontal becoming the base in turn, the triangle needs to be rotated 120 degrees. The triangle apex itself takes up 60 degrees, so 120 degrees remains to make up the half circle. Imagine actually physically lifting the triangle, turning it and then placing it down again on a flat surface.

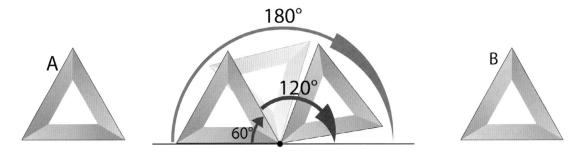

Think of the horizontal line above as cutting a circle in half. At this stage we are not moving the triangle to form a hexagon, but wanting all three colours to lie on the horizontal in order to pair them up in various ways. So now take B and work the sequence again for C.

Diamond shapes with rotation

When two equilateral triangles are connected along one side they make a rhombus or 'diamond'. Many different pattern rhythms appear with rotation and reflection placements of the triangle to form diamonds. This section explores the options.

The centre and far right triangles have been rotated clockwise from the original to give purple and tan bases. All have then been reflected to give the diamond shape. The result is a one-colour horizontal band in each of the three diamonds.

Note that the gradients pair up throughout, and the colours in the diagonals oppose.

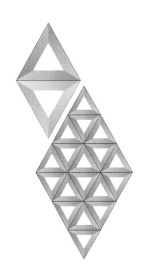
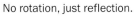

No rotation, just reflection.

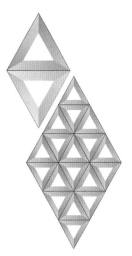

One rotation; reflected.

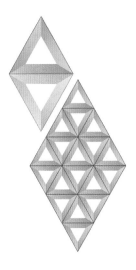

Two rotations; reflected.

Diamond shapes with reflection

In this set, reflections are made throughout. In each group, working from left to right, A is reflected vertically and becomes B. B is reflected horizontally to give C. Finally, the triangle C is slid, becoming D, which is placed under and joined to the original A to form the diamond. It is just as well to get into the habit of keeping a format going, as steps can be retraced if an error is spotted later on in a design sequence. 'Reflect, reflect, slide!' This is maybe not so critical here, but certainly when design elements are more complex it helps.

The diamonds in this set of reflections link up to form matching colour bars throughout – but note that the gradients oppose.

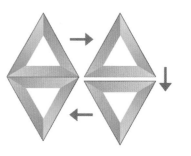
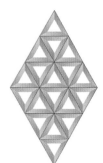

And the final one in this sequence has a tan horizontal band.

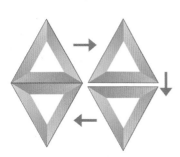
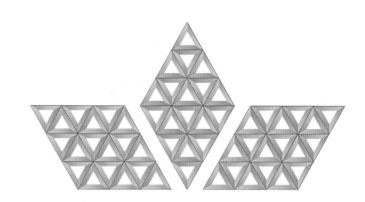

Creating one may be enough as by rotating one of the large multi-triangled diamonds the same colour bars can be brought to the horizontal. But for those working 'one-offs' it is quite useful to see how it all works.

Combinations

Here, A is rotated (either once or twice) before being placed at B. It is then reflected, becoming C. Finally C is moved left and placed under A (the original) and becomes D. A and D are joined to form the diamond and it is this unit that is used. The colour bands now start to mix up – and notice also that the gradients match up.

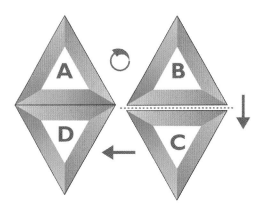

One rotation.

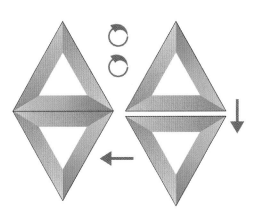

Two rotations.

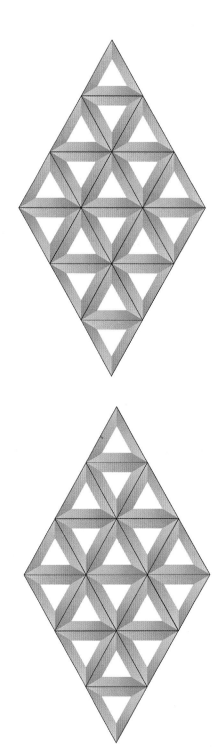

Hexagons

Hexagons are a very satisfactory shape to deal with, being a balanced and uncrowded division of 360 degrees. They are great for making roundels and can turn a simple floral motif into an apparently complex floret, or provide the guide for creating six-petalled flower heads. They can be identified within a regular tiling, combined with the square, or be the design structure for large, single, one-off pieces.

This next section shows how different a design can be when each apex of the triangle is placed at the centre in turn. In the second stage there is a reduction in colour opacity, except for the blue, which aids in tracking the moves; a floral element is also introduced to illustrate this.

Hexagons with rotations

Straightforward placements are used here. The triangle is rotated 60 degrees for each placement as it is moved around a central point to form the hexagon. Note that the tonal differences of the gradient colours now show on the spokes.

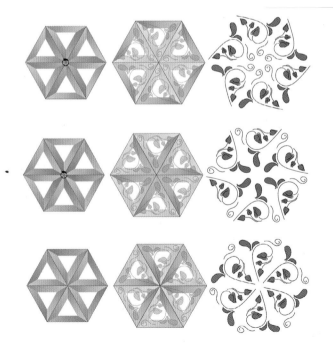

Hexagons with reflections

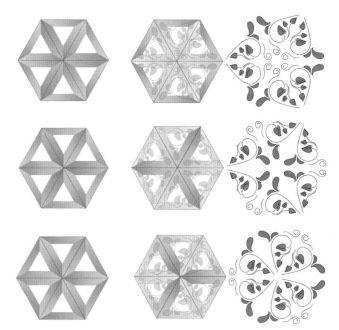

This next group shows the triangle continually reflected in its leading clockwise edge to form the hexagon. The colours pair up, making two groups of three spokes – but this time the gradients match up on all of the six 'spokes'. The floret echoes this with three mirrored sprigs.

Combinations

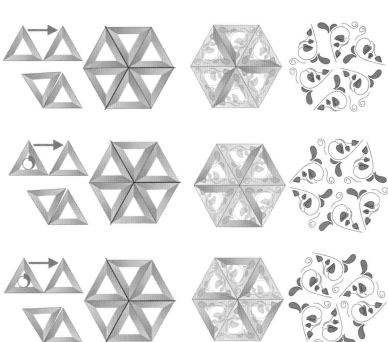

There are three more variations by creating diamond duos before forming the hexagon. It looks as though a reflection has been worked, but notice the gradients on the spokes. There are three same-colour spokes and three mixed. In this way we end up with nine florets from one drawing.

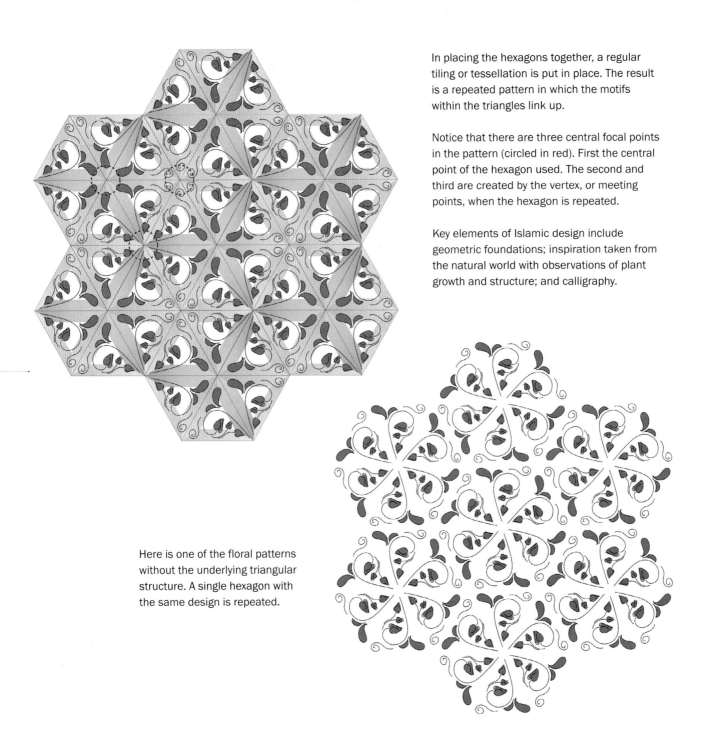

In placing the hexagons together, a regular tiling or tessellation is put in place. The result is a repeated pattern in which the motifs within the triangles link up.

Notice that there are three central focal points in the pattern (circled in red). First the central point of the hexagon used. The second and third are created by the vertex, or meeting points, when the hexagon is repeated.

Key elements of Islamic design include geometric foundations; inspiration taken from the natural world with observations of plant growth and structure; and calligraphy.

Here is one of the floral patterns without the underlying triangular structure. A single hexagon with the same design is repeated.

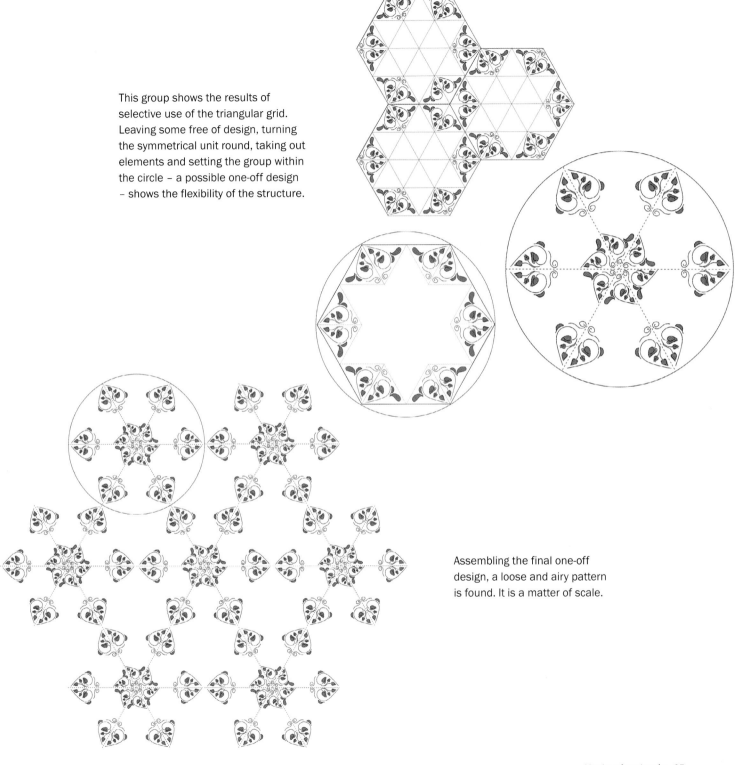

This group shows the results of selective use of the triangular grid. Leaving some free of design, turning the symmetrical unit round, taking out elements and setting the group within the circle – a possible one-off design – shows the flexibility of the structure.

Assembling the final one-off design, a loose and airy pattern is found. It is a matter of scale.

Combining shapes

 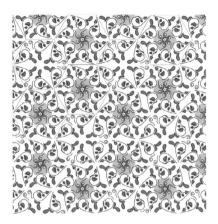

Two florets have been combined in this meandering pattern. To the most frequently repeated floret I have added a tonal focus with a drawn central detail. This is a denser, more intense central image in contrast to the second, more open floret that links them together. Once happy with the overall balance of the repeat, work can begin on fine tuning the drawing to enhance and improve the flow of the pattern.

By adding a few more leafy elements to the initial drawing, a small jewel of colour at the top and left apexes, and dropping in a background colour, the design is transformed yet again.

Breaking up the colour

Three warm analogous colours have been introduced to the background.

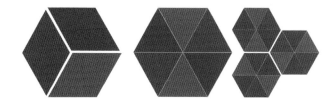

Colour has now been introduced to the diamond and gives both visual unity and a liveliness which prevents the background from appearing flat. The broad band of the triangles is still in subtle evidence. There are some tone and colour changes to the leaves. The base leaf has been redrawn so that on repetition it will form another shape when mirrored.

Colour has been given to each triangle rather than each diamond and by rotating one hexagon in a group of three, no same colours are placed next to each other in repeat. And so we find yet another pattern emerges.

Varying the scale

By setting three smaller triangles of the same design into one larger triangle the design interlinks and will also form more roundels when put into repeat. The size of the floral sprig can be altered to suit the space available.

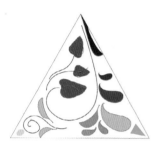 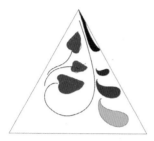

1. First, some shapes are removed.

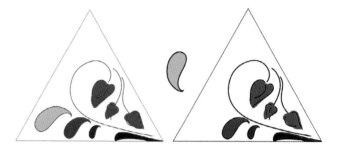

2. The large splash shape can be used as a central focus but will need repositioning.

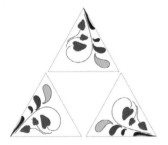 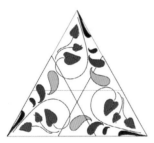

3. The triangles are rotated to keep the design elements constant at each vertex before being enlarged to form the repeating unit.

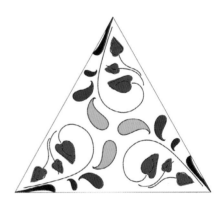

4. And here is the finished group of three. The splash shape makes a fresh central focus. It was turned, mirrored and repositioned after the three triangles were put in place so that the central and spatial positioning could be more easily seen.

5. As the triangles are placed next to each other horizontally in rows, and the pattern builds up, more hexagons and florets emerge as the three vertexes meet. By combining the new three-in-one grouping with the original, single larger sprig an interesting juxtaposition of scale is evident. Different colours have been given to this larger floret. An interlinking network is apparent, flowing nicely through the green splash shape. The design could be fine tuned to lose the hexagon shape, by effecting colour and scale changes and possibly additional motifs, which would mesh the two together.

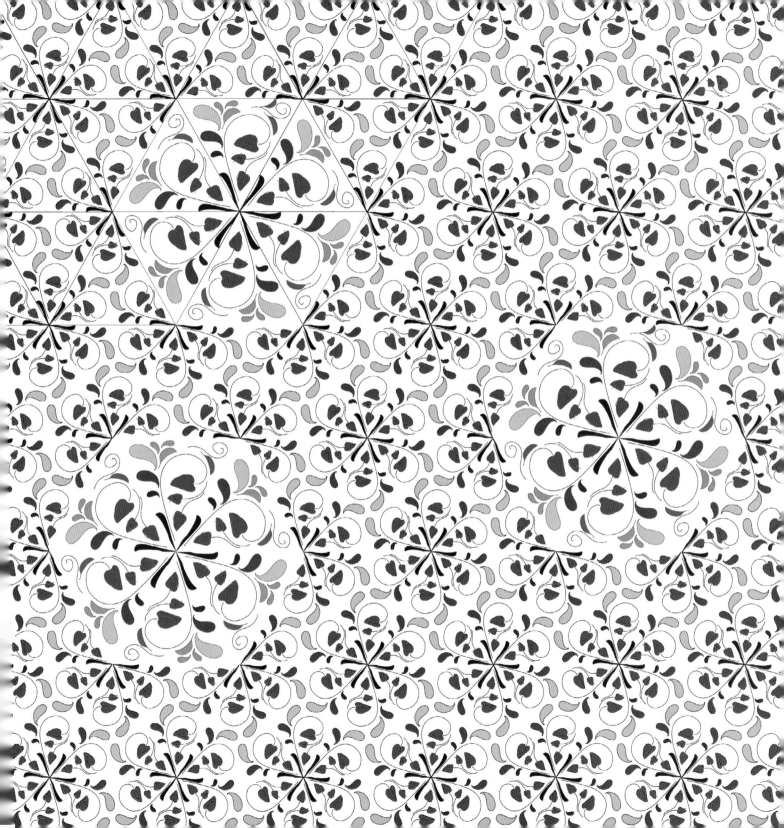

Building up colour

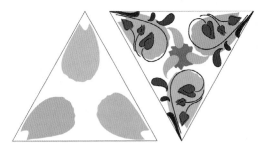

1. By adding a different colour to each vertex a bloom of three different colours is achieved.

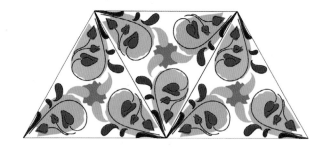

2. Form a group of three colours by rotating the triangle before placing.

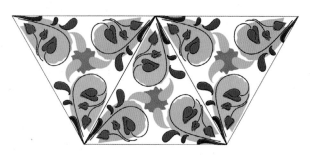

3. Then rotate – not reflect – that group to complete the hexagon and a six-petalled floret.

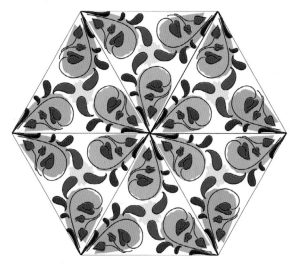

4. A flower head of the same colour is created by rotating the triangle round the central point.

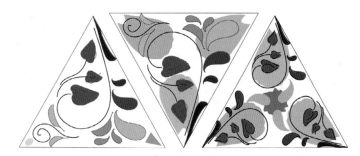

5. In the pattern opposite a hexagon made up with triangles containing one full-scale design has been added. However it still retains the three same-sized, differently coloured petals. By working with one drawing many designs can be created by moving the triangle.

Squares and triangles

Wonderful things start to happen when squares and triangles are combined, either to cover the plane completely or to create meandering patterned latticework. The next few pages give a taster of the possibilities by bringing together and organizing the motifs that have already been featured. I have chosen the existing blocks and, to begin with, the colours have stayed the same as they will be familiar.

These demi-regular tilings (of which there are 20, though not all are shown here) are the stabilizing pattern structures found in Islamic and Celtic decoration. Appearing very complex, with design elements worked in a free and relaxed way, they are a result of organization and planning of simple shapes through geometry. The other shape that crops up is the hexagon. The layout of the motifs within the shapes is the same throughout. Here and there some are deleted and some accentuated, either with colour and tone or with the weight of line. Just think of the other possibilities if rotations and reflections had been worked.

The series starts with straightforward placements.

Single square.

Original four rotation with all stems to the centre.

Additional four rotation with stems placed to outer middle edge.

Analogous colours are used here to add a background interest, which is not too intrusive, but which separates out the shapes.

When a single sprig motif is used in the square, and when the square is not turned, the pattern will have a definite 'right way up'. A pattern using the square containing the four sprigs rotated without the inclusion of the single sprig is multi-directional.

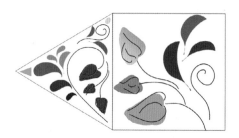

Preliminary correlations

Once the boundary lines are removed the movement of the florals is more apparent.

As a block repeat the space can house many other motif formats set within dynamic shapes. This would depend on the scale of the pattern.

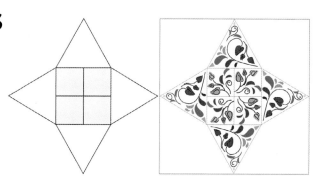

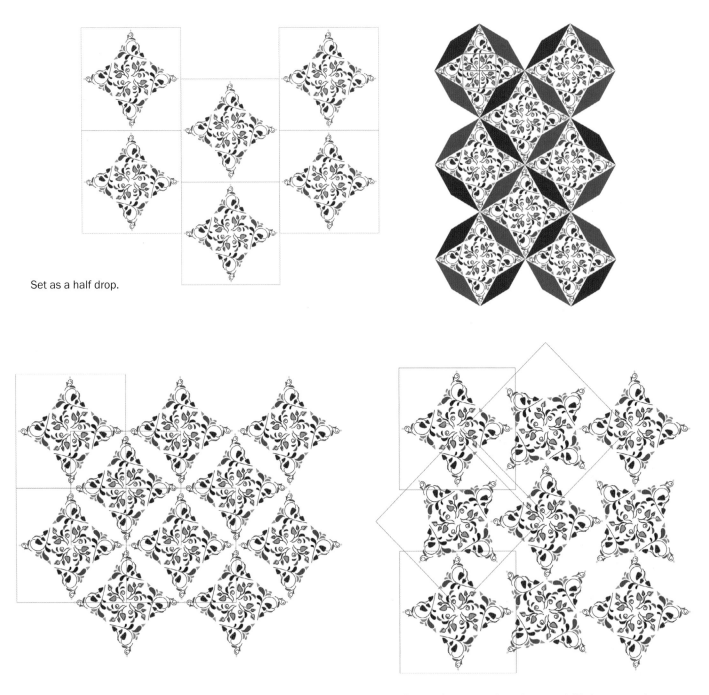

Set as a half drop.

As both a half drop and brick repeat – a quarter of the design overlaps. This arrangement is suitable for patchwork.

Every other square here is rotated 45 degrees and set centrally.

Scale variation

In this exercise, the accent is on scale. The repeating unit is made up of the design in three different sizes. Colour changes have been made to the central triangles that make up the hexagon floret, each triangle containing one sprig.

Increasing the scale, I have used one square instead of a four-square unit, which loosens up the design. To decrease the scale I have selected elements of the triangular motif and set them to each vertex. A repeating unit is shown right.

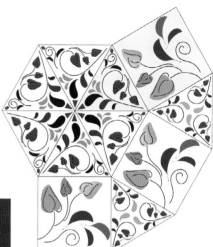

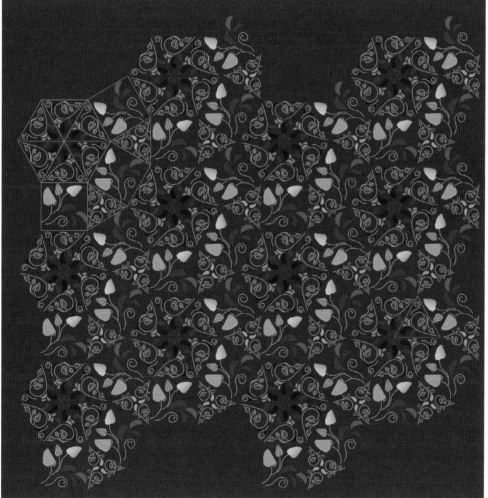

The repeating unit has had the four triangles split into two colours to give two blue-reds and two orange-reds. They are placed so that in repeat they create a split diamond.

Note the circle in the additional amended square.

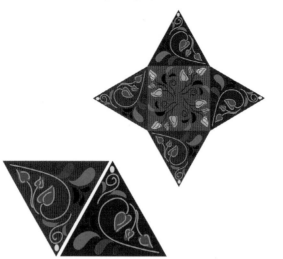

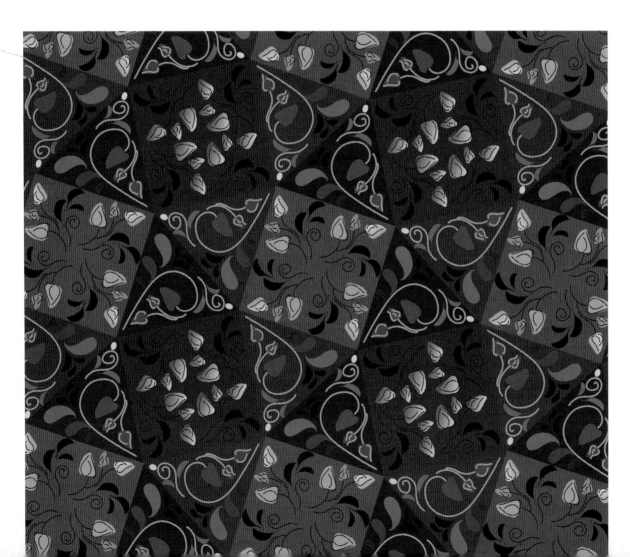

Tonal contrasts

Two squares now go to make up the central section and together with six triangles they make up the new repeating unit. Tulip heads set innermost are placed into the additional square resulting from this correlation.

The colour can be fractured even more by breaking up the oblong into separate small squares. Below an increased sense of movement is achieved by changing the tonal values of the curving line.

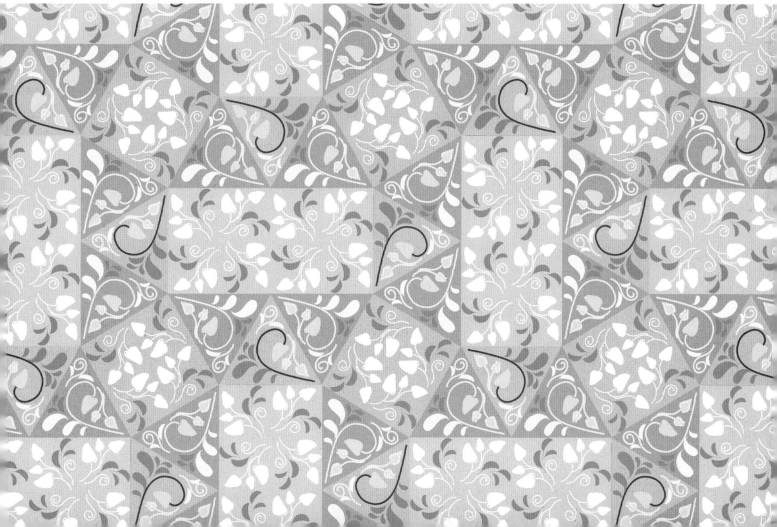

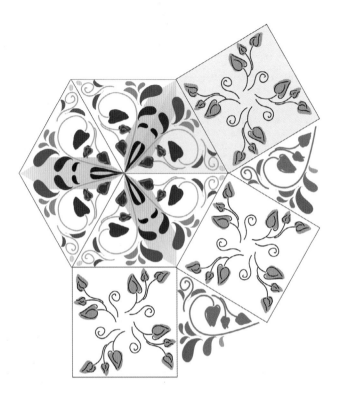

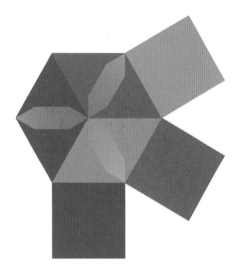

Tonal contrasts are altered, creating diagonal bands. There is masses going on but the underlying structure of the geometry conveys a peaceful unity. The components that have been used to build up the design are all present in the below illustrations and show just how much of a difference can be made with tone and colour emphasis.

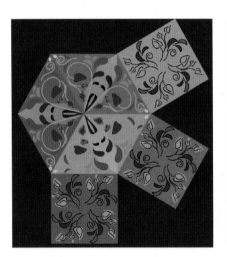

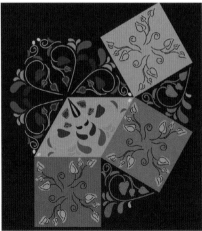

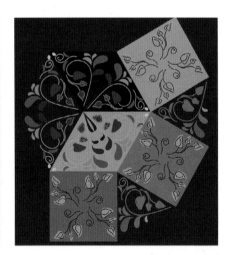

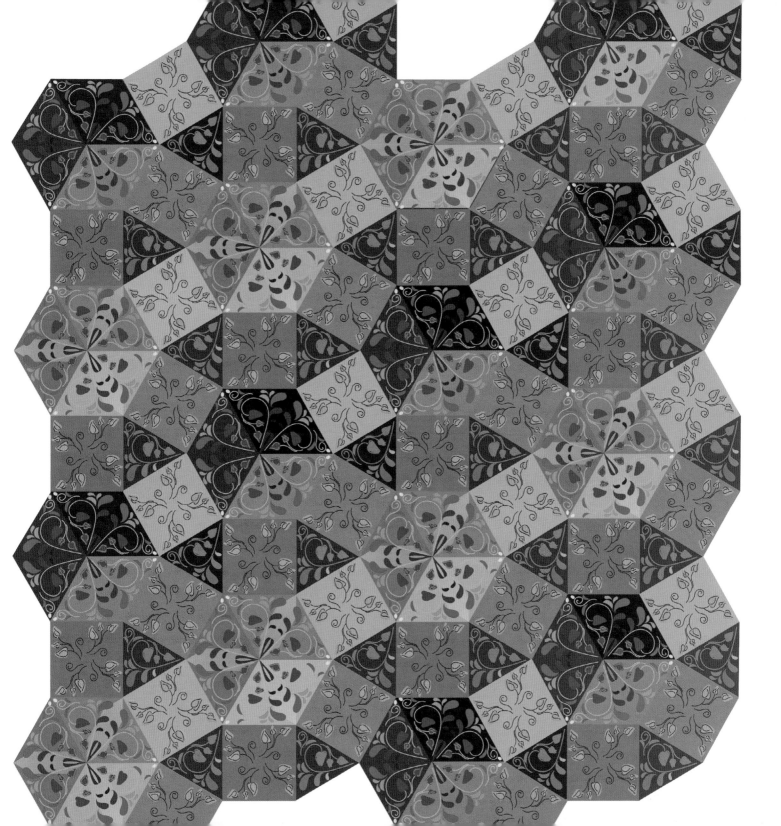

There is just a slight difference between the next two background colours; one being on the cool side while the other is warm. The pattern's main geometric structure does not appear as sharp on the warm background. The addition of white flower heads and variations in the stems of dark and light give a very different look.

The two examples opposite use the same colours, and then accentuate sections of the pattern by isolating shapes. A rich blue picks out the half curve of the dodecagon in a vertical placement. The second shows the full 12-sided dodecagon shape by setting it on white. The tiling is seen below.

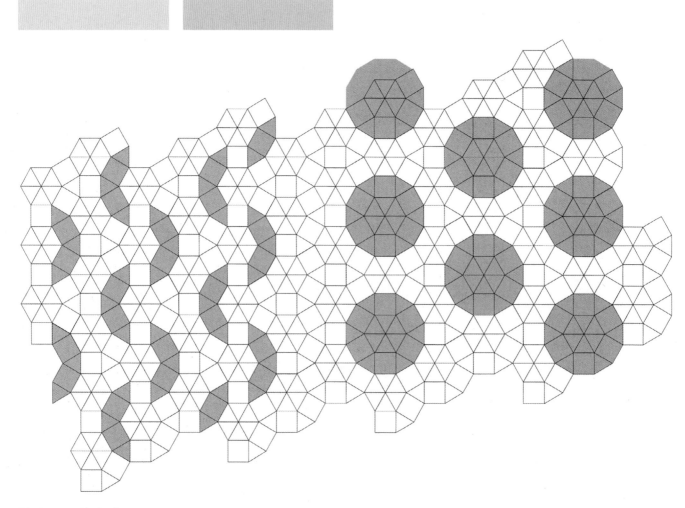

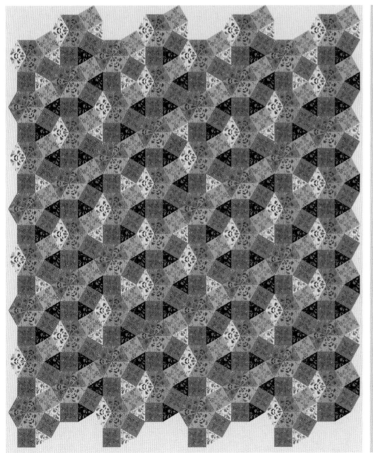

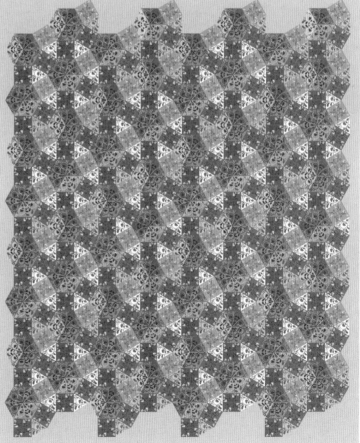

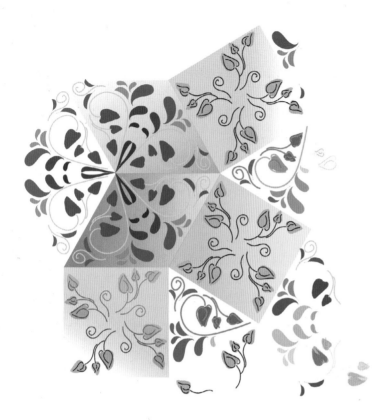

Breaking up the design and using fragments makes for some interesting possibilities – here is just a taster. Shapes set with gradients fade into the dark ground. Selections are squared up into repeating units. A fuller pattern is alternately repeated with a sparse selection of shapes for a block repeat. A 45-degree rotation has also been placed in the centre.

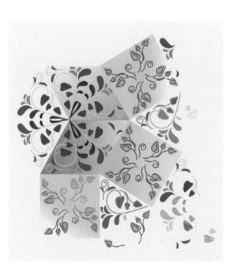

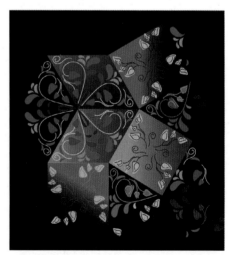

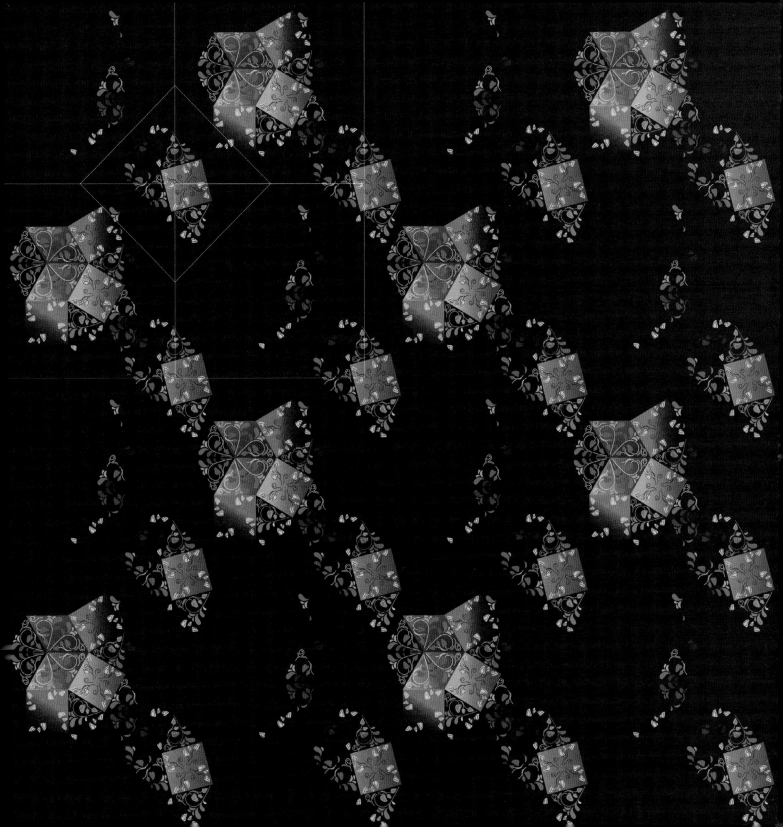

Circles

Before embarking on any circular project it is well worth spending time exploring all the secrets of the circle by using just a ruler, pencil and compass, and with nothing particular in mind, just watch shapes, connections and pattern possibilities unfold.

Rotation

The single circle can be divided up into segments quite quickly using a protractor and, by filling one of the segments with a design, a repeat is soon created by rotating that segment 'full circle', keeping it anchored at the central point.

Here, 360 degrees is divided by ten to give ten segments of 36 degrees. Use the protractor to plot out all the divisions and connect them up by ruling through the centre point. It is also worth drawing in more circles to help with the registration of the design from the centre outwards. This is best done once a design has been drawn in one section as you will be able to see where best to place these registration circuits. For sketchbook work it is helpful to have some circles with various segments already plotted out in clear, dark ink, which can be seen through layout paper or tracing paper. Sketching and planning can then be done more freely, exploring all the options of shape and colour, plus the flow of the lines, how they match up and so on, before making the final drawing.

Much depends on the purpose of the pattern. Is it to be used small scale to be part of a design or is it for a one-off large art textile? If it is a one-off textile then more detail is possible simply because there is more room.

I am using a familiar motif just to show that by moving shapes and lines and adding new ones, many interesting options come to light, from which new trains of thought develop.

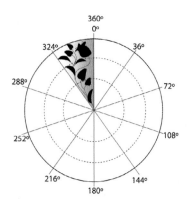

With one segment drawn in and circuit lines in place.

360° – 36° = 324°

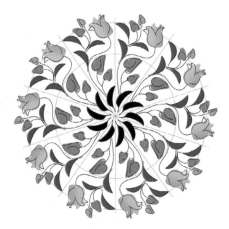

The design has been adapted to suit a circle format with ten segments.

Reflection

The segment is mirrored before it is placed. When the circle is completed there may be gaps and, again, depending on the scale of the design, these could be filled with related shapes and textures within whatever theme has been chosen.

Note that the even number of ten segments in rotation has now paired into five repeating units.

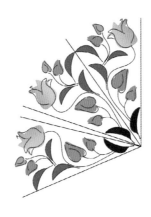
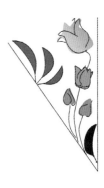

The reflection placement.

Shapes have been adjusted to give another design.

Ten segments in a reflection placement.

Developing a 12-segment design

The amended design for 12 segments (360 degrees divided by 12 to give 12 segments of 30 degrees) has an additional shape of green and red. As this sits on the dividing line it will be given to one of the segments rather than being split down the middle. The tulip head has been made smaller in order for the repeat to read more satisfactorily.

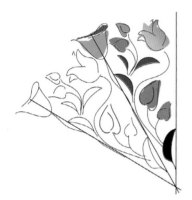

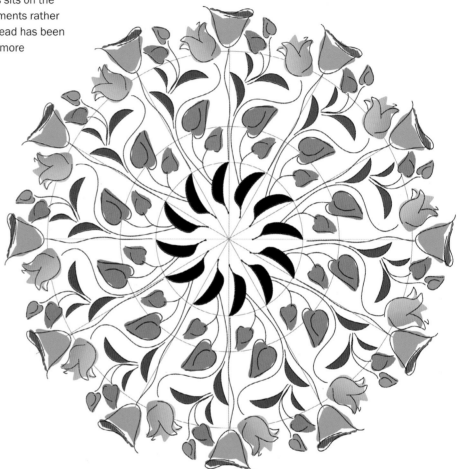

The central roundel has been divided into four groups of three for a rotating colour change – under-coloured. Because the shapes are quite bold and strong in the original, subtle differences are brought about by using softer, unsaturated colours, which will make the inner floret appear less harsh. Here, there is also an additional leaf.

Twelve is a great number to work with because it can be divided by two, three and four.

Further development of this roundel pattern takes leaves over the guidelines. These construction lines are to help with placement and registration. For a pattern to flow and make connections from one shape to another, motifs should be taken over these lines where it suits.

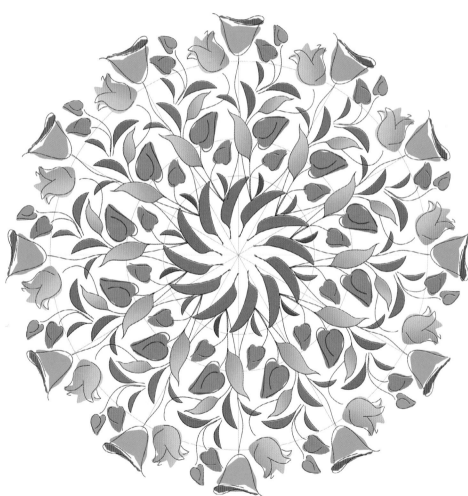

And here is the roundel all together.

Here, the example is the same design with some further additions that take elements over the lines. As a result the pattern becomes tighter and is more fluid. The red dotted line separates out the repeat.

Above, the segments have been grouped into a repeating pair, and each unit can be treated differently, either with varying motifs or, as in this instance, a colour change in a group of leaves. When seen in repeat these subtle changes give the impression that the pattern is more complicated than it really is, distracting from the predictability of the repeat.

When placed in reflection the 12 segments pair up to make six repeating units. These shapes will sit well in a hexagon and before putting them into repeat it is as well to set them into a drawn hexagon as this will keep registration running true.

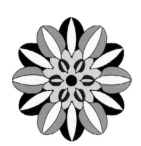

A central floret has been made by repeating and turning the group of shapes each time, giving them a new colour. Their positioning gives yet another two shapes – here in yellows.

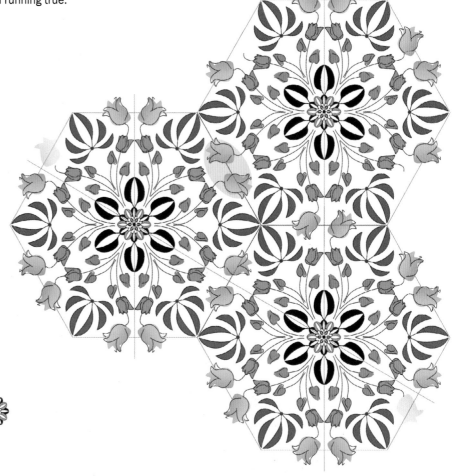

Placing this design together for a repeating unit offers, in this instance, two possibilities at the point of contact. One is to set a drawn hexagon tightly to the design. By removing one tulip head from each side the hexagons can be placed tightly together, becoming meshed, as they share the same design units. Some interesting links could be worked with the stems to improve the flow of a design here.

There are so many options for using the hexagon as a design motif. In many cultures it was used as a single unit containing a motif or patterning of some sort – an embroidered flower head for example, or a geometric, often with a wide, elaborate border. Used small scale it created background interest upon which a more elaborate floral would be placed.

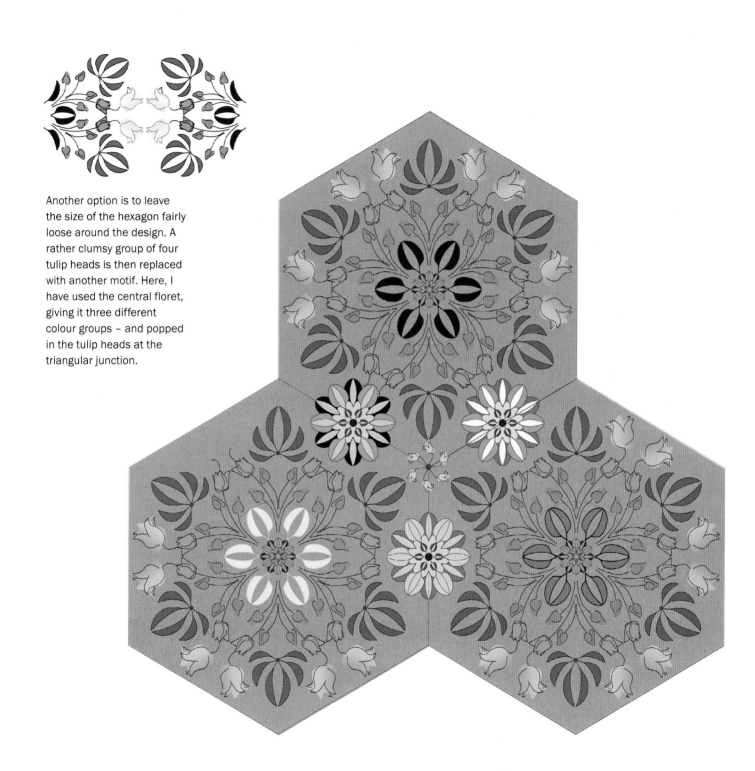

Another option is to leave the size of the hexagon fairly loose around the design. A rather clumsy group of four tulip heads is then replaced with another motif. Here, I have used the central floret, giving it three different colour groups – and popped in the tulip heads at the triangular junction.

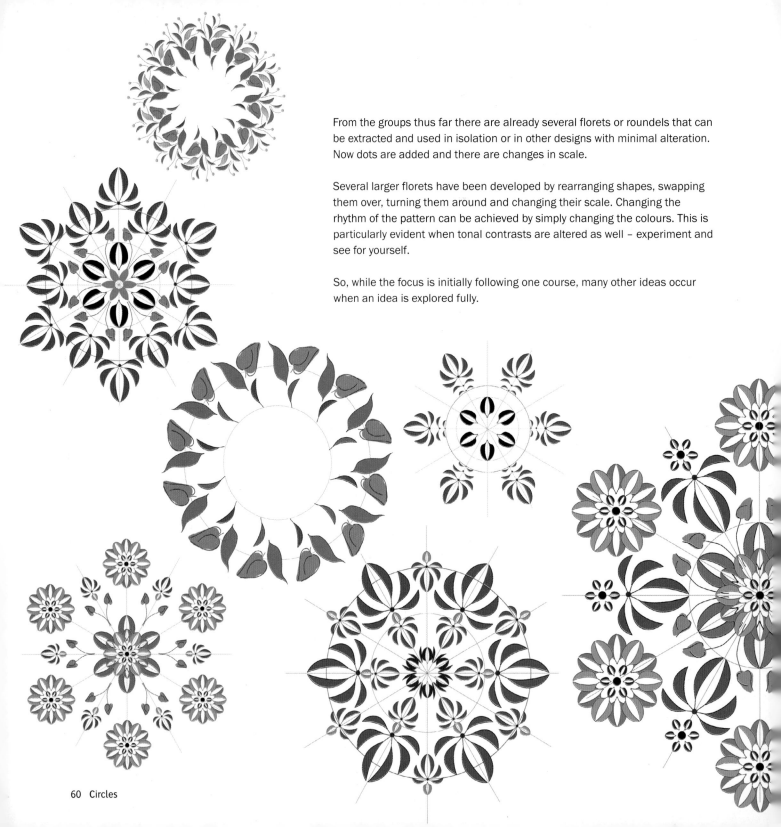

From the groups thus far there are already several florets or roundels that can be extracted and used in isolation or in other designs with minimal alteration. Now dots are added and there are changes in scale.

Several larger florets have been developed by rearranging shapes, swapping them over, turning them around and changing their scale. Changing the rhythm of the pattern can be achieved by simply changing the colours. This is particularly evident when tonal contrasts are altered as well – experiment and see for yourself.

So, while the focus is initially following one course, many other ideas occur when an idea is explored fully.

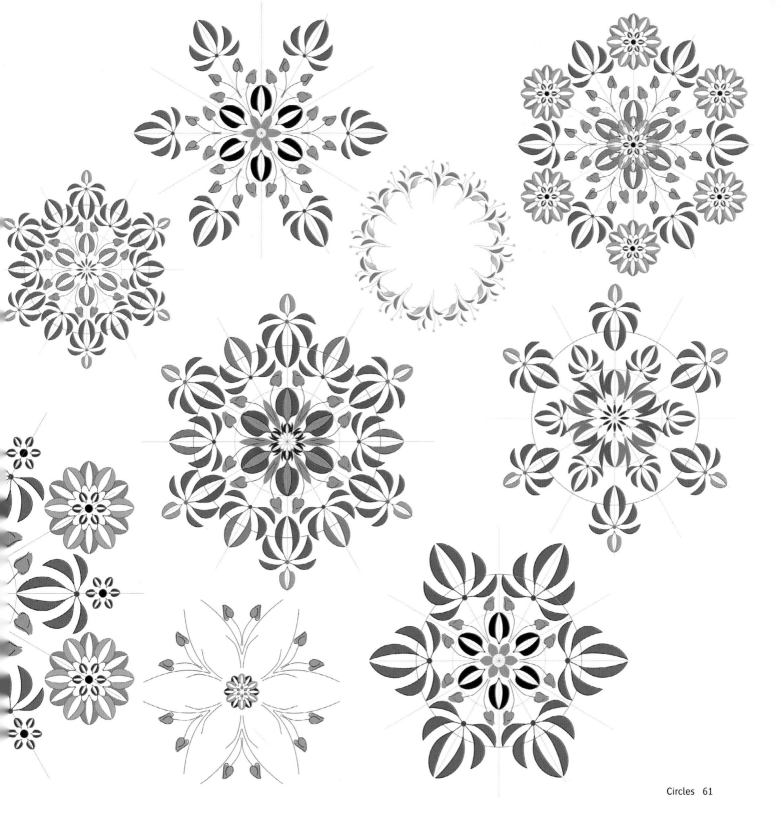

Borders and corners

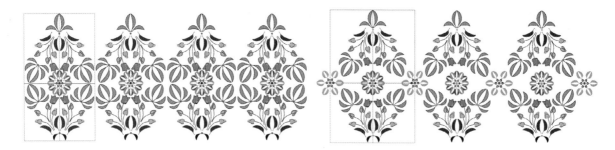

By setting the design into a rectangle, borders can be built up. The space between the design and the rectangle affects the overall design.

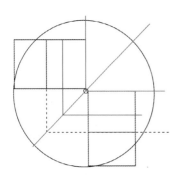

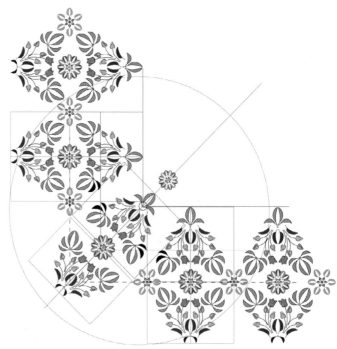

A few registration lines will help to set up a corner. Where these lines go depends how shapes in the borders line up; which shapes are key and need to be kept level. Often it is a case of making a visual judgment first, then drafting lines and a circle so that vertical and horizontal borders can be placed equidistantly from the corner component.

Here, in the corner placement, the top rectangle of the design has been lifted. The daisy is then centred in the space in the corner unit.

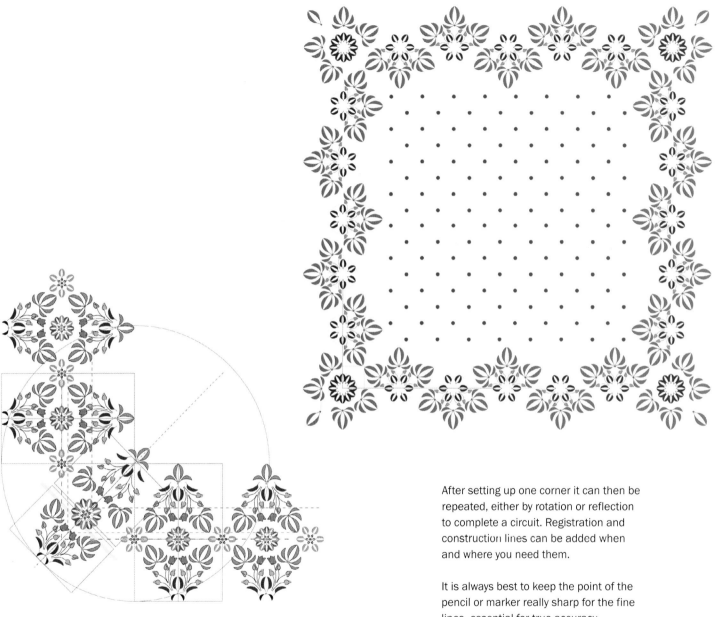

After setting up one corner it can then be repeated, either by rotation or reflection to complete a circuit. Registration and construction lines can be added when and where you need them.

It is always best to keep the point of the pencil or marker really sharp for the fine lines, essential for true accuracy.

Whereas here, the motifs in the top rectangle have been elongated so that the design is more spacious and the daisy has been enlarged. There is no extra daisy. The point is that by setting up registration lines the pattern will be well aligned and run true.

Stripes

Having repositioned the shapes to fit the circle format, yet another arrangement of the floral sprigs emerges. By repositioning the sprig yet again within the square, there is the opportunity to create a stripe or border pattern.

Below is a sighting to see how the custom drop looks: it is not strictly a true mirrored repeat as the reflected floral group is dropped.

Using the square ensures spaces between the pattern are consistent. The motif is positioned to one side and the moves are for a standard half drop.

Here is a custom drop. In both the half and custom drops an obvious gap is seen running through the middle. In the third stripe of the custom drop a group has been redrawn, which helps to disguise the gap. Alternatively a gap could give an opportunity for another pattern – such as a shadow pattern, as in the last of the four.

Now the design has been set tight to the side of the square. Using the half drop there is no longer a gap in the reflected repeat and much more could be done to create a new 'posy' growing from the point where all the stems converge.

By grouping the design into oblongs the stripe can be tightened up into a more intense format, with narrower gaps between columns.

By removing one of the tulip heads the pattern can be tightened up yet again with overlap placements. (The overlap sections have been tinted.)

The section with the tan tulip heads shows that every other one has been removed. It opens out the pattern and the horizontal becomes less apparent.

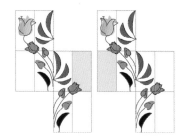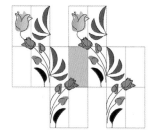

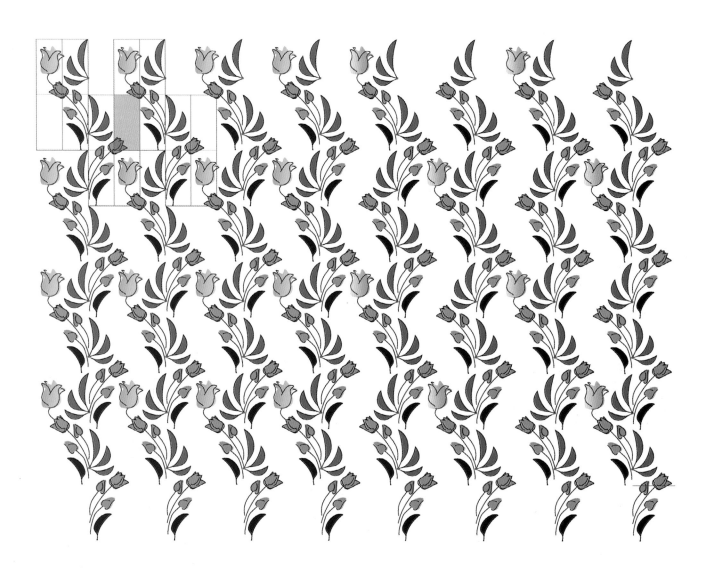

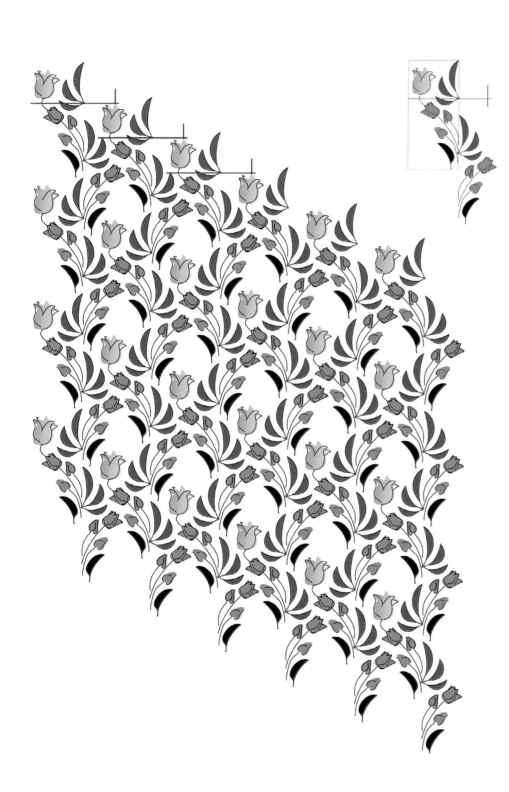

Custom drops can appear quite complex, which is why registration lines are really useful in keeping patterns running true. Here one oblong has been lost but set in place are horizontal and vertical registration lines, a mark for the tip of the tulip.

Reflected stripes

Various options present themselves for placement. The top example shows the pattern well spaced by placing the squares next to each other.

By overlapping half of each four-square block the pattern tightens up.

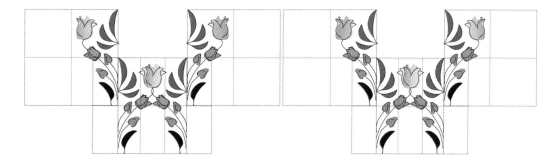

By superimposing the tan shapes a single connecting motif is created (shown in yellow). This could be worked as a new flower, or a changing motif to include daisy, iris or similar.

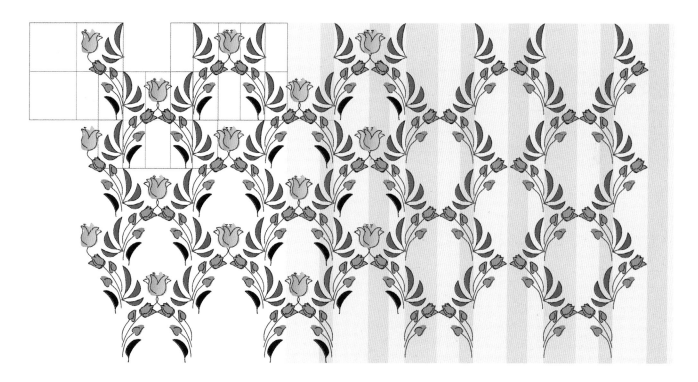

In this placement the pattern forms a compact trellis. Stripes make up the background and in this section the tulip head has been removed altogether, as have the dark leaves. Variations follow on pages 70–71.

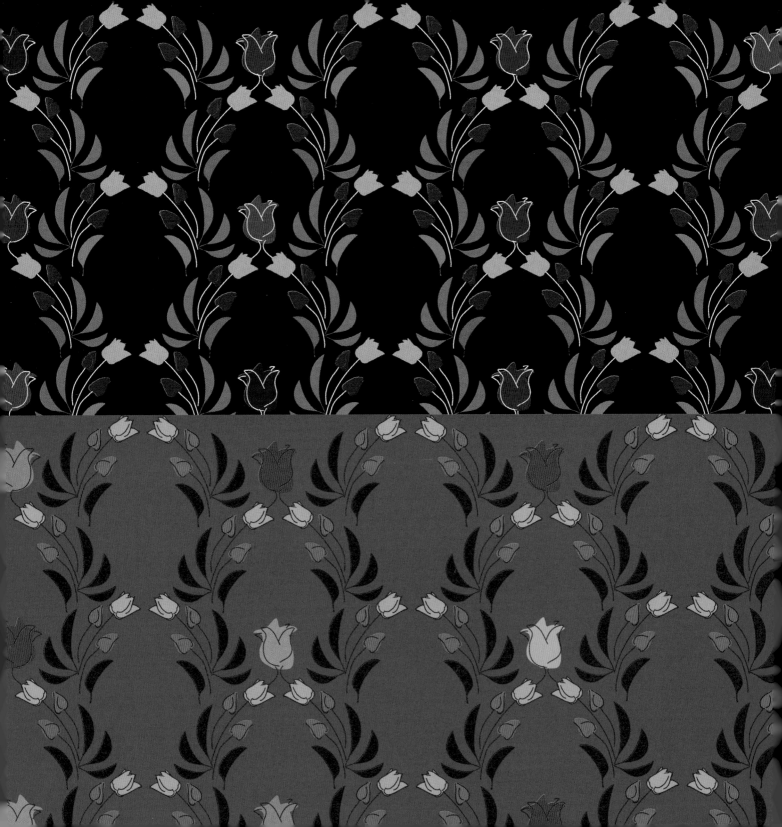

The sprig has been quite robust up until now, but, again, motifs have been extracted from the design and this time tweaked to give a more elegant look. The colours are softer also.

The circle is used yet again to plan and design domestic tableware.

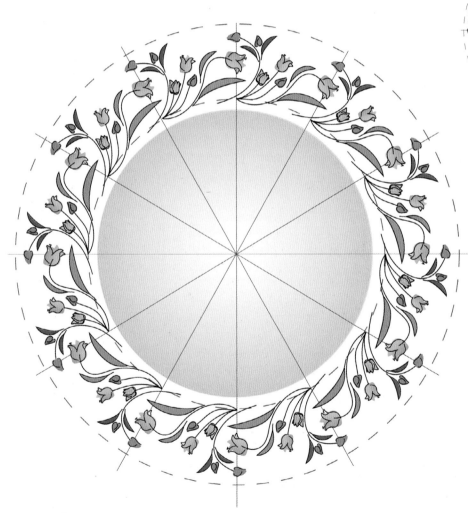

Three different placements
are shown here. The first is
a standard block, then a half
drop and lastly a custom
placement, which tightens the
pattern for every other row.

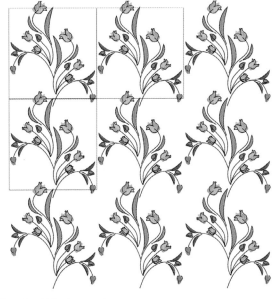

Standard block repeat.

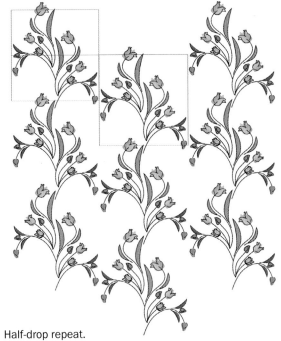

Half-drop repeat.

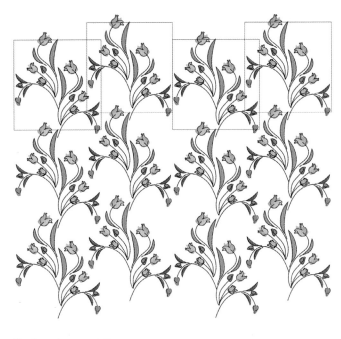

Custom-drop repeat.

Bold geometric designs

A square containing a simple bold design can, in repeat, produce lively geometric patterns. Here elements are gradually introduced that strengthen the diagonal or lessen its impact.

The linear half square suggests a diagonal when put into repeat. The solid ground colour emphasizes the diagonal.

On these pages we see the design as an achromatic study – that is to say, using black, white and grey only. The fractured quality can be made to appear greater or can be lessened by varying the tone or by adding other marks.

Other marks that can be used are shown above.

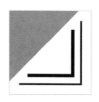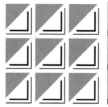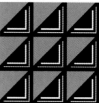

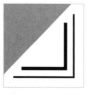

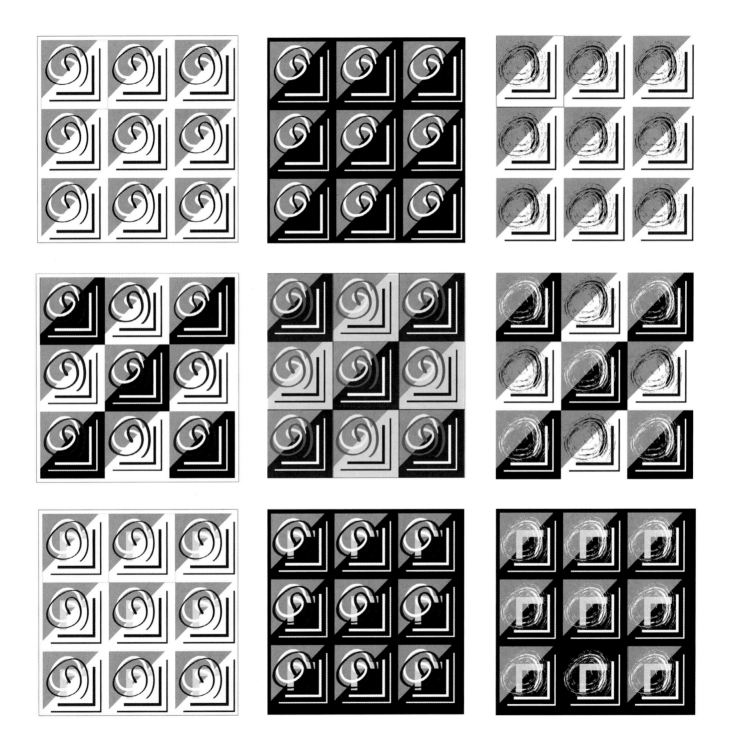

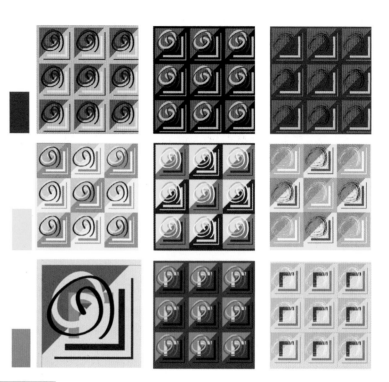

Monochromatic

Monochromatic shows variations in chroma (the amount of colour) and value (lightness and darkness) of just one hue.

Analogous hues

Analogous hues are to be found next to each other on the colour wheel and colour schemes can include tints (lighter) or shades (darker). Analogous colours can convey peaceful colour harmonies as well as contrasts. This collection shows dark/light variations and the colours progress in jumps rather than smooth, close transitions.

Complementary colours

Complementary colours are those found opposite each other on the colour wheel; these create vibrancy and energy, and the colours appear more vivid when next to each other. The same complementary has been used for each group. The purple/yellow reads as a tonal study as well.

Colour themes

This group presents standard ranges from a software program. From left to right: bright; cool; dark; desaturated; light; saturated; touch of bright with dark; saturated with desaturated and finally warm with cool.

Leaf

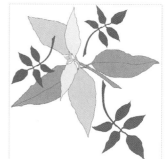

You don't have to be a grade 'A' photographer to produce a design, as this rather uninspiring photo of buddleia leaves shows. But when the image is put into a repeat pattern, rhythms and sequences are clearly seen. By isolating shapes and exploring repeat options this photo offers many design possibilities.

The selected shapes have been drawn directly on the computer then separated out for clarification. The shapes are then reassembled – a particularly useful exercise if the intended technique is appliqué.

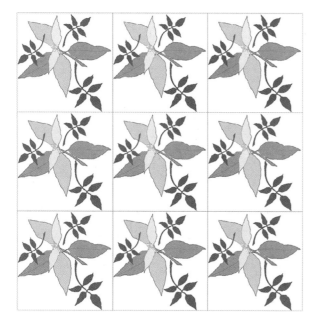

Once the squares are put into repeat it will become clear where to place further shapes to enhance the flow of the pattern.

Keeping the shapes within the box ensures that there will be no overlaps in the various repeats. Once a repeat has been decided upon, shapes can be added or taken beyond the boundary to help the flow.

Also known as a slide repeat, the step and repeat reveals strong horizontal or vertical bands through the longer leaves.

Half drop

This can also be done for quarter and eighth drops or a custom drop. It all depends on how the pattern develops and on the width of the fabric or surface in relation to the scale of the repeat.

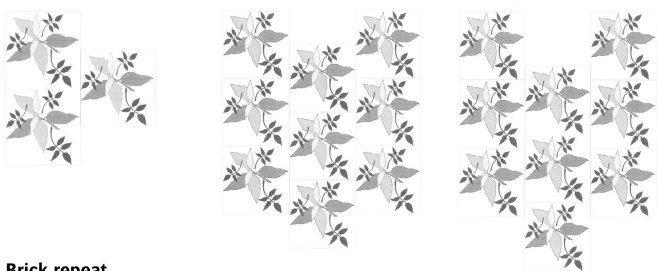

Brick repeat

In the brick repeat (below right) the lower leaf group has been reduced in scale by 65% in order for the square to be moved into a custom brick with quarter lift to tighten the pattern.

Reflective symmetry

The original motif has been realigned – turned – in the square and another leaf has been added.

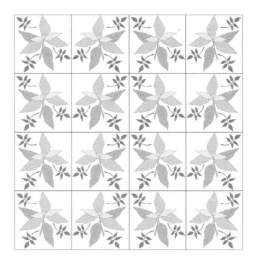

The design is mirrored, or reflected, and the pair is then used as the repeating unit. In these patterns the large dark leaf dominates which is corrected to a degree by lightening the tonal value.

The symmetry is set on the horizontal only – this placement is very useful for border patterns for both simple and complex designs.

The pair is moved one square along for the drop. This makes the repeat appear less predictable within the small groups.

Full reflective symmetry

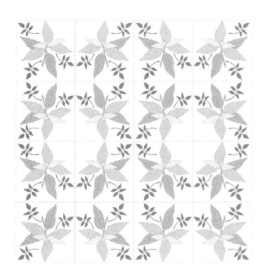

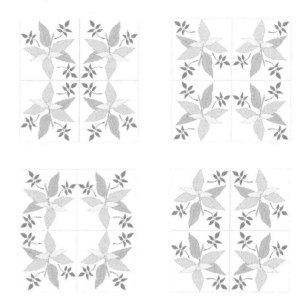

The square has been reflected horizontally and vertically. This placement sequence is very useful for creating more complex units, such as florets, as only a quarter need be drawn up.

In this instance the repeat sequence provides designs for four 'one-off' projects.

Now the original design (see page 78) is set at full reflective symmetry.

Moved along one square with a quarter lift.

Rotation

Fresh connections and links are created by rotating or turning the square and using both squares as one repeating unit.

One turn

A new pattern can be created simply by rotating the leaf motif and placing the pair in a brick pattern. There are also opportunities to set the repeat as a half brick and as a quarter drop.

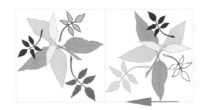

Because the pair is being used as the repeating unit, the small groups of leaves have been treated differently in two of the examples. The tonal value of the large leaves has also been lightened.

Standard block.

Brick pattern.

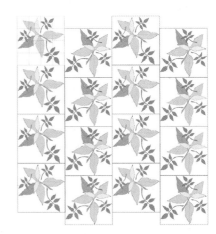

Quarter drop.

Two turns

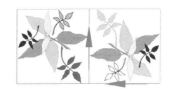

This arrangement brings about some lovely connections which are enhanced by changing the tonal values again.

Standard block.

Brick pattern.

Half drop.

Three turns

Again, adjustments have been made to tonal values. The lower right example has been set as a custom drop and overlap which tightens the pattern.

Standard block.

Brick pattern.

Custom drop and overlap.

Tonal backgrounds

We see a change from all-over pattern to a possible one-off piece as the background gradually changes from dark to light. This is the same three-turn pattern placement shown on page 83 with some of the outlines being changed to white or omitted.

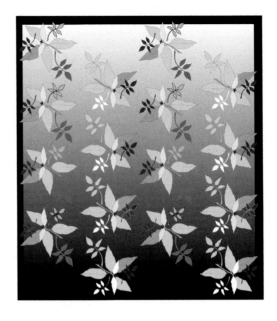

The addition of colour outlines makes a remarkable difference to the temperature of the pattern.

Rotating groups of leaves with colour added in a four-spot repeat sequence. The background is set in sequence with the gradient placement rotating, which gives its own diagonal emphasis.

Developing the pattern

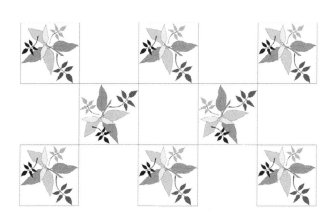

There is also more room to develop the pattern further and make links to connect each motif unit.

Opening out the design, either by placing it in a bigger square or leaving a block space, gives a breezy feel.

This pattern is made up with the original orientation (see page 78) and with one turn anticlockwise in alternate rows. A leaf stem and a flower head have been added and the position and scale of the leaves have been adjusted to form links.

The central floret now has a new growing tip. The unit has been repeated with an additional leaf to lead the eye to the next group. The stems have been joined and curve more. Berry clusters have been added, which contrast with the flat shapes of the leaves.

Here the original design has been placed diagonally as a work and turn (blue squares). The two remaining squares, previously the spaces, have additional floral motifs. Finally, tiny leaves have been added as a background link interest. This set of four blocks can now be used as one repeat unit.

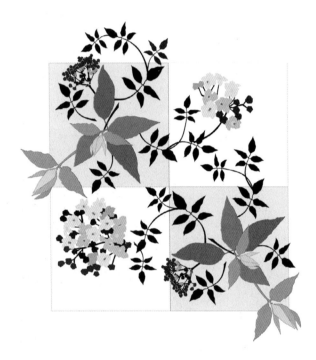

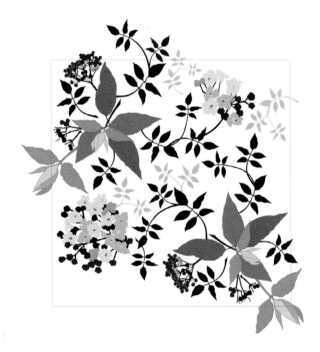

In the accumulative placement on the following page the darker background colour (top left) brings out the lighter, delicate plant forms. The larger leaves appear less dominant as tones are close. Lighter colours have been added to the circled motifs, which gives a delicacy.

On the lighter background the tiny leaves have been increased in tonal value where the colours are very similar.

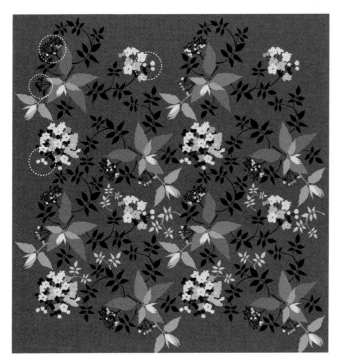
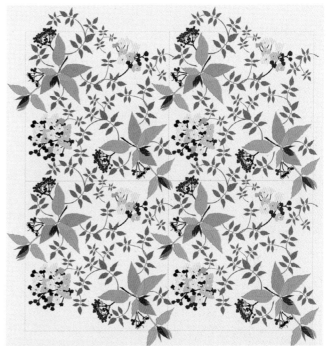
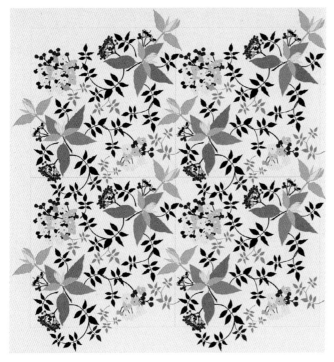
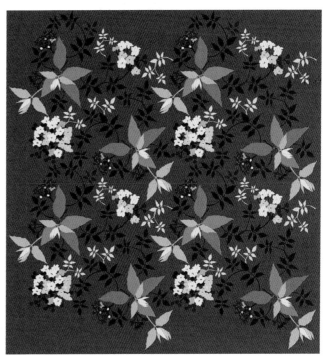

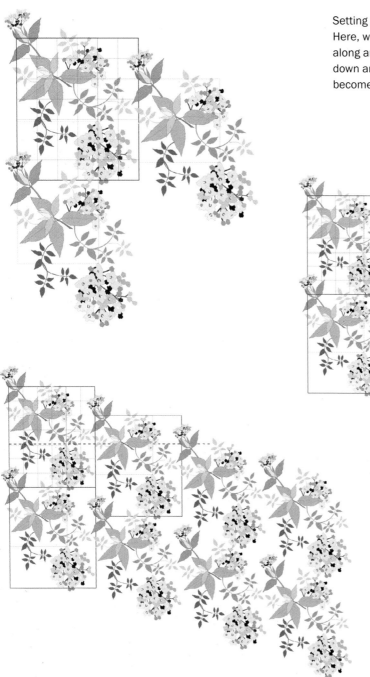

Setting up a grid helps with placement of a containment block. Here, working horizontally, the block is moved six small squares along and two down. Vertically it is placed seven small squares down and directly underneath. Once established, the repeat unit becomes an oblong.

There are several options for pattern placement. To the left, the placement sequence continues using the two-square down drop, resulting in a diagonal.

Above the unit is placed like a custom drop. This is used for the colour variation shown opposite – an amendment has been made by increasing the size of the half cluster.

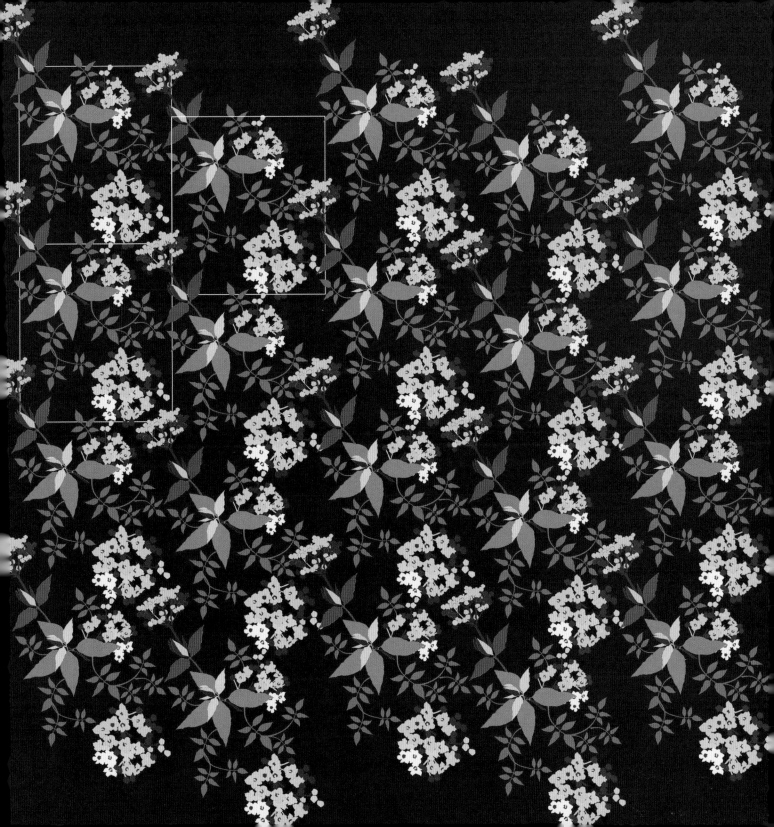

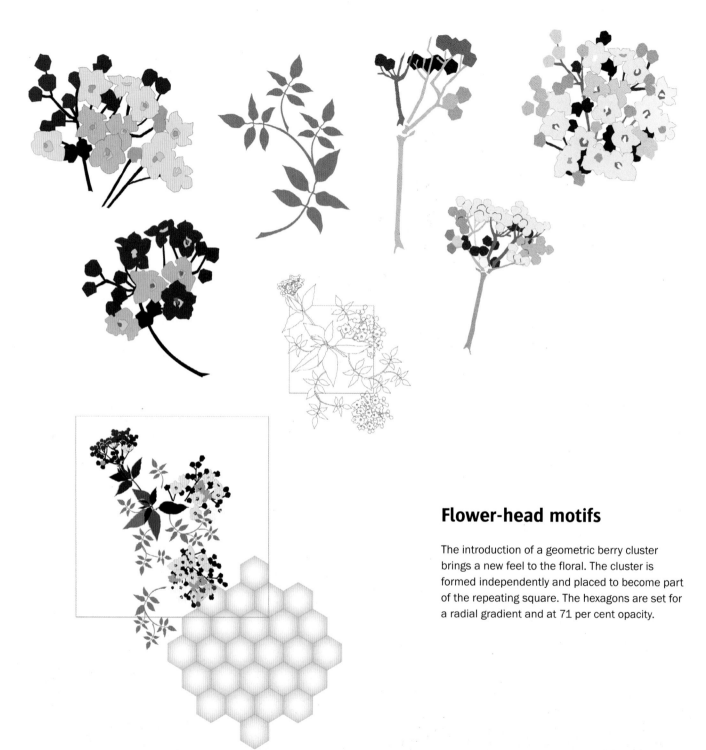

Flower-head motifs

The introduction of a geometric berry cluster brings a new feel to the floral. The cluster is formed independently and placed to become part of the repeating square. The hexagons are set for a radial gradient and at 71 per cent opacity.

The location of the gradient within a shape can be controlled to either fill the shape or keep the colour close to the outline. Four examples show the differences that can be achieved by moving the location setting of the gradient bar using two colours.

Differences can be made when the opacity of the complete unit is changed. Below they are set to 50 per cent. Useful for backgrounds.

Textured backgrounds are added and bold stripes are evident with the greater tonal contrast. The introduction of static coloured blocks on the opposite page throws the leaf into clear definition, while the outline preserves the flow of the motif. The design progression in 'Leaf' has moved through smaller diaper patterns, stripes, a possible one-off design and large florals.

The duck

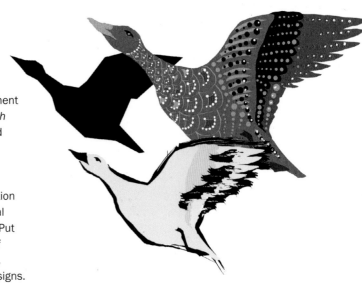

The diamond grid was used throughout India and Persia for the placement in particular of posies and linked florals, including the well-known *butah* motif, and was known as *mina-khani* or 'beautiful garden'. Animals and birds were used within the grid where stylized shapes produced bold, charming patterns.

This series takes a well-established route to find a pattern. If the intention is to end up with a design featuring ducks, for example, source material should be gathered to provide a reservoir of information to work from. Put in silhouette, the duck brings to mind the drawings and visual magic of Escher; the outline of pastel in black designs of the 1940s and 1950s, while the highly decorative infill is suggestive of Persian and Indian designs.

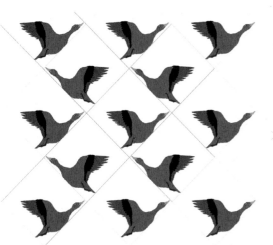

The duck has been repeated in each diamond, and then each row has been reflected, or mirrored.

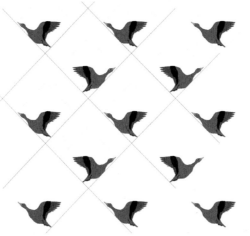

The grid is kept at the same size but the duck has been reduced, making the pattern more open and gives the opportunity to add an additional background pattern.

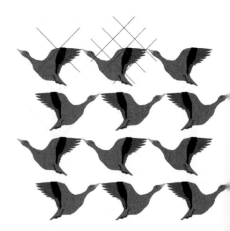

The pattern has been tightened up by using a half drop (red grid) placement combined with a quarter brick repeat (purple grid).

Abstraction

Here, the essential shapes are abstracted. Simplified, they are opened out to form a group of three shapes. This is rotated 180 degrees and set in a square for repeat sequences. New shapes can be added into the negative spaces.

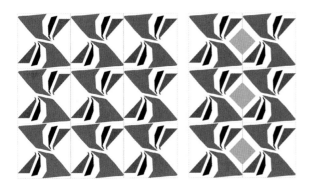

Block repeat.

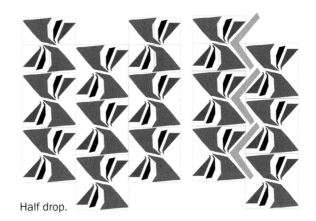

Half drop.

Brick repeat.

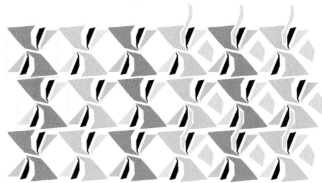

Custom brick, shown in pastels.

Finding diagonals

In this section further changes have been
made to the standard brick repeat.

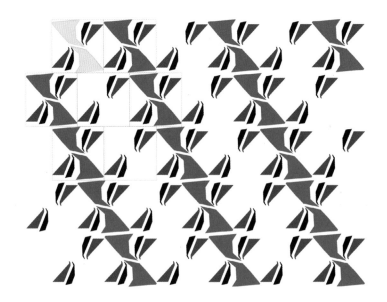

By removing every other diagonal line formed by the largest
shape the pattern takes on an organic feel and could be
redrawn and interpreted as plant forms.

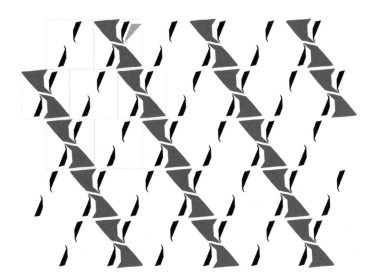

The subtraction is taken further as another shape is removed,
making a well-defined and fine opposing diagonal.

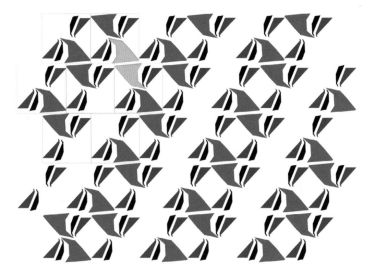

The duo created by the same large shapes has been removed
resulting in a broad, chunky diagonal.

Adding background colour

The second arrangement on page 96 has been combined with a flat background colour and a broad wash diagonal stripe (49 per cent opacity) of colour, which remains the same throughout. The smaller marks in black collectively reveal diamond shapes.

In the samples on pages 98 and 99 the patterned stripe has been set on the opposing diagonal and has been worked with stronger, more vibrant colours. Black has been introduced as a background. Working freely on paper with paints and inks, resist materials such as wax crayon, and a variety of brushes and papers will give a wonderful starting point for a visual dictionary of textures, stripes, checks and colour combinations.

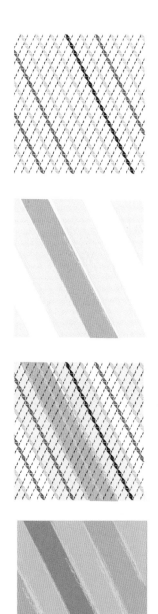

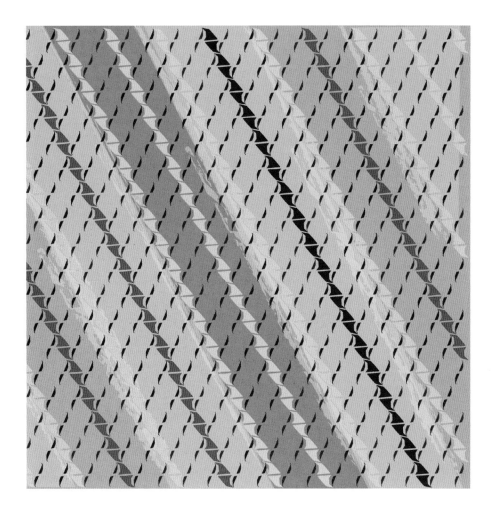

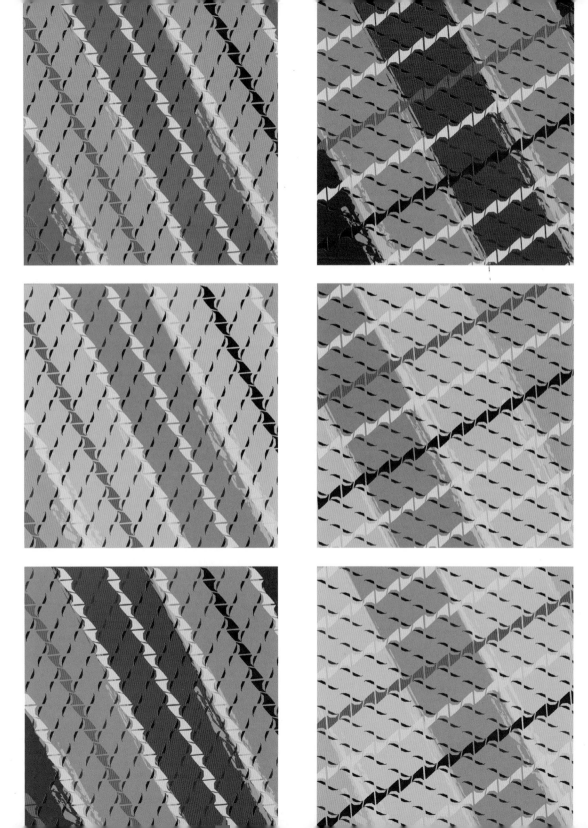

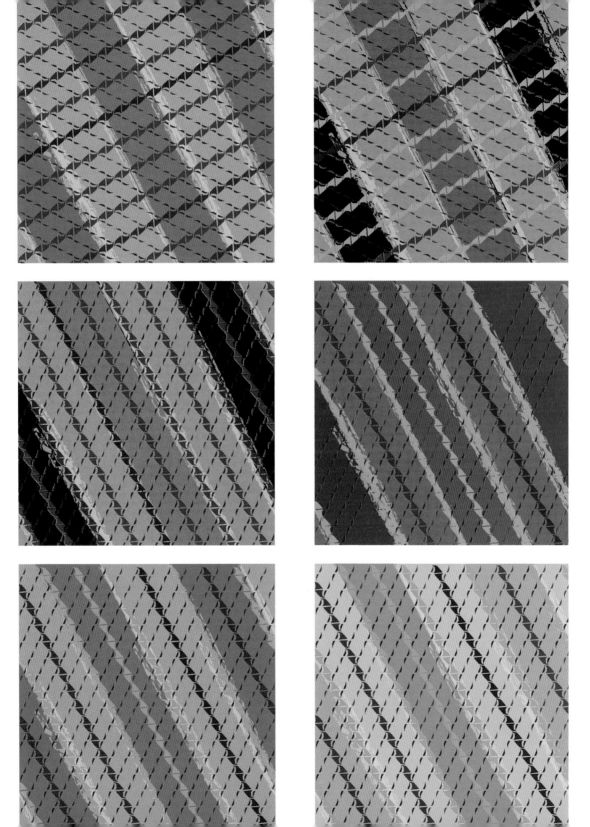

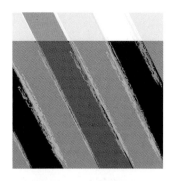

Checks

By continually repeating a process and applying layer upon layer, intricacy and texture are created.

The development of the pattern begins with the original washed stripe being laid down on the black ground. It is applied again after being rotated – a broad check is formed.

Textured yellow lines have been added at 100 per cent opacity to retain vibrancy and a black line has been added also.

The pattern layer has been placed over the top – and finally placed again on the opposing diagonal (see the larger image) to give a rich tartan-like check.

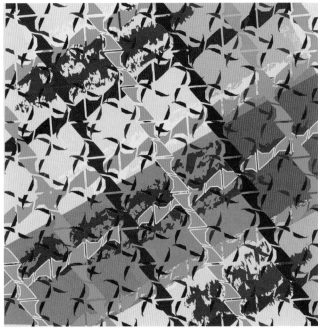

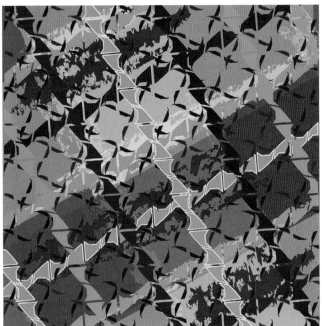

These images have had an increase in scale, which allows for further detail in the way of outlines to some of the linked stripes. The textured lines have also been increased independently.

Using hexagons

By introducing the hexagon at this stage, the pattern arising from exploration can be used yet again to form a new variation by being contained.

 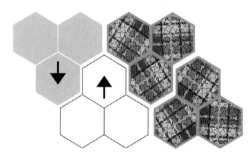 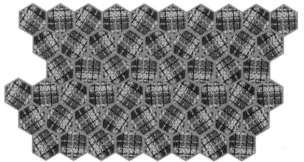

A hexagon forms one of the regular tilings, but it could be just as effective placed singularly.

Here it is rotated once to give a second image, which is then reflected to give the third. Each displays the diagonals at a different angle.

The group of three now becomes the repeating unit. Using this group, a row is worked, which is then reflected before being placed 'dovetail' fashion to make the repeat.

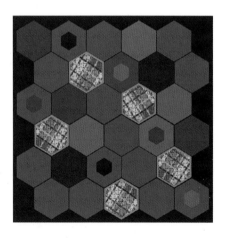

All these formats using the hexagonal block would suit patchwork quilts.

In this set of examples, the detail has been removed and the pattern is further simplified.

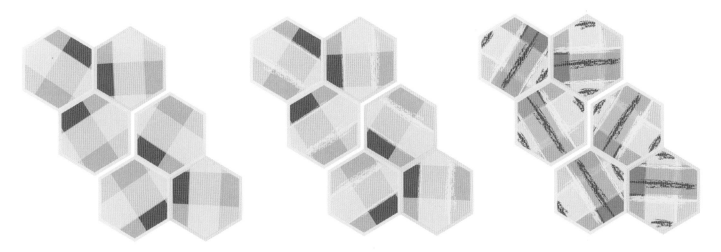

This has been stripped right back to a chequered layer and a broad, interlinking split hexagon network is revealed.

The yellow textured line is reintroduced, although now it is in a paler and less saturated colour, and it emphasizes the interlinking hexagon.

The pink textured line is reintroduced. The base has been replaced by cooler lilac and green washes that are softer and lighter than the previous design.

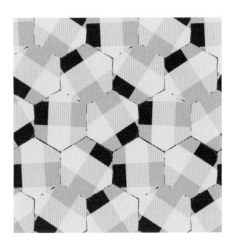

Here they are all shown without the hexagonal border.

Introducing circles

In keeping with the sentimental view of ducks flying across the setting sun and so on, a circle has been introduced at the central point of a group of seven squares. Its placement does not depend on the smaller pattern, being seen independently of it, but it is in step with the grid, every other row being set centrally to those above.

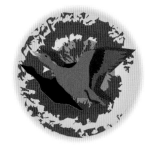

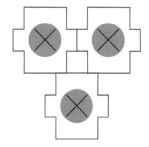

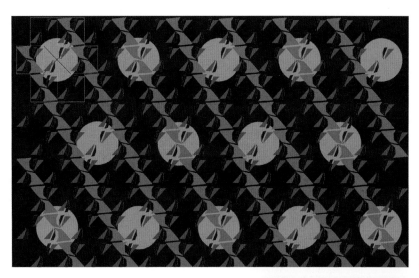

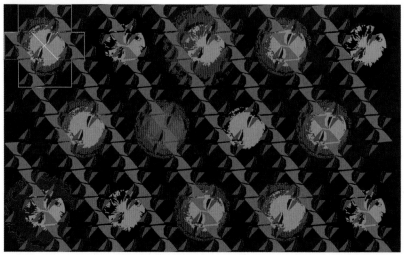

More abstraction

 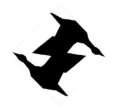 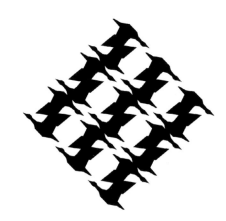

The duck has been rotated and then placed to form a new repeating unit. Still recognizable as a duck, the shape is adjusted to develop the design further.

 The new shape... 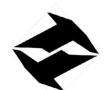 ...rotated and placed.

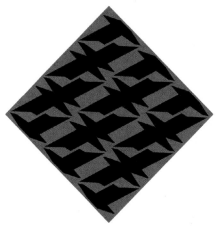

The squares can be set as a block repeat then half drop, where the two units read as an elongated shape and brick. Finally it is set as a brick repeat.

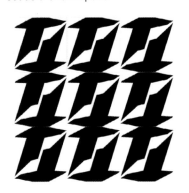

Block pattern.

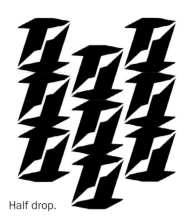

Half drop.

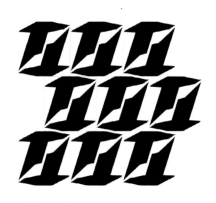

Brick pattern.

Introducing colour

These are three very different looks. Giving each section a separate colour breaks up the elongated shape.

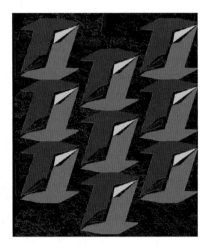

A half drop with flashes of colour on a two-tone textured ground.

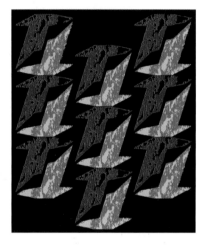

Texture of contrasting tonal value is added to the shape.

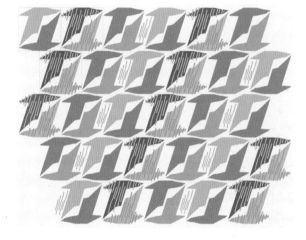

Here it is set as a brick repeat and a diagonal is emphasized through colour. Stripes add a directional texture.

Flashes of colour fill the gaps when the elongated shape is brought together as both a custom drop and brick repeat to form a tooth-type diagonal. The grids themselves also make for motifs and are grouped with other shapes.

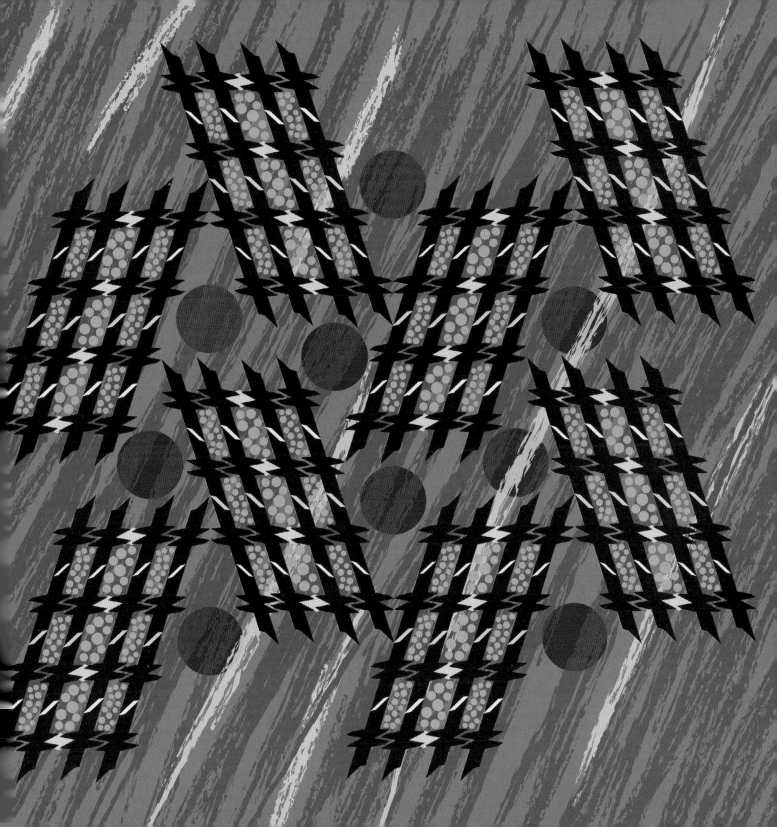

Decorative infill

In this example the filigree infill is superimposed on to the angular shape. The result of this combination imparts a sense of the flurry of feathers and of a flock of birds in flight. The angular shape is finally lost at the end of this series.

Reflected symmetry is shown here (left) with full reflected symmetry (right). This also has the image repeated again, having been rescaled down and rotated. Tints are shown at 50 per cent opacity. Note how the negative space reads as strongly as the positive.

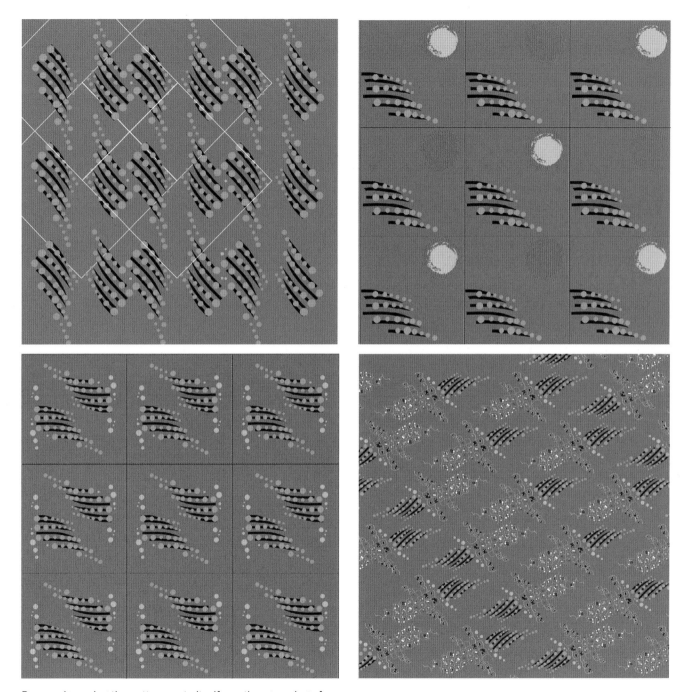

By superimposing the pattern on to itself, another grouping of dots and dashes appears. Some of the dots have been removed.

Using triangles and hexagons

Here selected elements have been arranged in the triangle. Rotating these 60 degrees around the central hub of the hexagon gives further options. Two of the background colours have been set at different opacities, to give lighter tints.

Two triangles of each group go to make up the hexagon used below. Note the difference in the pattern when the position of just one of the designs in the triangle is altered by being rotated 120 degrees – it adds energy.

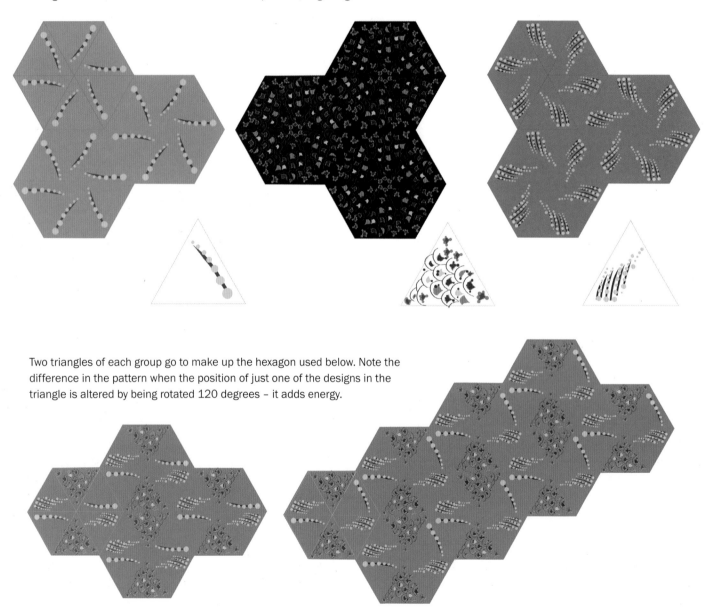

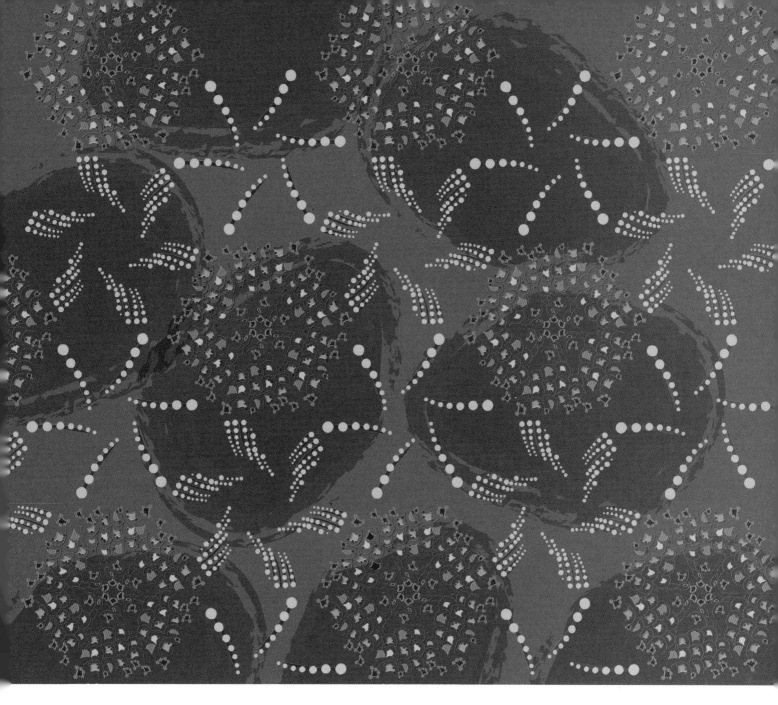

The three different hexagons have been placed in turn. An additional blob at 30 per cent opacity with a different coloured border breaks up the solid ground. Seen as a large-scale print on silk the repeat would be difficult to find. There is a triangular break running through the pattern, which could be eliminated by taking motifs over the triangle's grid line at the planning stage.

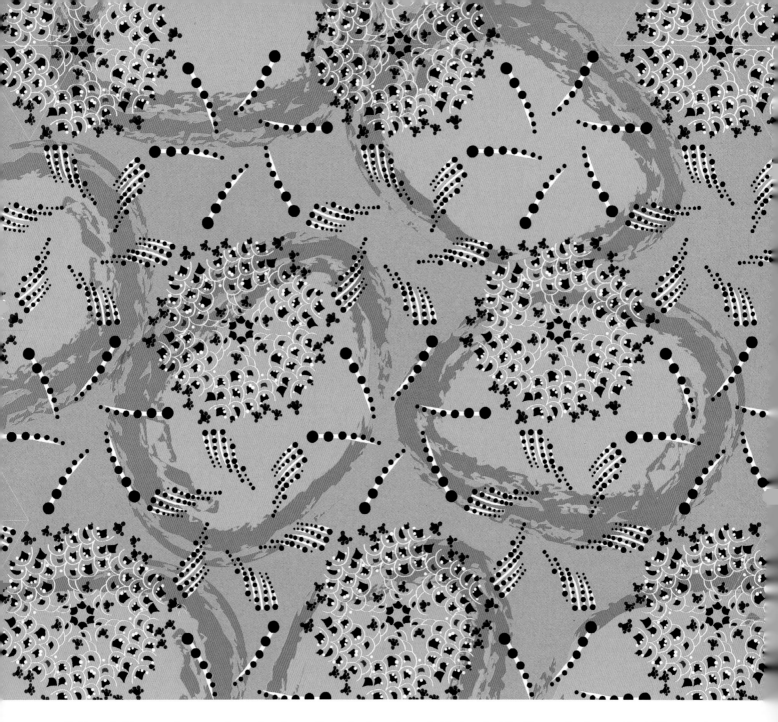

Set in muted tones and a near-achromatic scheme, the main elements are in black and white. The grey background is at 90 per cent and the two-colour blob at 25 per cent.

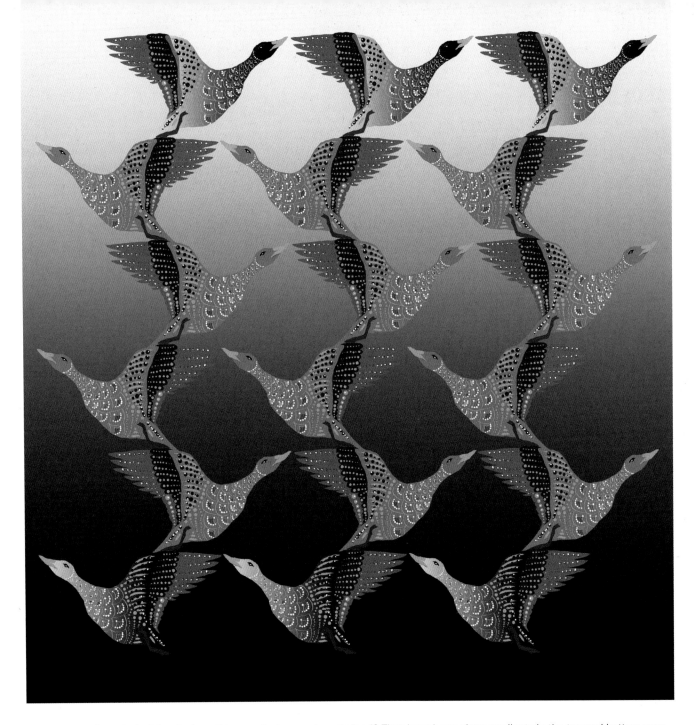

And here are those indecisive ducks – this way, that way, where to land? They have been given gradients in the top and bottom rows, which keeps the contrast crisp.

Disguising the repeat
Creating repeats without a computer

Before you begin, make sure you have all you need:

• A good-sized set square is essential and at least a 30cm (12in) metal ruler; in fact long plastic or metal rulers are very useful and more accurate than the repeated use of shorter rulers when drafting.

• You will need pencils such as F, H, HB and B, plus a fine black felt-tip pen for clarifying lines.

• An assortment of coloured crayons can also be useful to distinguish lines.

• You will need a sharpener, eraser, masking tape and tracing and/or layout paper.

• A light box will be available at local colleges and makes the sighting of drawn lines and designs much clearer. At home, however, you can set up a back-lit drawing surface using opaque toughened glass and low-watt lighting. Or tape your original to the window if all else fails!

• Make sure you have a good, solid craft knife and new scalpel blades. When working with scalpel blades always use a non-flexible steel-handled knife. Select blades without a curve such as 10 and 10A. Always cut against a metal ruler, not a plastic one and work on a cutting mat. When cutting out following a curved freehand line, swivel blades are suitable for tight curves. Otherwise, small, sharp-pointed scissors can be used.

Step 1. Square up the design using a set square and ruler. Take a tracing first, or a photocopy if you do not want to mark the original. Make sure measurements are accurate.

Step 2. Prepare your tracing paper. Rule up right angles and dimensions using the finest line you can create clearly. Pop in registration lines in preparation for quartering the design.

Step 3. Line up your traced lines on to the lines of the design. Stabilize the tracing paper with the design using masking tape.

Step 4. Make a tracing.

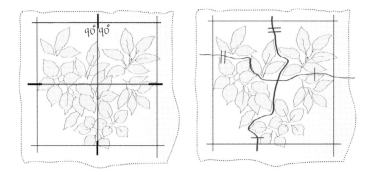
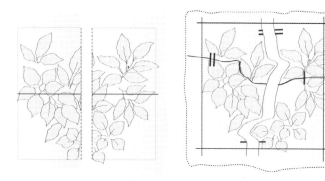

Step 5a. Working on the tracing, rule in the quartering lines. All corners should be 90 degrees measured with a set square. These can be marked in before the tracing is taken. Add registration marks.

Step 5b, freehand. Draw a line between the shapes. Add registration marks. These can be one or more strokes across the cutting line.

Step 6a. Begin to quarter the design using a sharp scalpel and metal rule.

Step 6b, freehand. Use a swivel blade or a pair of small, sharp-pointed scissors.

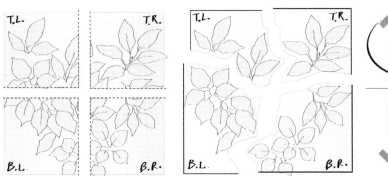
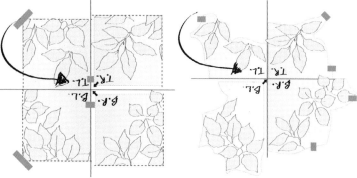

Step 7a. Quarter the design and trim the tracing, leaving four perfect squares if measurements are accurate. Mark each one respectively: Top Left, Top Right, Base Left and Base Right.

Step 7b, freehand. Mark Top Left, Top Right, and so on. The outer corners should be accurate with squarely trimmed right angles. If any shapes extend beyond the trim line either cut them off or trim tight to their shape. Keep these.

Step 8a. On a clean sheet mark in central horizontal and vertical lines. Now rotate the quarter squares 180 degrees to bring all the outer corners to the centre. Use the drawn lines as placement guides. Secure and make steady each quarter as you go.

Step 8b, freehand. The same procedure applies.

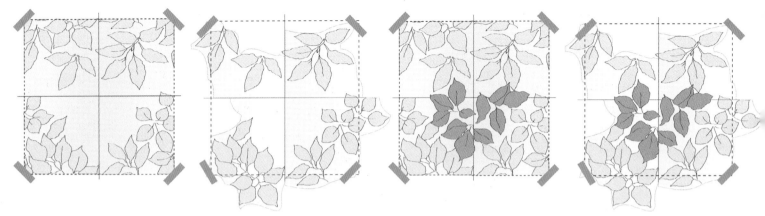

Step 9. Both methods reveal the space that can now be worked on with further motifs to help the pattern flow. Secure and make steady the four quarters. (Keep these, as they may be needed should the repeat not be as you wish.) Take another tracing. Include the horizontal and vertical lines and any registration marks. Now work the new clusters in the space.

Step 10. New shapes and leaf clusters are added to the design. Some leaf shapes overlap but there is a clear through channel remaining.

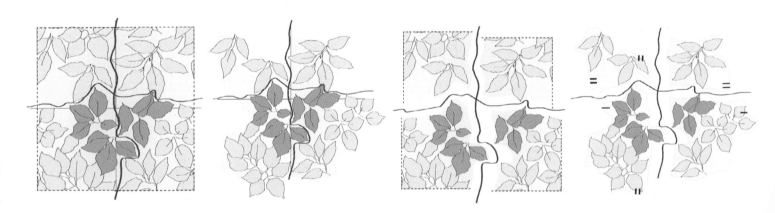

Step 11. With the new shapes in place the repeating unit needs to be clarified and the additions assigned to the most appropriate quarter. The design is quartered yet again, this time through the channels in newly drawn elements.

Step 12a. These are then separated out.

Step 12b, freehand. We already know that the protruding shape on the right will fit into the space on the left, and it could be left at this stage. However it is pleasing to work a pattern up in the format in which it was originally conceived and it is always best to double check. The illustration shows the jigsaw shape as originally cut, not having been drafted on a fresh tracing.

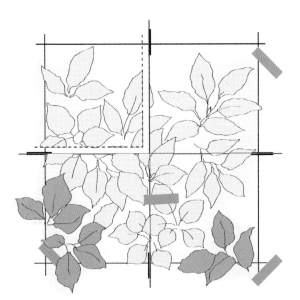

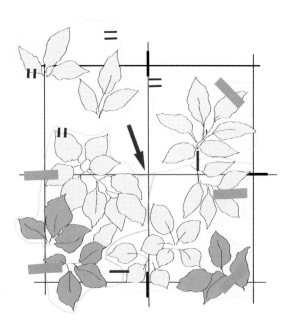

Step 13a. Each quarter, with any amendments, is rotated to its original position as per the labelling: Top Left etc. The design that was cut through at right angles is more straightforward.

Step 13b, freehand. Match up the registration marks when repositioning the jigsaw quarters. Once assembled, draw in the vertical and horizontal lines – the new repeating unit is apparent. The design can now be reworked on a fresh piece of paper with confidence that the repeat works.

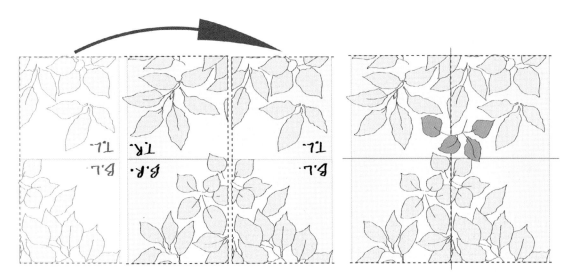

(**Note:** By bringing the sides together as at Step 8a, the link between the vertical placement can be assessed and again design adjustments and additions can be made in order for the repeat to flow through. These can be traced off on to the working design.)

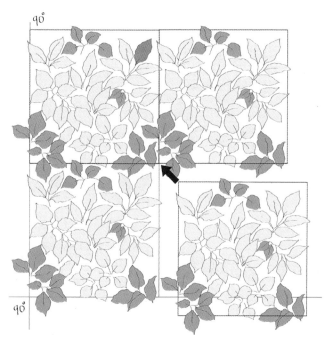

Step 14. Make further copies of the completed repeating unit and bring them together with the aid of horizontal and vertical registration lines and accurate right angles. You will then have a good indication of how the repeat looks. Remember to include any sections that have been cut off when trimming.

This diagram shows how the new unit looks. Various tweaks have been made as regards scale and placement to enable the repeat to flow a little better. The purply leaf has been made slightly larger and no longer dips.

Once closed, still more adjustments were made – some leaves were made larger and more were added to fill in gaps. Repeats are more easily seen on small-scale designs – here, dense and looser areas make a horizontal band evident, but the actual original cluster is much more difficult to find.

Notice the leaf stem highlighted in red, top left. It links with the stem in green to the right and together they emphasize the horizontal band. By simply aligning the red stem to a different angle the horizontal band is less apparent in the next stage. Little tweaks like this, although they take time, are worth doing to improve the flow of a pattern.

The amended pattern is set on a flat background opposite.

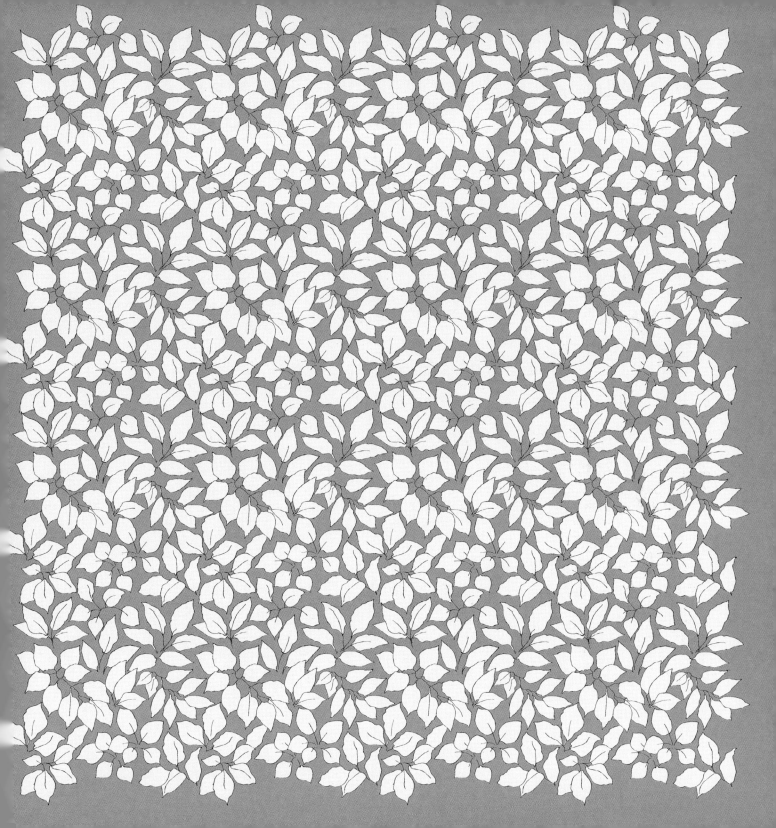

Hiding the motif

A repeat is easily identified when a motif sits large within the square, or there is only one motif. It is a look most associated with straightforward block repeats. When the square is larger, a number of smaller, separate design units can be incorporated within it, which helps to disguise the repeat. Part of the fun in turning a design or drawing into a repeat is to fill in the gaps. When a design is large or for fashion the repeat may never be in evidence; the fabric becomes three-dimensional, clothing the body, and not all visible at once.

There are two approaches to this. The first is to set the design centrally in the square then work outwards to the border with new shapes and groupings. The other is to work a design along the side and base lines and work back across and into the middle of the square.

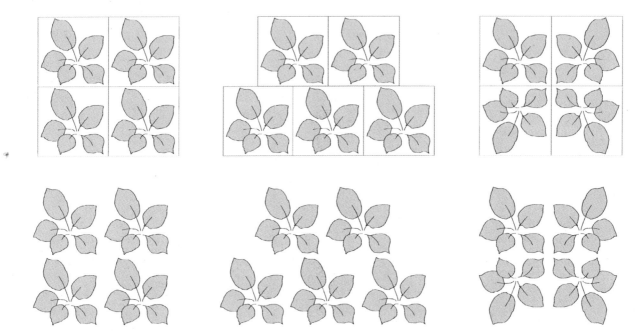

Step and repeat.

Brick repeat.

Four-square reflection.

Here the cluster of leaves has been positioned first as a step and repeat, then as a brick repeat and, finally, as a four-square reflection, often termed full-reflected symmetry. Even without the boxed outline it is quite clear how the repeat works. In the next few stages the cluster of leaves may take a little longer to find, but the repeat is still easily identified.

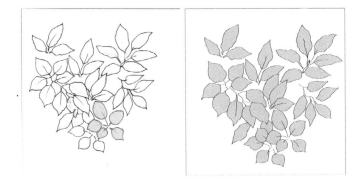

Here is the cluster set in the original pencil study of a group of leaves, now scanned and flat filled.

Here the group of leaves, including the cluster, has been put into a block repeat and although it is more difficult to find the cluster, the group repeat is easy to see.

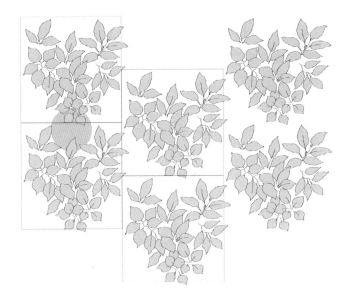

Now the original design sits tightly within the square. This reduces the surrounding white space, allowing the shapes to sit closer together – but the repeat is still recognizable. First, it is worked as a standard half drop.

Here a custom drop with a slight overlap tightens the shapes even more.

These two examples have been worked in an attempt to lose the cluster. The top shows a standard brick repeat – again the repeat is easy to see.

Below, two leaf clusters have been removed and the positioning of another changed to suit a new placement. This new arrangement is set centrally within the square and worked as a block repeat. In addition, it has a centred overlay placement, which acts as both a half drop and brick repeat and tightens up the pattern.

Within the resulting stripe, the repeat is still very apparent, but the cluster is beginning to be more difficult to find.

The next stage is to identify what needs to be done finally to disguise the repeat and to work further on the design so that it reads as an all-over multidirectional pattern. This process is referred to as 'putting the design into repeat', in this case a block or basic step repeat.

The original design, shown in light grey, when placed as a block repeat reveals gaps that need additional leaves. Some of the drawing has been amended, top left, and the red shape has been removed.

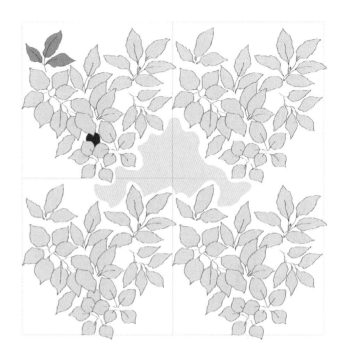

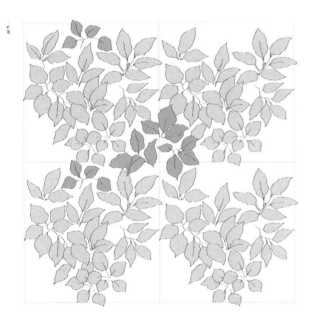

This example shows leaves – in green – drawn and set into the design.

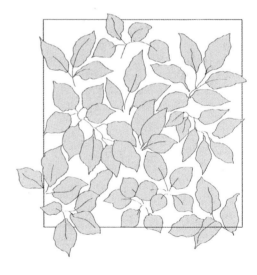

Here is the new repeating unit. It has the new additions placed in a balanced way, not all on one side of the block.

Using a half drop

The design needs to be redrawn in order for the pattern to flow in its new repeat format.

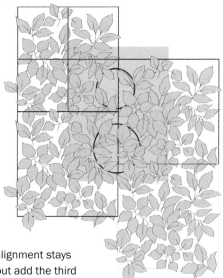

In the half drop the horizontal alignment stays the same between two blocks but add the third to complete the half drop sequence and the shapes along the vertical junction need adjusting – some areas are overcrowded while others (circled) are gappy.

However, adjustments made here will affect the alignment of shapes further back into the design in this case. The additions and adjustments have been tinted pink.

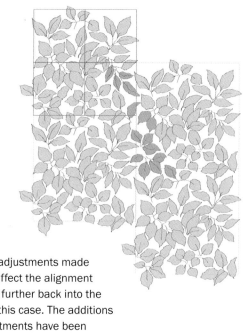

Often it is not until the repeat is put together that unsatisfactory shape alignments are seen.

Here all the changes have been 'attached' to the one repeating unit with some more changes. A very dense area has been replaced by a group of three (shown in tan). The green leaf has taken the place of two.

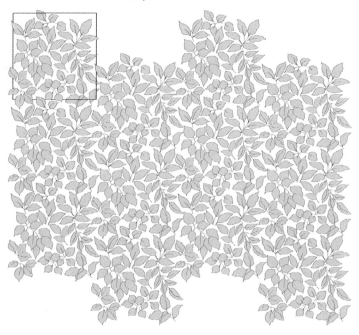

Here is the completed half-drop pattern. The original leaf cluster is hard to find.

Using a brick repeat

In a brick repeat the shapes fit together quite nicely. However, the same problems of overcrowding and gaps arise.

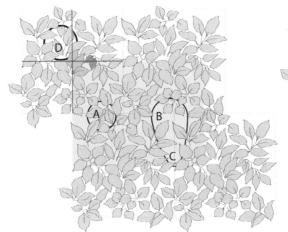

Groups A and B will be adjusted to read more pleasingly. An additional leaf will be added at C. The leaf stem at D will be redrawn. The three yellow leaves will be changed for the group of three used in the half drop.

The two green leaves will be redrawn. The leaf, bottom right, has been realigned to link through into the design.

Here is the brick repeat pattern from the repeating unit shown above.

Backgrounds

Setting the design on a mottled background can bring informality to a tightly drawn pattern. The background can be thought of as a repeating unit the same size as the main floral pattern, as a larger repeating unit or it could be interpreted as a randomly applied background.

In the initial design the colours have been changed and the weight of some of the outlines has been increased, which adds a liveliness. Colours are cool. This design will now be set on various backgrounds to see how dramatically the ambience can change.

 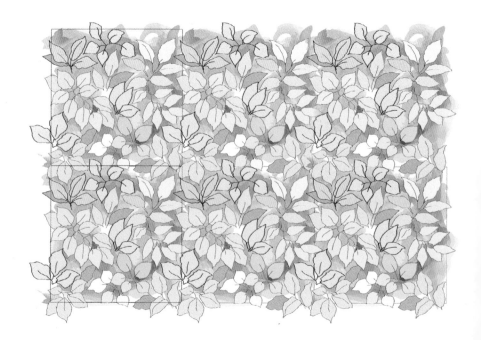

Here the background is positioned as a step repeat, which sits directly behind the pattern, also a step repeat. The softness of the outcome would suit a fine cotton or silk.

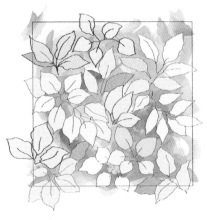

This time the background design has been rotated. Clearly visible when on its own, it becomes hidden by the floral. A touch of warmth has been added, a complementary to the blue and grey, which is also used for the outline. The background opacity is set at 45–100 per cent.

The floral has remained as before and is placed in a step repeat.

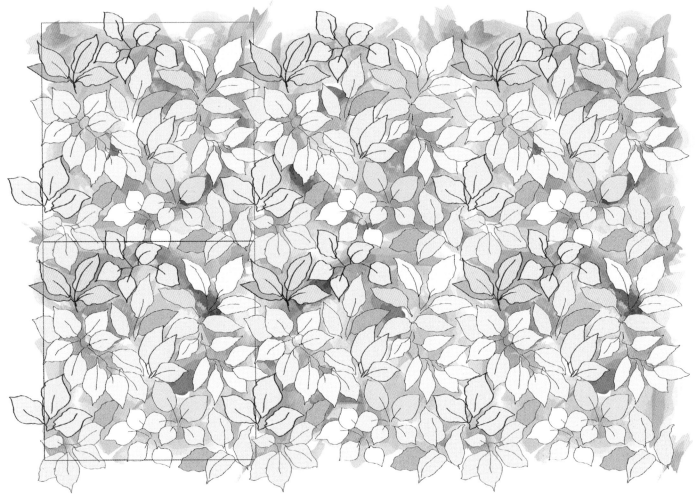

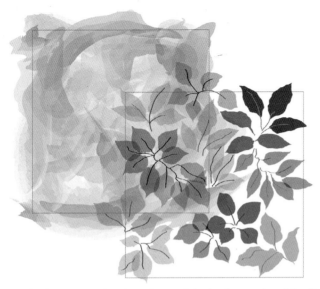

In these examples the colours of the background and the floral are the same. By using translucent colours the two blend and merge. The leaves are not outlined and are worked at 35, 50 or 65 per cent opacity in the first example.

The backgrounds are placed as a step repeat giving a swirled movement (left), and as a four square reflection (right), which gives a tiled effect.

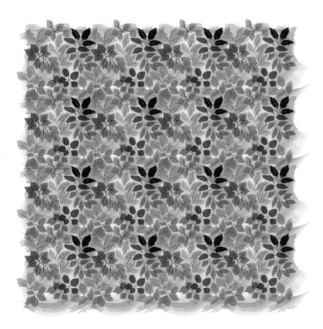

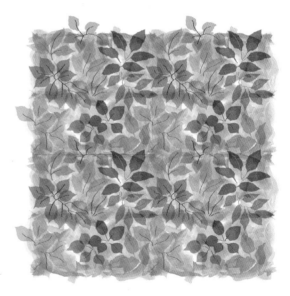

The floral remains as a block repeat in these two examples. First, it is placed on the background at the same scale.

Here the floral is at 35 per cent opacity throughout and set at a larger scale to the background – you can see the underlying tiled effect. Altogether it creates a very leafy glade. (See opposite for detail).

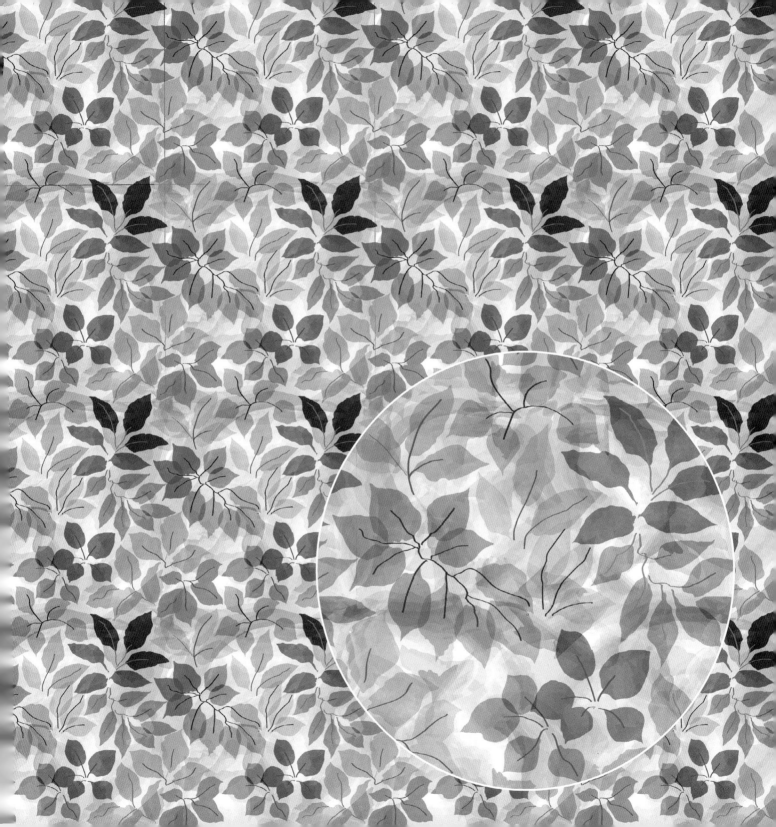

There are some very dramatic changes here. These
examples show the floral with the same overall colour.

The floral above right retains the random pattern for the
background. The example above right shows the leaves
emerging from underneath, which creates a misty,
out-of-focus effect. The floral above left is at 100 per
cent opacity, the right at 85 per cent, which allows for a
better blend. Some of the random shapes have been
removed to allow more leaves to show.

In the sample shown right, the floral is at 25 per cent opacity
but has a 100 per cent fine outline. The warm tones have
been removed.

Three layers have been used to build up the final pattern.

First a flat base colour is laid down, on to which the random opaque shapes have been placed at 200 per cent larger than the floral.

Top right shows the outline of the leaves being used in a plain, pale grey.

In the example shown left, the leaf outlines have been worked in a charcoal effect, which gives the design a much looser, informal look.

Changing the colours of the charcoal and placing the mottled background on to three different coloured 'underlays' results in very different looks. The first is sophisticated, the second, summery and light, and the third is hot and vibrant. The base layer is the flat colour, the middle the random effect and the leafy design is uppermost.

The drawing is the same throughout. The weight of the line has increased and some of the leaves have been removed to allow for this.

Four floral block repeats have been superimposed over a one-block mottled layer in the large examples. Note that the opacity of the mottled layer changes: left 79 per cent; centre 100 per cent; right 60 per cent.

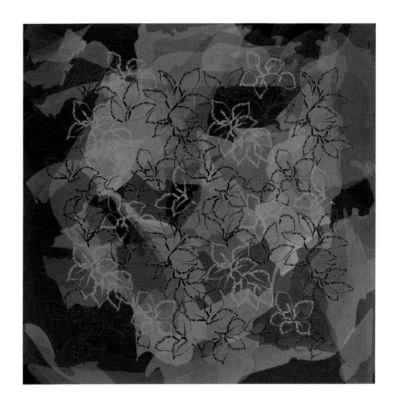

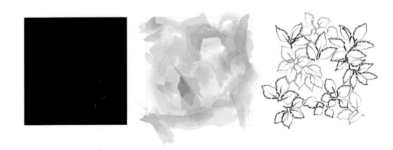

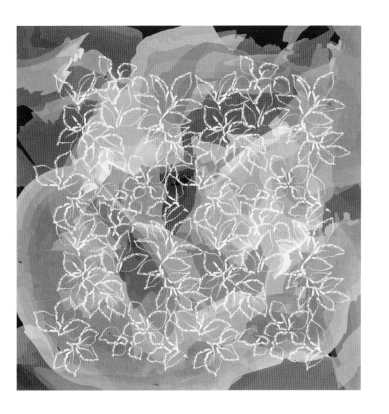
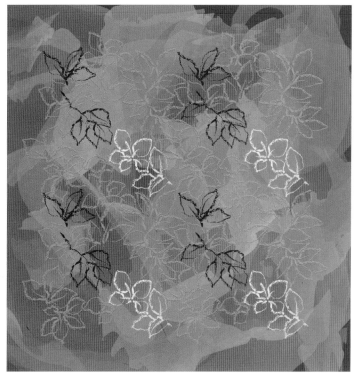

Emphasizing line

Now there are two different drawings rather than two different backgrounds and with this approach the same design offers further translucent layering effects.

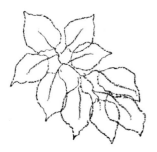 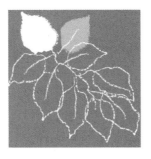 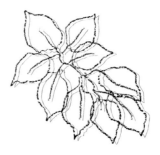 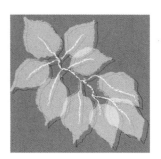

The original drawing has been given a charcoal or textured effect; some shapes have been filled at 50 per cent opacity. The illustration shows the difference between 100 per cent white, which gives total coverage and 50 per cent, which blends nicely.

The cluster drawing has then been repeated in a fine calligraphic style to contrast with the texturing of the charcoal and is set slightly out of alignment. This fine line is not constantly visible because it has been set under the leaf-cluster layer, but on top of the background. It emerges beyond the leaf, providing an accent.

The mottled background colours have been changed and are brighter, fresher and less stormy without the purples. The design is the same but is enlarged at each stage. This gives a softer, less intense feel to the background. There is no flat-colour base layer.

The ethereal background changes the quality of the line and the infill of the leaves. The weight of line is critical – too heavy and too dark and it would simply all fall to earth!

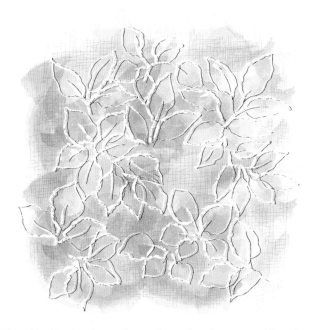

The leaf infill is in a grey with varying degrees of opacity – from about 35 per cent. Both white and black outlines are drawn in a smooth, calligraphic style. The black, being set underneath, is obscured by both the white lines and the mottled background.

The white line has been changed for a heavier textured line. A hand-drawn crosshatch introduced in between the leaves adds further texture and suggests netting. The fine line used has been worked in 18 per cent opacity and sits uppermost.

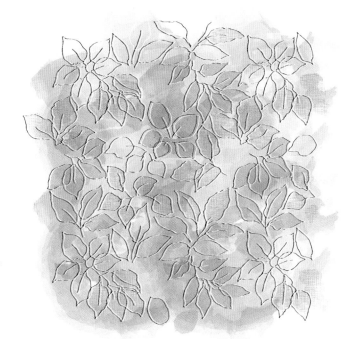

The fine-line crosshatching has been introduced to some of the leaf shapes at 30 per cent.

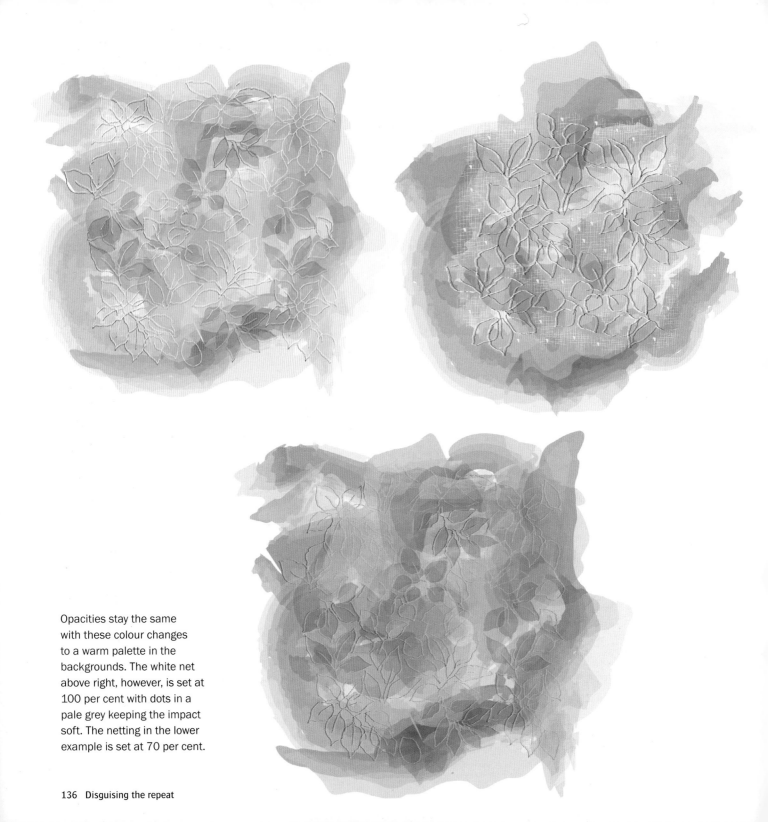

Opacities stay the same
with these colour changes
to a warm palette in the
backgrounds. The white net
above right, however, is set at
100 per cent with dots in a
pale grey keeping the impact
soft. The netting in the lower
example is set at 70 per cent.

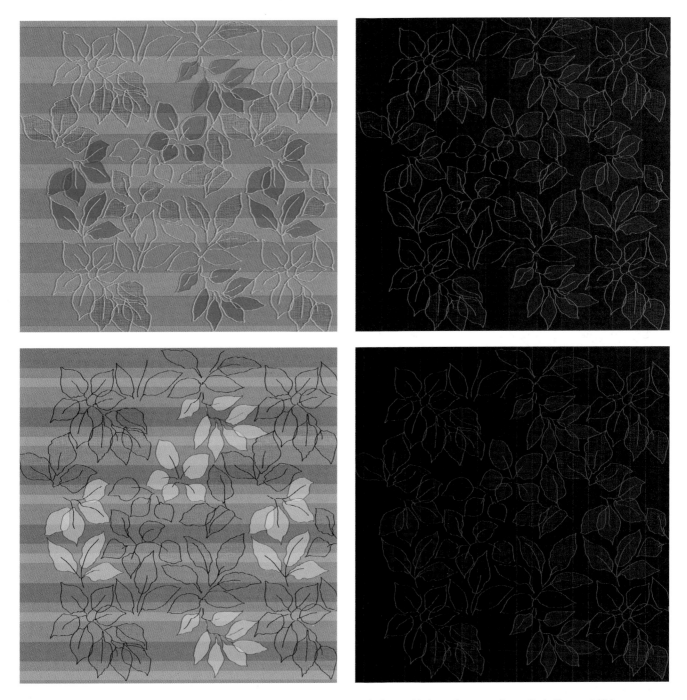

These four further colourways set the repeat on a stripes. These could be present in the woven cloth prior to patterning techniques. Various degrees of opacity in line and fill have been used.

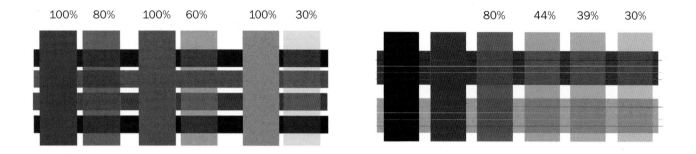

The following patterns using the same design have a limited palette of red and greys for the most part. The subtle changes in colours have been created by using various levels of opacity. You can see the number of variations – and yet more could be arrived at. Turquoise has also been used as an outline and background only.

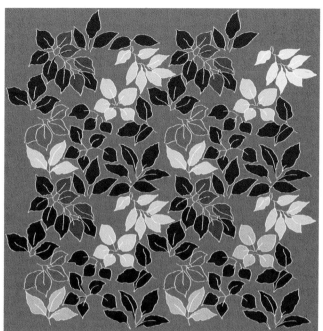
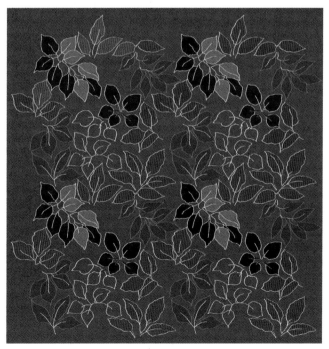
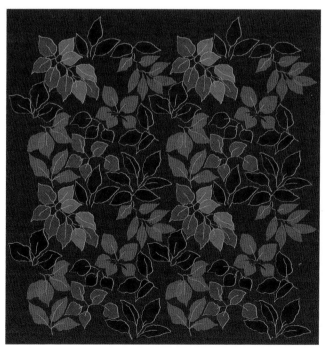

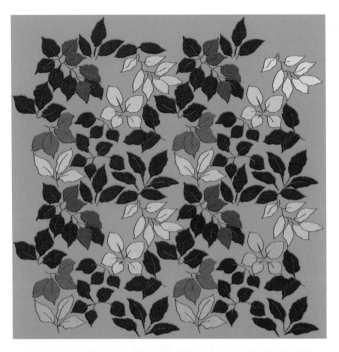
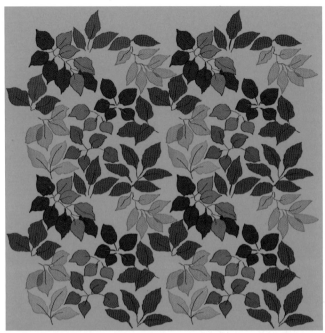
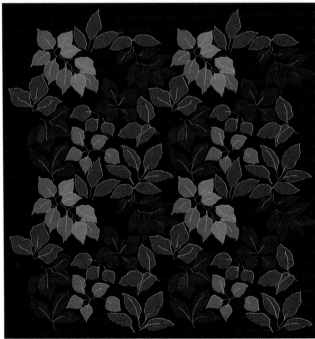
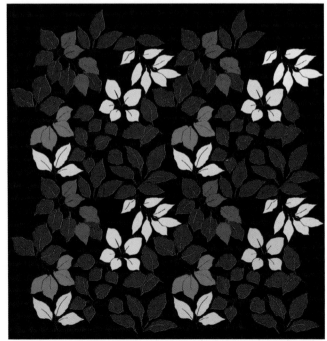

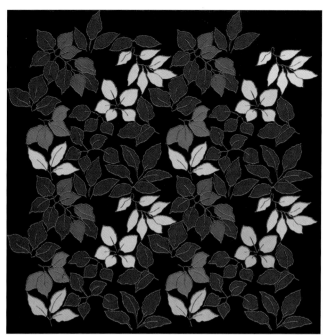

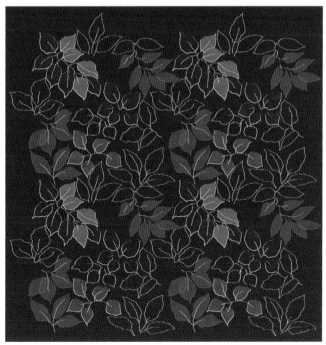

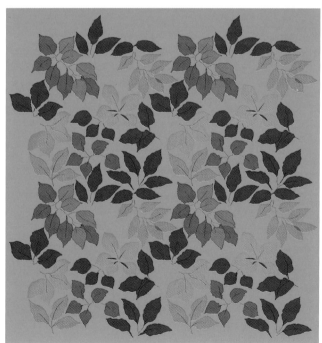

Patch

The tile

It is impossible to talk about squares, tiles and repeats without mentioning patchwork, as 'the tile' is the basis for patchwork techniques. Repeated shapes and patterns so far have been put together and separated out so as to hide the joins of shape to shape and colour to colour. The aim of putting a pattern into repeat is to ensure that the design flows seamlessly, and the repeat is disguised. However, the mechanics of patching has a direct influence on design preparation and outcome. Shapes and colours should now be thought of as separate, physical different pieces of cloth that need to be joined.

The simplest form of patchwork is to join several same-shape tiles together in their groups, such as the square, triangle or oblong, and the simplest method of joining is in a straight line.

More complex designs are created when several tile designs are used to make up one block. Several different blocks, either similar or with different designs, can be put together to make one textile piece.

Depending on the complexity of the design these are referred to as a four patch, nine patch or 12 patch. It is from these that endless patterns and designs can be created. Many are traditional but, with a personal touch and interpretation of colour, scale and fabric choice, all are unique. Here the tile shapes are all represented in colour.

Grids are used extensively in pattern design to form a repeat and here they can be used specifically to help design patchwork tiles.

Square tiles of different tones and colours are joined to form a finished piece. This shows an achromatic tonal progression with a zap of energy from colour, which is lighter in tonal value to the black, giving a punchy contrast.

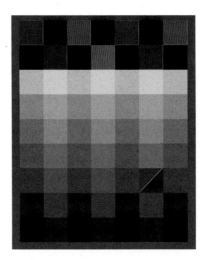

A simple change is made to a tile by subdividing it on the diagonal, making two right-angled triangles. This new shape, splash of colour and linear direction imparts energy in a calm area of grey. There are many different ways in which the tile can be subdivided and altered to add interest.

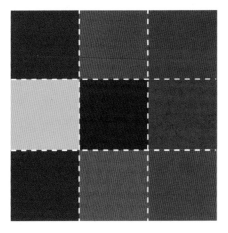

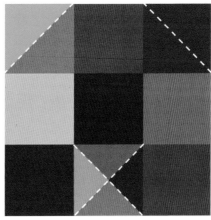

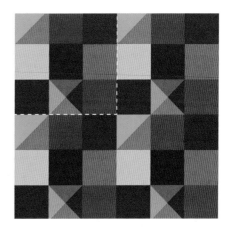

1. Here nine 'tiles', separate pieces, join together to form a block – often referred to simply as a 'nine patch'.

2. Two tiles have been subdivided and one has been quartered. This is still basically a nine patch.

3. This new block can be repeated. Step repeat, rotation, half drop and brick repeats can be used. This example shows a step repeat. The suggestion of a diamond is clearly visible.

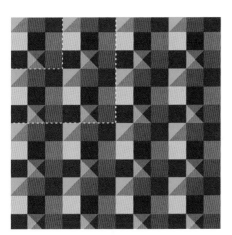

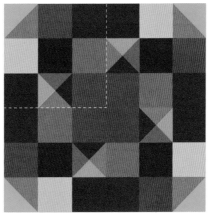

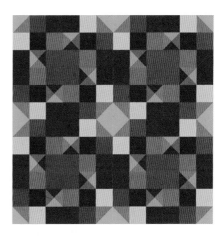

4. The block of four nine patches can themselves be repeated – a chevron appears strongly. Here they are all the same, but each nine patch could also be different.

5, rotation. The nine patch has been rotated – follow the green triangle round.

6. The rotated four have been placed as a block repeat.

7. The rotation repeats of the block of four from step 6 sees a familiar patchwork pattern emerge.

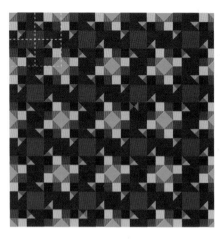

8. A change of colour balance is achieved by removing some shapes.

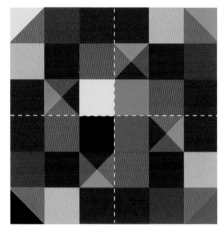

9. Here each nine patch is made different simply by altering the colour of each outer triangle and inner square.

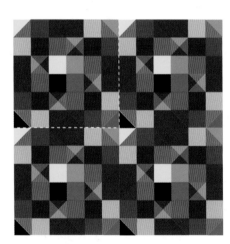

10. Repeating the new colourway.

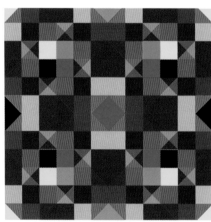

11. Reflected symmetry of the new nine-patch colourway.

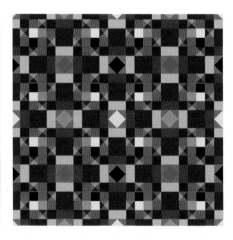

12. The repeated design gives a fractured pattern and introduces oblongs.

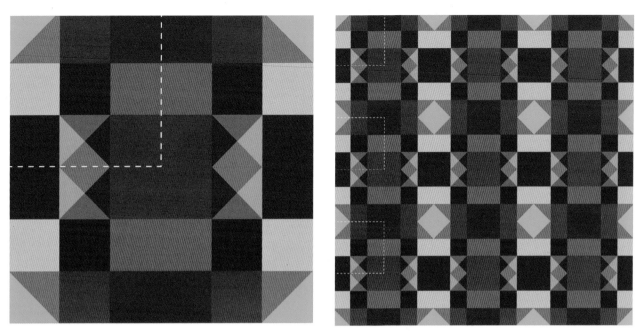

13, full reflected symmetry. A new block has to be physically made for symmetrical reflection repeats for patchwork.

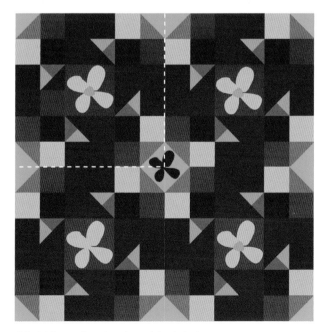

14. Adding a floral to the original design.

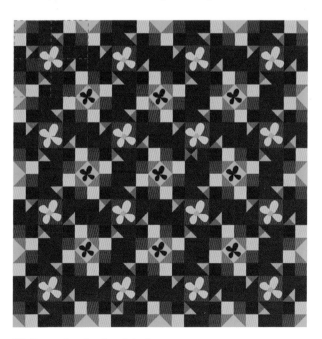

15. Repeating the floral design.

Rotating the square

The following diagrams show a progression from simple beginnings to a more complex pattern by altering the scale and rotating the square. Triangles appear as a result and are integral to this process. The next few designs lend themselves to quilting and patchwork but are not specifically designed with that outcome in mind. Rather, this is an exploration of how to go about finding and developing shapes and ideas, and then from that process ultimately come up with a design on which to work practically. To design specifically for a patchwork project (in which shapes link accurately) it is advisable to begin drafting a design on a square tile, which has been subdivided into a grid.

There are two main ways to look at repeats in this section. First, there is the pattern repeat – the organization of the design motifs and shapes so that it repeats successfully with no evidence of 'a join', making it suitable for a screen-print textile. A shape is not cut as the join would be evident, spoiling the flow of the design.

Second, there is the physically pieced block, made up of tiles – the most popular being the square – that would be used by the patchworker repeatedly. Shapes and colours are seen as independent pieces of cloth that need to be joined. Blocks of different designs can be used in one piece to form a large overall design. The very fact that layers of fabric are built up through seaming and patching give the art form a unique surface quality and handle. Within this area you will find all the practical problems of manipulating and piecing fabric. Development of designs would go, in part, hand in hand with practical skill. However, great achievements also go hand in hand with great enthusiasm.

The two different ways of reading a repeat have been isolated and are shown next to the example in some cases. I should also mention that any exploration of either would greatly benefit by focusing on drawing geometrically with pencil, ruler and compass, and extracting from the crisscross of lines linking shapes.

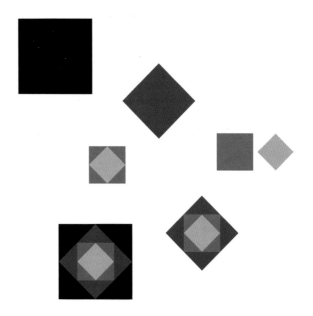

Here is a square rotated to form diamonds and triangles. In the linear demarcation below right, the geometry of the construction is revealed.

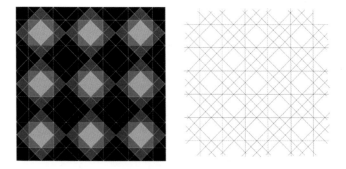

Try cutting out squares of coloured paper and build up different 'blocks', then photograph these or scan them into the computer. Try other colours and various sizes. Without the need of a specialist program they can be cropped, copied and rearranged. Try this with small fabric squares prior to finally settling on a design.

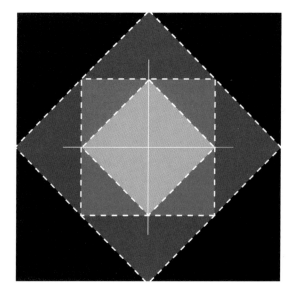

Here is the design from the patchworker's point of view. The broken lines indicate the lines of stitching joining the separate pieces to make the tile.

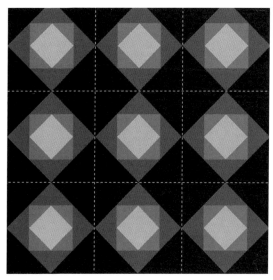

Here is the block repeated nine times and pieced together. A new, large plain blue square appears.

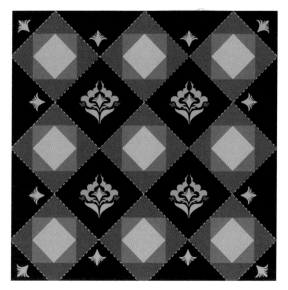

By looking at the design afresh it can be separated out into two blocks as diamonds: this is known as *en point*. It looks identical, but the advantage is that this time the plain square has no seams.

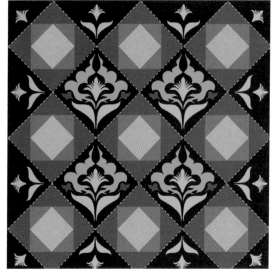

Opportunities arise for pattern development through other techniques such as appliqué, block printing, embroidery or a mix that would benefit from the seamless flat surface.

Tiles that have been sewn together alternately to form strips are then joined in a half-drop format. Changing the scale of the floral alters the overall tonal perception of the pattern.

Back to building up the design, here a link is set in place between each of the large squares.

A tiny square is set in the centre.

Tones have been switched and another square is added to the arrangement. What remains is a slender border of dark blue.

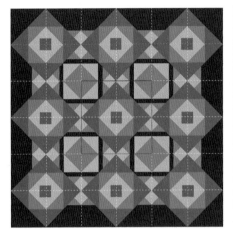

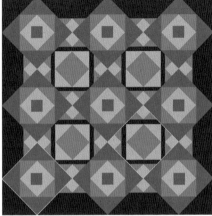

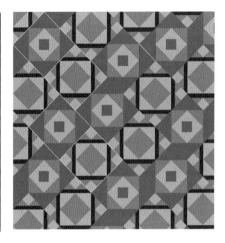

Seeing the pattern vertically and horizontally by superimposing a white grid over the geometric enables you to identify the separate tiles needed to make up the design thus far. The central square shows a new tile design, identified by a red outline.

Looking at the diagonal structure of the pattern and seeing the blocks *en point* it is clear that there are just two with different designs (seen outlined in yellow).

Here, the previously identified blocks have been realigned in a half drop and set on the diagonal. Triangles link together to form a parallelogram – they are outlined in red.

A larger block can be found. It is, in fact, the original block but now the four plain blue outer triangles have a three-tone pattern. This block can also be put into a half-drop or brick repeat or a custom repeat to create further designs.

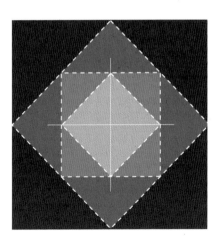

Original block.

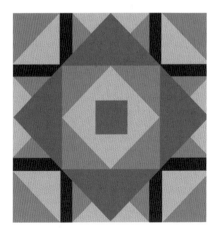

Revised block.

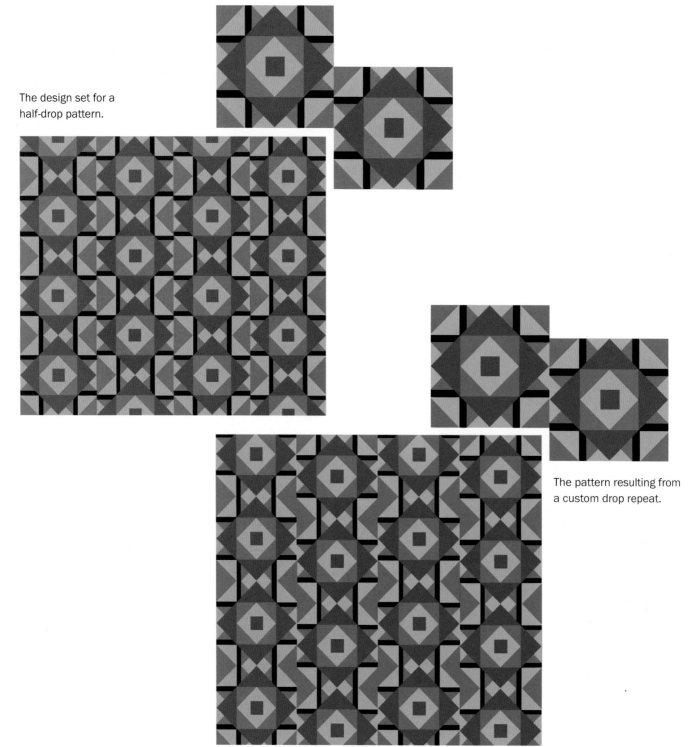

The design set for a
half-drop pattern.

The pattern resulting from
a custom drop repeat.

And finally, in the basic development, four central squares are added – outlined in red.

Below are some other options and ideas bringing in a contrasting/complementary colour for impact.

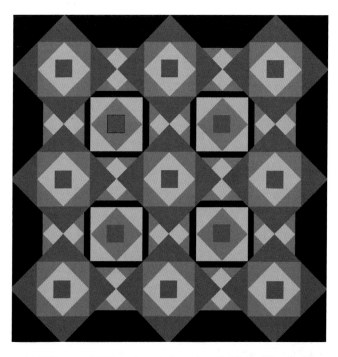

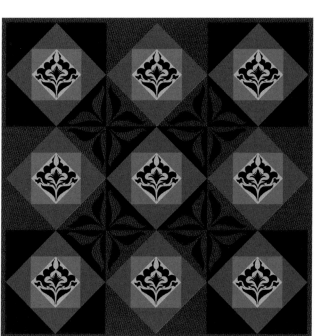

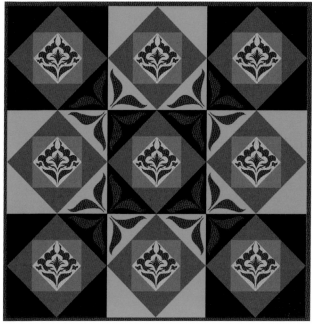

Overlaying colour

Overlays of colour can be used to explore further shapes and patterning. Placing a triangle in soft apple green at 40 per cent opacity is enough to tint the colours underneath. The result of this is a vibrancy muted by softer hues.

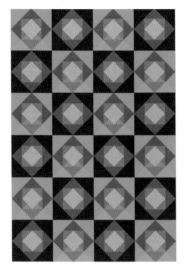

The triangles are placed in a set format.

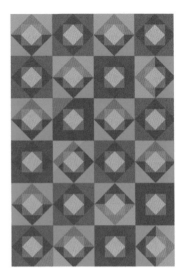

Here they have been placed randomly.

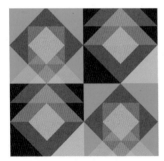

The two top squares would be required to be made up by the patchworker. Left and right are swapped over then placed underneath to make up a block of four, which is then repeated.

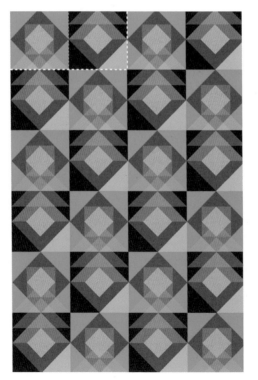

The repetition of the triangles and their closeness of hue and tone give the design a fractured look.

When working directly with fabric, keeping a few tinted acetate sheets or cellophane to hand to lay over fabric is useful – it provides options for colour choice and change, either as a flat sheet or as cut shapes. You may not need it for the project you are working on, but it is so easy with digital cameras and scanners to record interesting combinations and visual ideas, which can be uploaded on to the computer and kept for use in other projects.

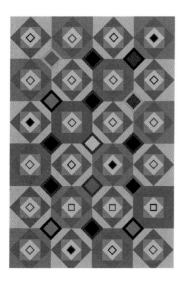

More squares have been added to these two designs, bringing detail to the pattern.

Colours of the block change in the diagonal, while the smaller squares change randomly.

The sample on the left sits on a cool blue background, but set with the green/blue palette it looks lilac. On the right, the background remains the same. The background colours are shown in isolation below.

The last two patterns explore the use of these tilings. The first is in warm hues in which the colours change randomly within the squares. Set on a muted background this random placing gives a jewelled quality, achievable with hand-produced pieces.

The second design uses the blue palette again in a subtle diagonal format as before. In the square, instead of a plain background the tonal value lightens towards the centre with each block. It is reversed in the circle. This introduces a transient sense of lighting that could change if the piece were moved.

Introducing circles

Triangles appear automatically; squares and diamonds are superimposed – a progression integral to the process. Now shapes that are not integral, such as oblongs and circles, are introduced to the design. The same colours are used for continuity and for the effect of the addition to be realized.

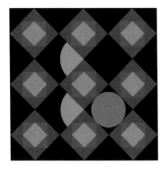

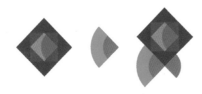

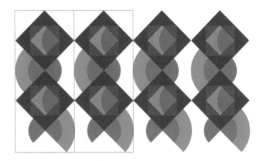

A new design element is set in place with a slightly cooler, bluer green – first to the left of the diamond and then to the right, to form a repeating duo.

The unit is reflected and placed underneath – except for the internal green quarter circle, which stays to the right. This duo makes up the repeating unit which is used as a block repeat.

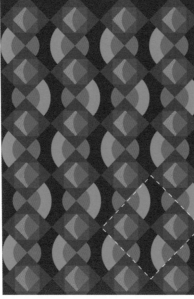

The pattern is completed with a dark background. The patchwork block is defined in white.

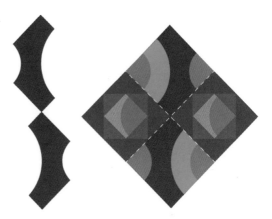

In a patchwork block, the 'background' would be treated as a separate shape. This square above would be the repeating unit.

The design changes dramatically, not only by changing the placement of shapes,
but also with the use of different coloured grounds and colour separations.

The block has been placed without
rotation or reflection.

Here the upper and lower squares
have been reflected.

Variations

The large turquoise curve is kept on the same side of the squares. The central green half circle appears from the right of the central square. Tiny quarter circles in alternate colours are brought in from the square's corner. Combined with the smaller shape they add some detail to a bold design.

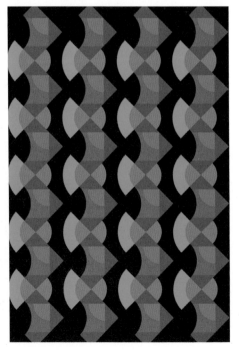

There have been a few changes in this example. The palest diamond has been removed, the tiny quarter circle has been considerably enlarged and the green quarter circle now appears top right on the central square. The pattern on the right has the same background colour, which emphasizes the horizontal stripe and wave.

On the opposite page shapes disappear as same-colour backgrounds are applied.

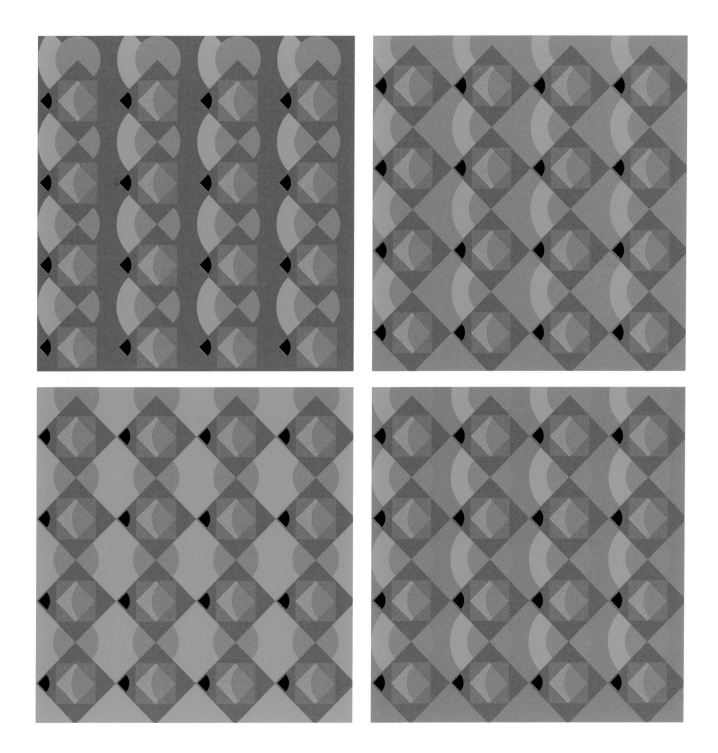

Working with colour

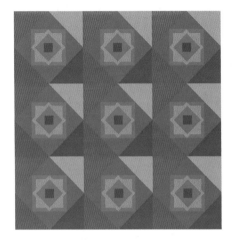 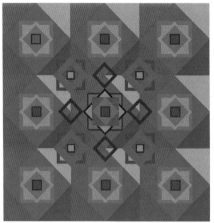 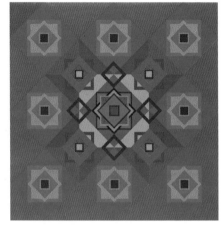

1. The initial nine-patch example had a plain blue square. Now each outer triangle is given a different colour.

2. Intricacy is added by introducing smaller shapes and borders.

3. Rearranging the colours to focus on a central section results in a block format suitable for a one-off design.

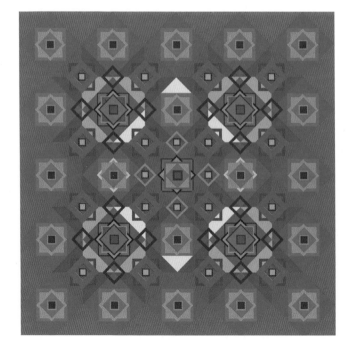

Fully exploring placement options for colour and tonal value with simple dynamic shapes and borders within full reflective symmetry.

Working with tone

A tonal exercise with triangles.

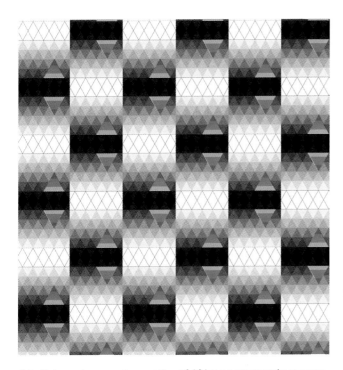
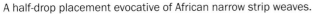

A half-drop placement evocative of African narrow strip weaves.

Here blocks have been put into a rotation repeat. A considerable project for a patchworker, but nevertheless it illustrates the effect of simple shapes when repeated.

Windmill block

An effective way to begin patchwork is to start with a traditional block design. These are based on the windmill block. Patches were traditionally made from old remnants of fabric and designs would have included patterned as well as plain fabrics. Here the difference between patterned fabrics or patterned and plain is simply shown as a coloured shape.

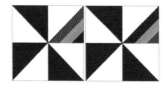

1. A straightforward design of four squares subdivided into triangles. Here I have broken down one triangle into stripes.

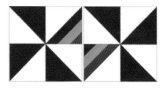

2. Two rotations of the block bring the altered triangle tiles together to create the bow-tie alignment.

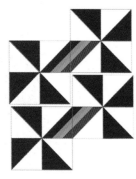

3. This design is built up from two blocks, rotated and set at a half drop. The colour sequence of the triangles links to form a rhomboid.

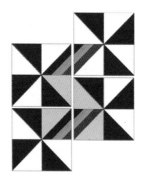

4. As soon as the blocks are placed together secondary blocks emerge (block A).

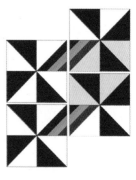

5. By bringing together the top of one block and the base of another, a new large four block is made (block B).

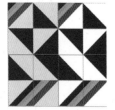 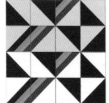 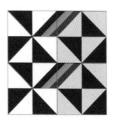

6. The result of the new blocks placed and brought together is shown here. To the left is a vertical alignment; in the centre a horizontal placement; to the right secondary block B with the original block.

7. The pattern for a side-by-side placement of block B with the original shows a tonal study travelling anticlockwise in the tile to the left. A reflected placement (vertical axis of the duo) is shown opposite.

Variations

Here the fracturing of the triangles continues with a division of each of the four tiles to suggest a spiral. A sharp blue is added.

The block is put into a step and repeat – without the suggestion of seam lines.

In full reflected symmetry – with the suggestion of seam lines.

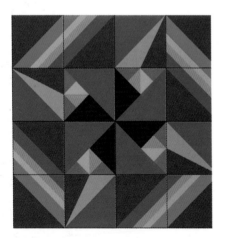

Here is a rotation, which, in the secondary block, or middle block, brings the pattern full circle by re-forming the traditional windmill in the centre.

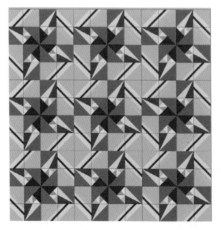

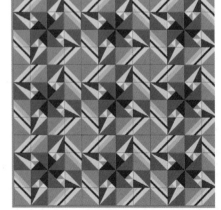

New colourways in a smaller scale. Notice how the lighter tonal background brings out the blockiness, the horizontal and vertical alignments of the pattern. With the closer and softer tone the diagonals are more prominent.

Another pattern emerges by using a three-quarter drop – this matches up the striped section in a different way and links one square to the other.

The colours in the stripes do not link in the first example but do in the second colourway (below right).

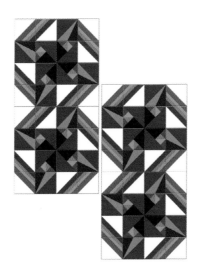

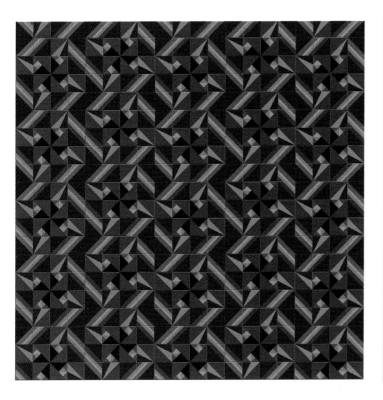

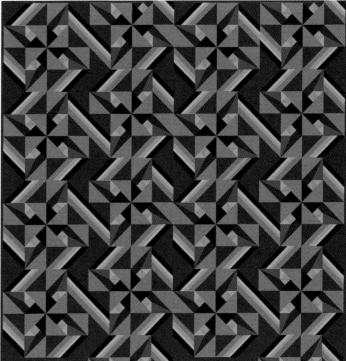

Hydrangea

A drawing of hydrangea heads opens various options for exploration with regard to their treatment for patterning.

The overall opacity of the background colours of the flowers is at 30 per cent, as are the linear brush applications, which help define the shapes. Over-printed, they add tonal depth. The small splashes of pink are at 68 per cent.

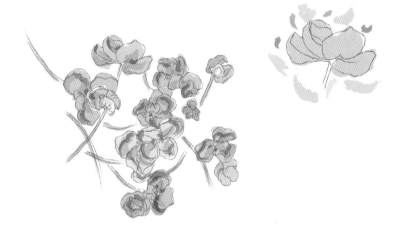

A charcoal-effect line has been used with the same colourings and below drawing and colours are seen on a dark ground. Both charcoal and flat line quality are used on the blue ground. The opacity of the wash colour is increased to 60 per cent on the red where a flat line is used throughout.

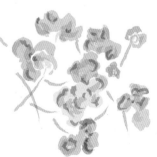
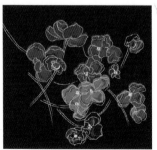
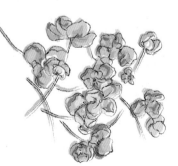

Above all the lines are in the same colour, including the effect lines for shading. The undercolours remain the same.

By selecting the complete image (often a mistake!), lines and shading and infilling with colour, the result is a bold design.

It can also be rendered elusive when the line selection for the complete image is white.

A mixture of blue and white infill and line colour makes a crisp alternative.

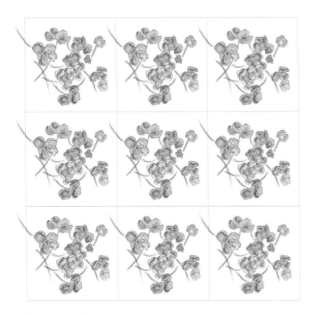

Standard block placement.

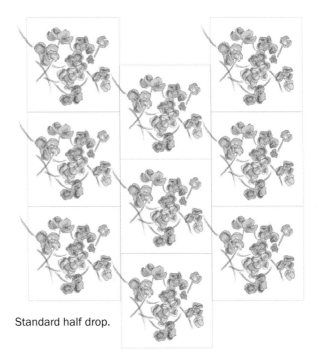

Standard half drop.

In this custom half drop the cluster is dropped further and also overlaps to tighten up the pattern and connect the movement of the lines. On every other placement one of the lines has been removed as it sits too tightly to a flower head. It is repositioned with another line to break up the horizontal gap.

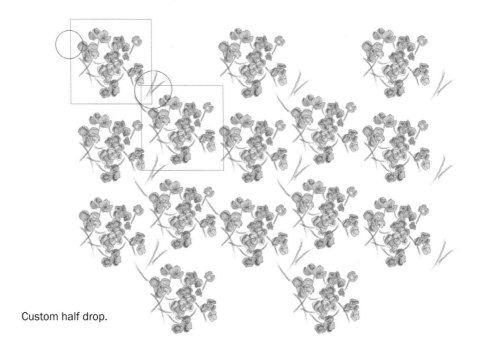

Custom half drop.

The boxed placements show the standard brick repeat. However, additional splash lines have been added to link the placements, which also create a second diagonal, and with that a diamond format appears.

Brick repeat.

One of the lines in every other descending row has been removed and repositioned (red to green). Two other lines have been added to link the placements (yellow).

Custom brick repeat.

The same custom brick repeat design with the colours reversed.

Selected areas have 30 per cent opacity and are combined with
100 per cent fine line to create this shadowy effect.

Clusters and clumps can be put together by rearranging the preliminary square. Here it has been repeated twice, giving a clump of three. One of the motifs has been moved to avoid sitting too closely to a stem line. The groups are put together freely.

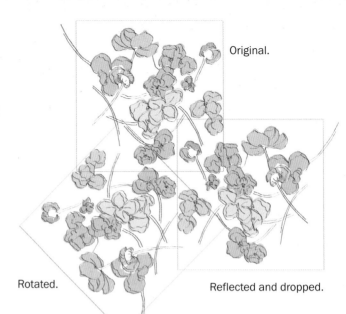

Original.

Rotated.

Reflected and dropped.

After finding an arrangement, that was pleasing, a simpler containment tile, the oblong, is used for the repeat placements. The design sits to one side to give space.

The lines are worked in a light colour to show up on a dark ground and the 30 per cent opacity has been increased to 60 and 70 per cent intermittently to add further interest.

The opacity will pick up the mood of the background colour – here the design looks warm, but worked on a black or dark blue the colours will appear cool.

Shadowing

Setting another cluster into the oblong either as a linear version or as a solid area will add texture to the spaces, depending on the tonal value. The container oblong could be made slightly deeper for this custom brick repeat.

There are two ways to go about this, depending on the processes chosen.

Here, the shadowing on white is created by using 30 per cent opacity for a translucent blue.

A close-match solid colour has been used for the shadowing. On white it is in stark tonal contrast.

Here the translucent colour is placed on the dark ground.

The solid colour on the dark ground has the same effect.

Translucent colours are affected by the underlying colour. Placed on a warm colour ground it appears as a warmer tone. The solid colour, lower right, remains cool.

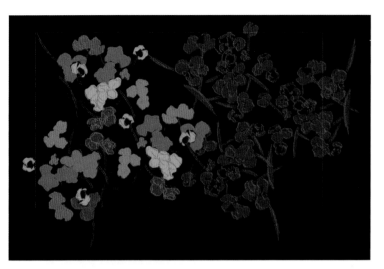

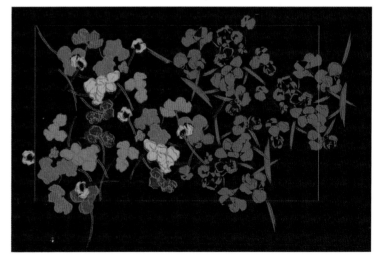

Here are some variations of shadowing using the multicoloured design.

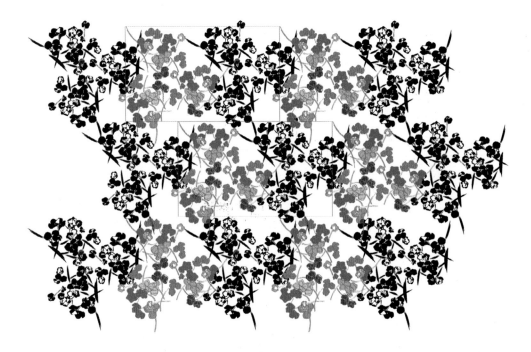

An almost black addition to the block repeat dominates the pattern and looks very stark. When placed on a dark background, however, it becomes almost just a texture and the original colours appear stronger and jewel-like again.

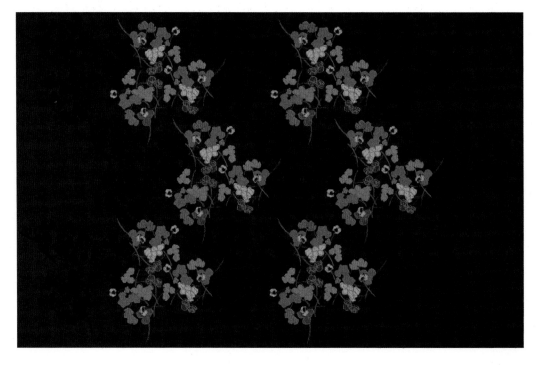

By scaling up one of the group of three a new pattern rhythm is created. The containing oblong has been increased in depth to accommodate a custom half drop. Fine lines have been added to fill in the gaps, giving a hint of landscape. Red sits in selected shapes and lines with a bright yellow for selected flower centres.

In this development paler areas are set behind the dark shapes, which throw them into greater relief. The groups of three and the larger, single pinky shape alternate, emphasizing the diagonal of this half drop. A splash of warm orange adds some energy.

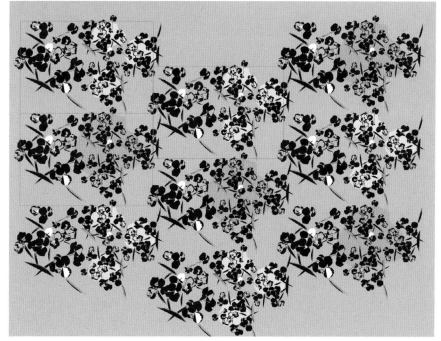

Separated out, these oddly shaped splodges make a complementary pattern to the floral. Set as a brick repeat, shapes have been extracted and arranged to make a simple design. Their placement in the square will result in a tighter or looser pattern.

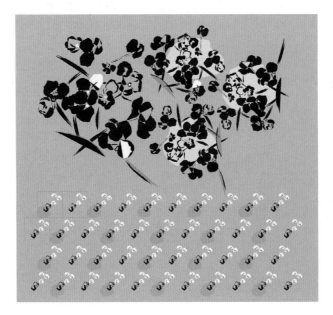

This example shows the selective removal of shapes from the design, which is set at a much smaller scale. The colour of the splodge has been changed.

Opposite, tiny flower centres add delicacy.

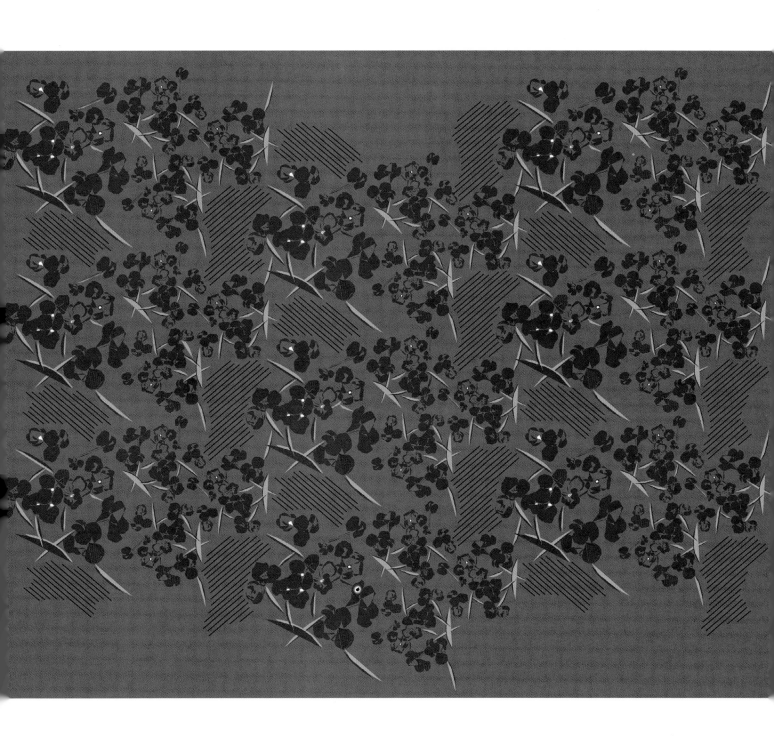

Tree of life
En point placements

The result of rotating a grid 45 degrees is a diamond format and although these placements can be achieved with a straightforward grid it is somehow inspiring to begin with the grid set at this angle. A motif can be designed to fit the shape completely or it can be used simply to regulate placements.

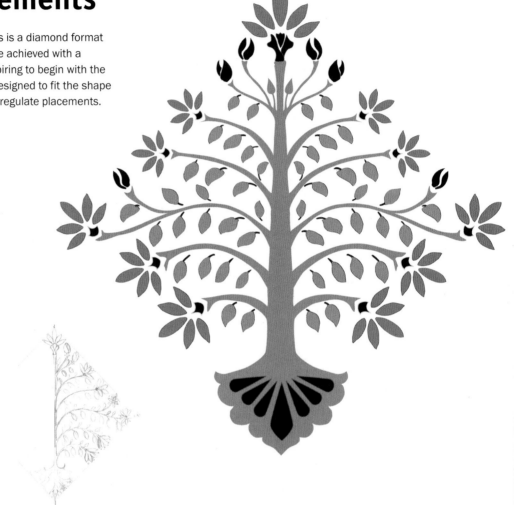

Putting in place vertical and horizontal lines to start with will provide guidelines on which motif ideas can be developed. It is helpful to sketch out the design prior to working in detail as it gives an overall feel for the pattern. You can accentuate directional flows by the weight of a pencil line.

If you are exploring ideas, why not draw up such a grid on the computer and print out several copies in pale colours. Use these sheets for working drawings to help you visualize pattern possibilities. It will also help to clarify shapes.

This series starts with a folk tree of life placed very traditionally in the diamond grid. Using various colours, placements, additions and subtractions to the design, alternative patterns can be achieved through rotation and reflection. The initial sketch was scanned into the computer and drawn up.

Left we see the design set up in the square grid format, and then right in the diagonal format, which results in the diamond shape. These placements have more meaning if borders are to be considered (see page 196).

The computer graphic

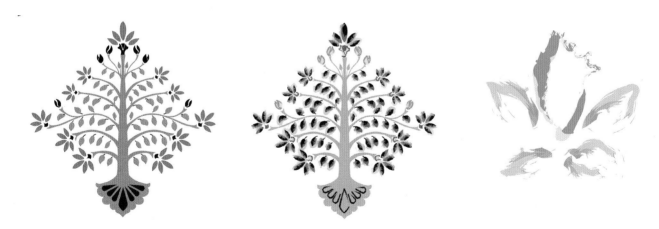

Though the hard-edged graphic is used for the most part it is interesting to see a softer design by using alternative 'brushes' achieved with just a few clicks on the computer.

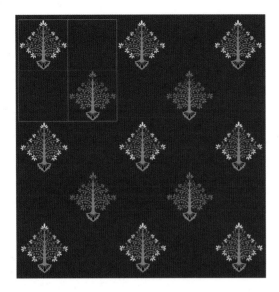

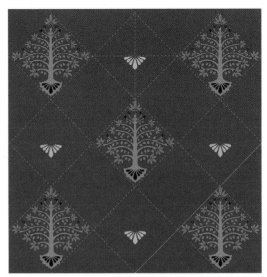

With added background colours the pattern takes on a much richer look. Here, the design has been structured within a straightforward grid.

Here, the diamond format is illustrated with a cluster of shapes used as a separate design motif, which hangs from horizontal grid lines.

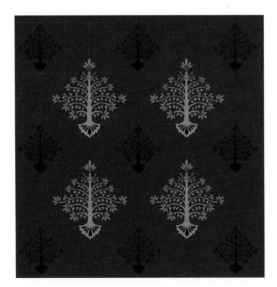

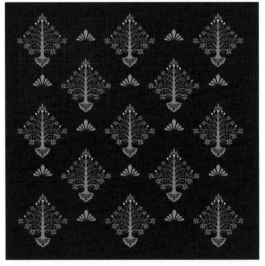

Now the image has been given two identities. First, it has been worked in just the one colour and second, it has been enlarged by 170 per cent.

Here, the little motif sits on the horizontal line. Here too, scale has been altered uniformly, making the design more intense. Further grid lines are added to re-set the drawing accurately.

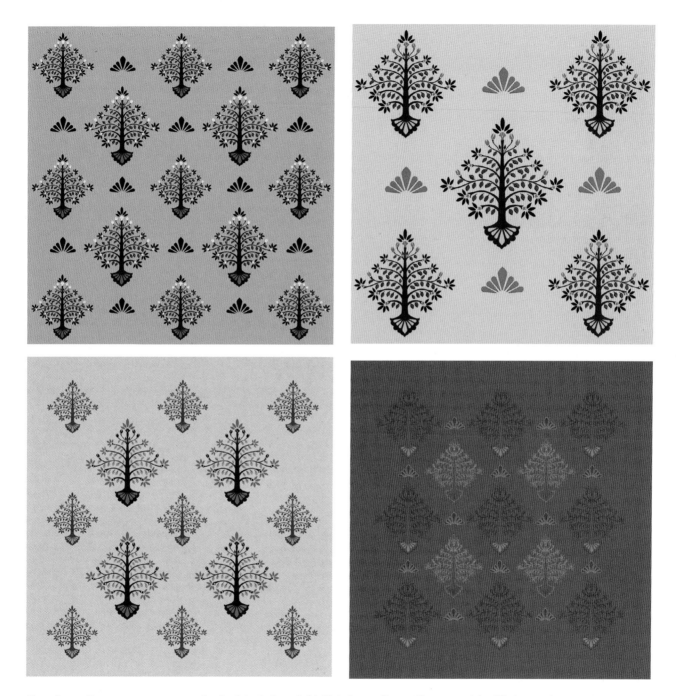

Here the pattern appears more predominately dark on light. Note how a fine outline around the fill shapes throws them into clearer definition (top right). Mostly outline is also shown (lower right).

Rotation

Setting up the design four times tightly within the diamond creates full reflective symmetry, which can be used as a repeating unit.

With this there are endless options for the addition of interest points in the way of dots and tiny motifs to punctuate the pattern in the traditional style.

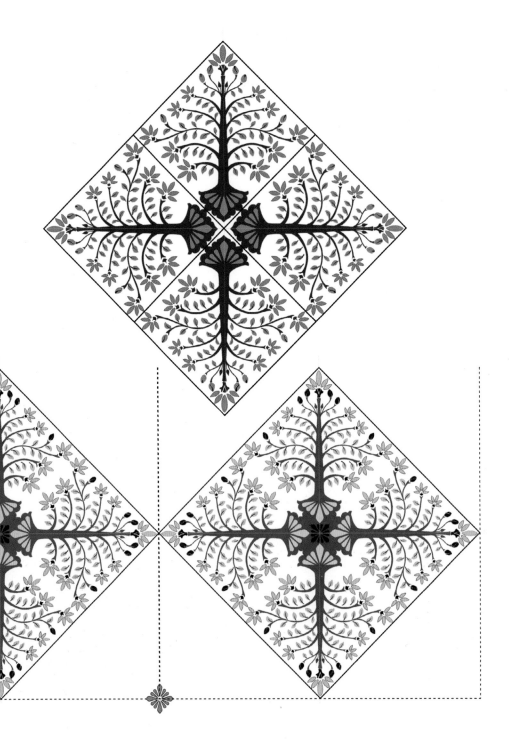

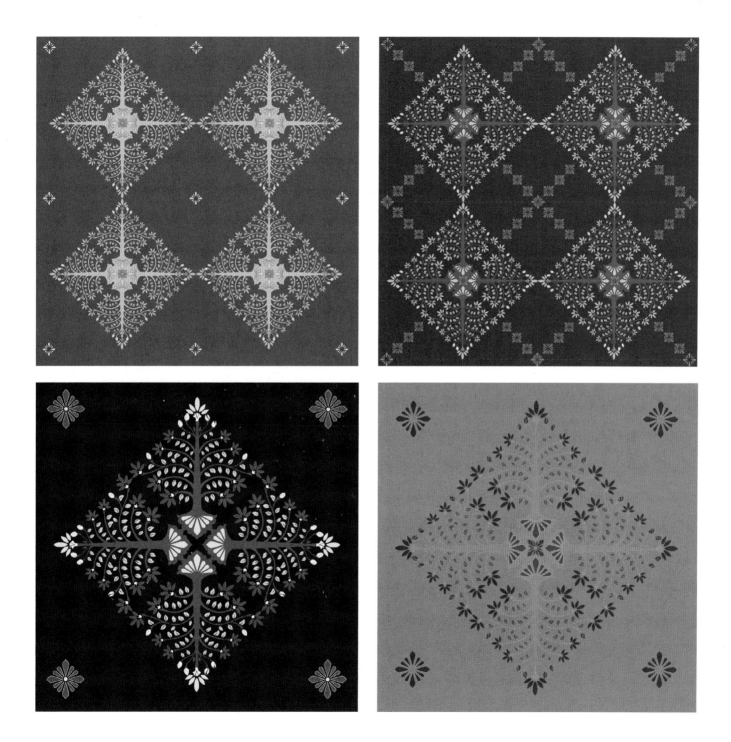

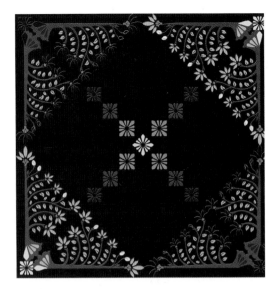

Here, the design is seen as smaller detailed patterns resembling embroidered surfaces. The tonal value of the diagonal squares change.

By alternating the tonal value behind the central points a sense of depth is achieved. This could be done with dye before the fabric is stitched.

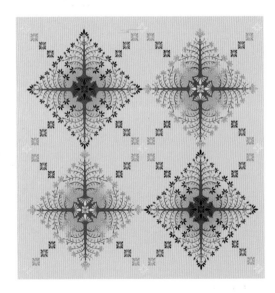

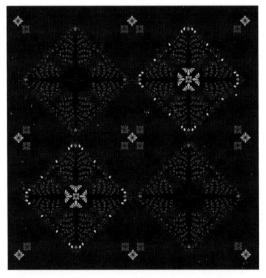

Here, I have added soft edged colour, barely visible. Again, if dealing with textiles, an organza randomly placed or a printed surface, through either block or screen techniques, could be worked prior to stitching.

This pattern sits on a plain, flat background.

Colour, tone and texture are added and despite the busy design these additions lift the pattern, making it richer and unpredictable.

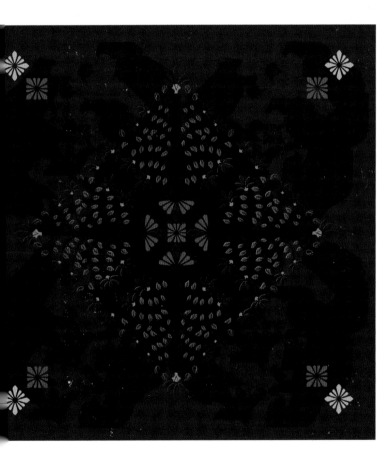

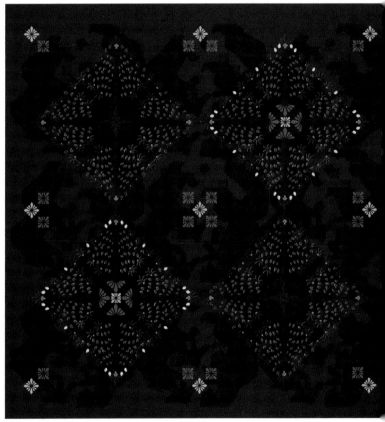

The textures suggested here could be interpreted in various ways if working a smaller one-off piece. There are many techniques that create wonderful textures, which could be applied prior to the controlled pattern being added. Dip dyeing or 'scrunched resist' techniques, a textured screen print or sponging could all be employed to break up the ground surface. By working the mottled effect on a different scale of grid, the pattern is unpredictable. A 75 per cent opacity is used for the mottled effect. The black circles are at 93 per cent and these sit behind the central motifs, emphasizing the contrast. A gradient gives a soft edge and suggests blending.

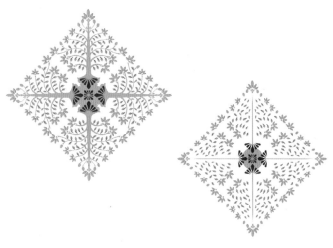

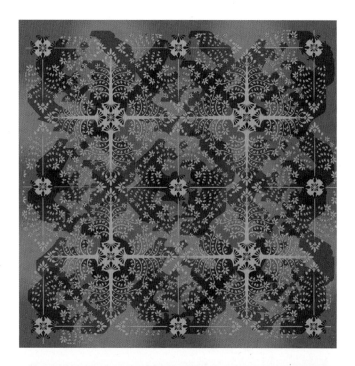

New colours are introduced. In this example, the design remains the same but in the second squared-up motif the main trunk has been removed, giving it an altogether lighter appearance.

By using a grid as scaffolding (right) the two complex motifs are alternately placed and result in a very rich pattern, which sits on a textured background.

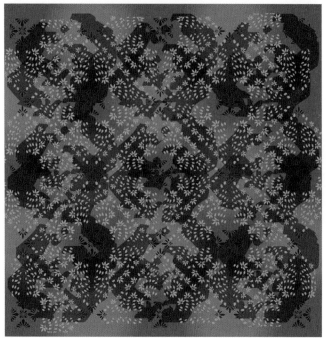

The central circle to each square, the trunk and branches have been removed as have the fine outline to all the leaves. The addition of a hot pink to the top cluster of leaves turns this into yet another design, which now emphasizes the diagonal.

Finally, here are a few more variations on the theme. The mottled, textured background has been added at 75 per cent opacity.

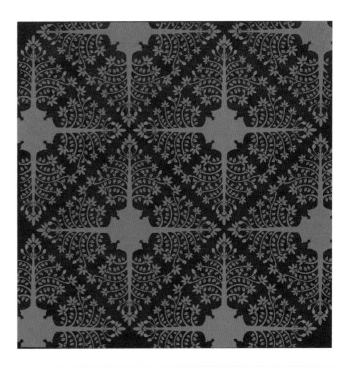

Here it lightens and intensifies the red/brown background. It sits behind the pattern. This variation has the main trunk and central motif set in two alternating colours.

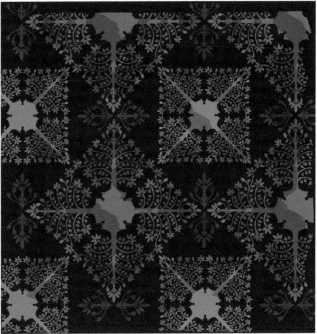

A cool rather than warm colour has been used at 38 per cent opacity, which darkens the background. It lies on top of the pattern, breaking it up and providing a 'light and shade' interest – a tonal variation. An extra motif has been added. This is the top flowering unit from the tree.

Simple options

This collection of daisy designs comes from a motif extracted from the pattern and rearranged. Starting with very straightforward patterning elements the selection then moves on to provide much more complicated-looking patterns, and then placements of motifs for borders.

In the first instance notice the difference of scale using the same motif and the motif's position in the grid. Its

treatment, whether set as a solid shape or as an outline, has a real impact on the overall effect. A large, solid shape in some instances could look too heavy, but in a pale shade or as an outline it can add subtle colour and delicacy. Its placement within the grid can change the flow of the pattern. In most cases the grid contains the motif, but this doesn't have to be the case. Note the impact of tiny dots.

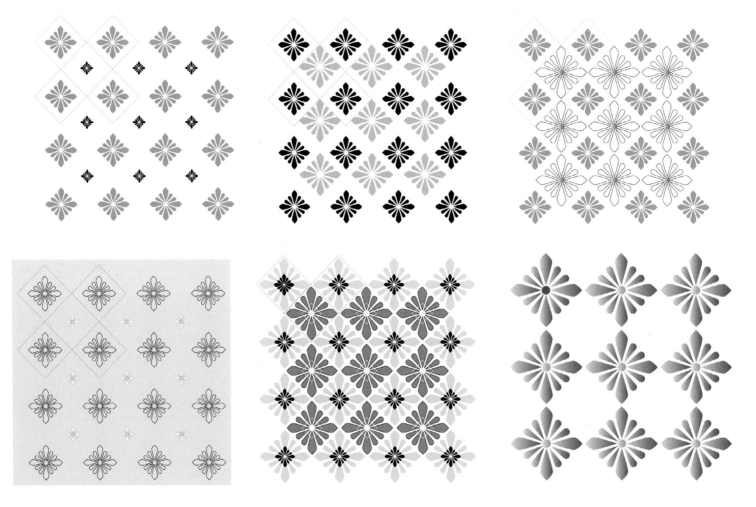

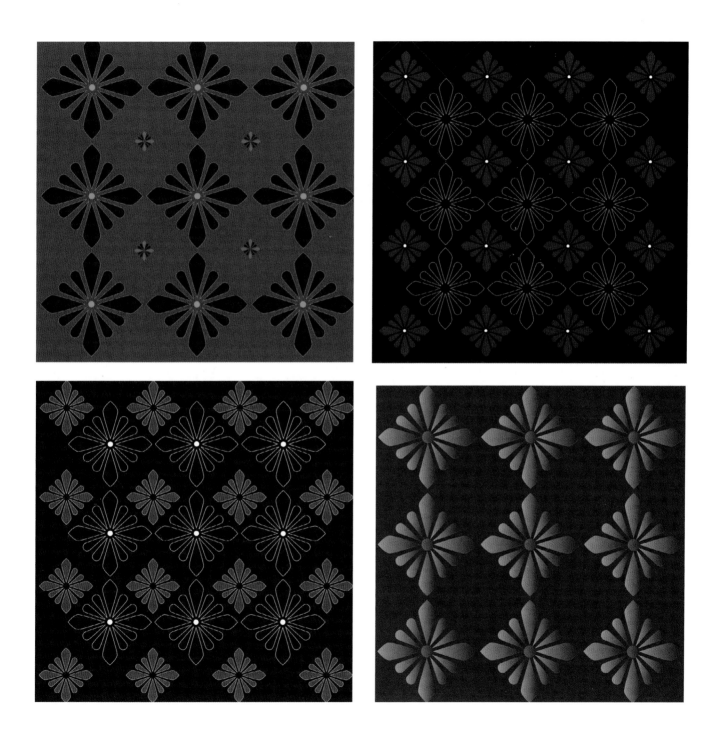

Using contrast

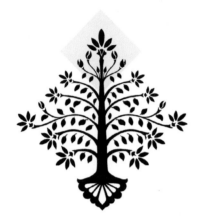

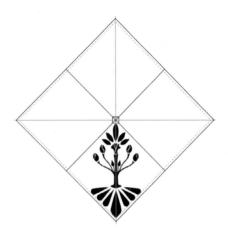

This set of designs deals with contrast and evokes latticework. The balance and exchange between solid areas and filigree shapes imparts a satisfactory rhythm to the design. Still in a straightforward grid format with a four-square reflection, it nevertheless looks far more complicated than it really is. Selected shapes are used with changes in scale.

To set up the repeating unit it is essential to draft up registration lines as these will keep the placement accurate throughout. It can help to use different coloured lines.

Once the block is complete, either a grid or diagonal format can be used.

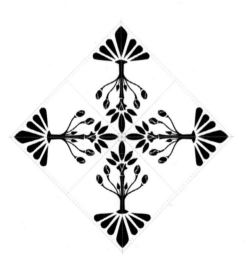

Set in rotation.

With the outer design inwards.

Repeated four times, re-creating the first design as a central roundel.

These examples show how, by carefully changing the placements and the scale, complex patterns appear, all of which rely on the grid and accuracy.

Gradients can suggest different surfaces – glass for instance. Where the light source is constant, dark tones all to one side for example, a three-dimensional surface such as quilting is suggested. Where the gradient remains constant to each motif it suggests controlled dyeing effects such as dip dyeing.

This section introduces
gradients to the shapes.
The design now takes on
a completely new look.

Black-and-white linear
gradients are used with
locations to suite the shape
and style of the patterns.
Radial gradients are used
for the spots.

This example, right, illustrates
how the underlying layer, all at
100 per cent opacity, affects
the gradients and degrees of
opacity placed on them.

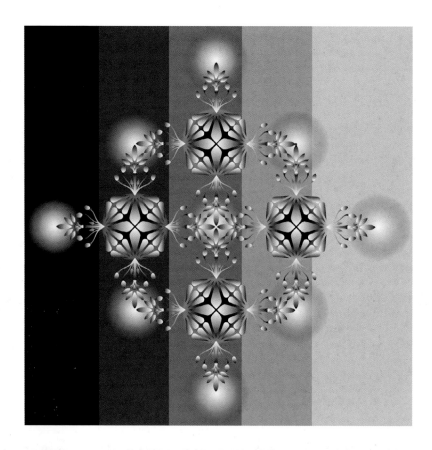

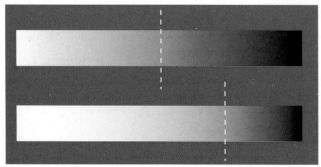

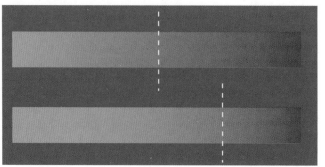

In this example, the top bar shows a linear gradient with a
location of 50 per cent. This means that the change-over, or
balance if you like, is central. The location of the lower bar is 75
per cent. Both black and white are set at 100 per cent opacity.

Changes can also be made in opacity. Here, the two bars are as
before but now have an opacity set at 50 per cent, which means
the gradient bar is translucent and is affected by whatever is
placed underneath.

Border options

The following border patterns are made up from motifs extracted from the design and then shortened, lengthened and rearranged. In some cases the borders themselves are repeated to form new patterns, one of the oldest ways in which pattern was created.

Registration and lines of containment can be drafted to suit the spacing once the look of the border has been decided upon. Setting the motif within a grid will keep the placements accurate.

The following could be seen as borders to an overall pattern: deep border edges to plain or patterned scarves, as lace edgings or lace ribbon.

The first few borders show what marked effect spacing has. In the first instance the cluster is well spaced with each motif reading as a separate and definite unit. It is delicate, airy and light. As the placement gets tighter the design becomes more intense, heavier and more substantial. Eventually it reads as a new unit, which is repeated to form an all-over pattern.

By simply pushing through the variety of placements and scales, additions and subtractions of motifs, it really is amazing how many options surface from one starting point.

It doesn't always work that designs fit neatly into squares. With small groups it can take a while before a design settles into a larger repeating unit.

In this example it has taken four drops of the border and four placements along (outlined in red). The square is marked in green and it can be seen that the design has been tightened vertically as well. Note the leaf accents.

In the set of three designs above components have been systematically removed, leaving a grouping of six shapes.

The pattern to the right has been made by the straightforward repetition of the band. It has been made to twist visually by the use of tone and colour variation.

This border has also been worked into four more repeating patterns. On a dark background it looks very different.

In this complex pattern (left) it has been rotated by 45 degrees, duplicated and then superimposed – shown in red. Two diagonal patterns emerge by lining up the border in different ways and removing some of the components (above).

Here the borders are wider, more complex and detailed. Subtle changes to the size of dots and diamond shapes in an alternating sequence add further to these decorative bands.

It is often the case that only when a few repeating units are placed together the potential for another component is revealed. Backgrounds, colours and new shapes have been added to make up the following lacy designs.

Here, shaded borders are created by combining the gradient setting and the opacity percentage in both the background and the shapes. All the settings vary in the examples above and have been adjusted to suit each design.

Shibori

Four shibori samples have been worked using the same stencil. On first glance they look the same, but they are all slightly different due to changes in stitch and binding techniques. These four have been used repeatedly to develop a shibori pattern for a whole cloth, to illustrate shibori patterns that are possible in real terms. For this task the computer is a wonderful tool.

The dots or flower heads have been worked in three different ways using binding and stitching techniques such as *ne-maki* and *maki-age* shibori. Two main stitch examples are shown, but even these differ because of dye nuances and directional emphasis. The stem has been worked in *ori-nui* or double *hira-nui*.

Scale of design plays an important part in the use of shape combinations for stitched shibori. Care needs to be taken when putting a collection of shapes and lines together to form a repeating unit, and remember that the effects of shibori extend beyond the drafted line. If one area is pulled up successfully it may be to the expense of another shape, if not spaced correctly. Indeed, the threads may not be able to be pulled up at all – sample, sample, sample before embarking on a major project.

Step and block repeats

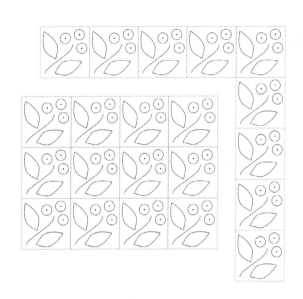

Here, a pair are placed as vertical and horizontal stripes giving an intense pattern. Leaving out a complete box between each unit results in a more spacious diagonal. Dots (flowers) and leaves differ.

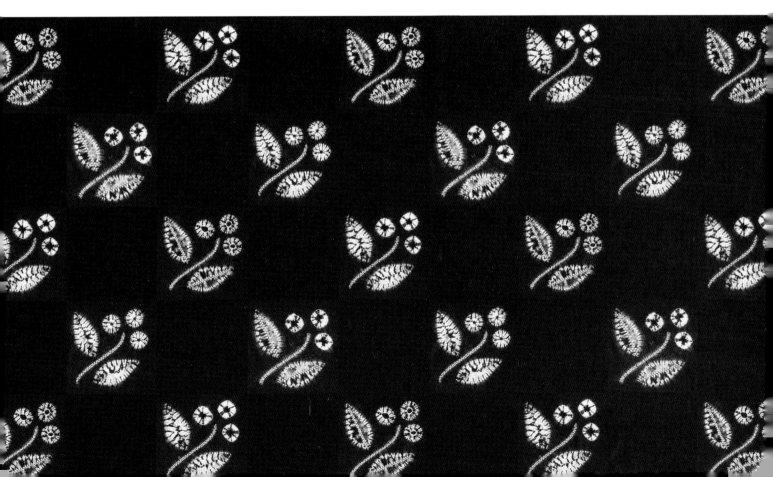

Rotation placements

1 turn clockwise

The repeating unit is turned once clockwise.

The duo is then placed directly underneath.

Then placed one square along.

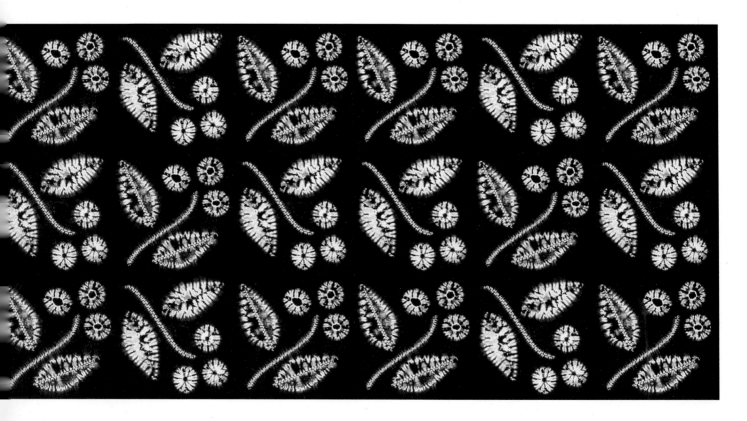

2 turns clockwise

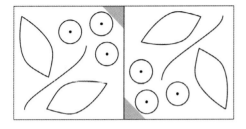

The repeating unit is turned twice clockwise.

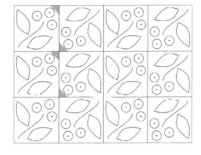

Placed directly underneath.

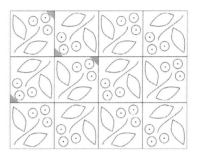

Then moved one along. Note the dotty diagonal.

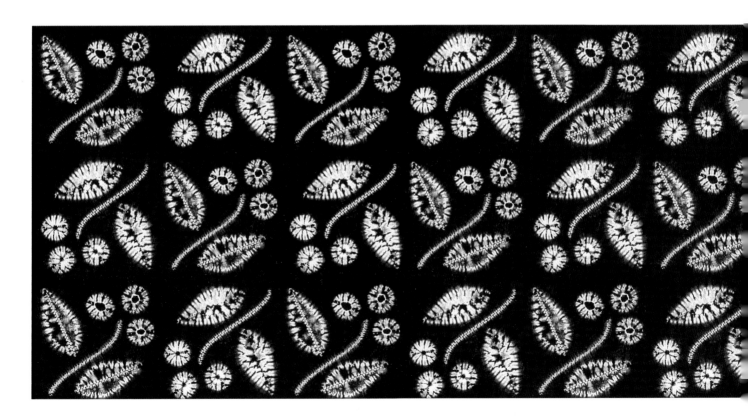

3 turns clockwise

Three turns can look like a reflection in some instances, however it will not be symmetrical.

The repeating unit is turned three times clockwise.

Placed directly underneath.

Then placed one square along.

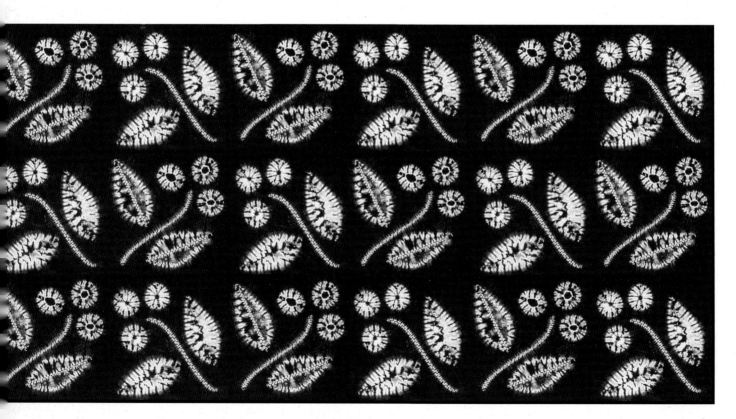

Half drop

Three different repeat units have been used in this pattern which has a diagonal emphasis. It could be tightened to prevent a vertical plain stripe that has emerged.

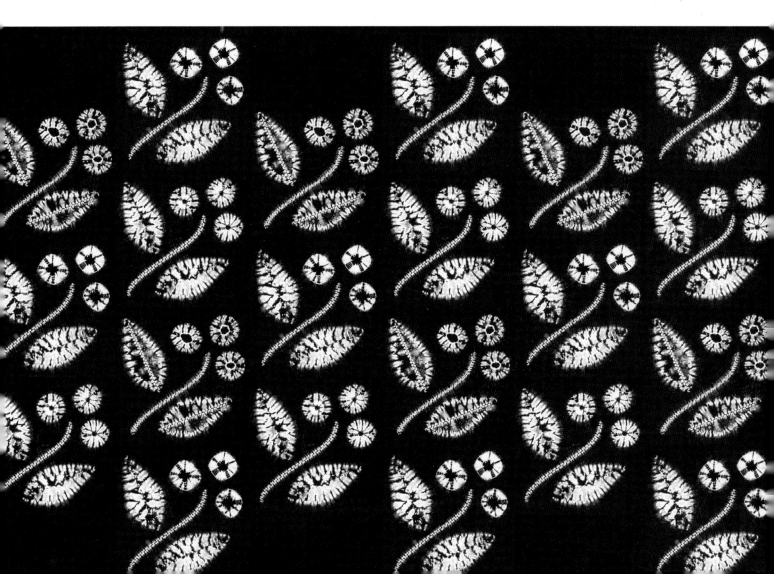

Brick repeat

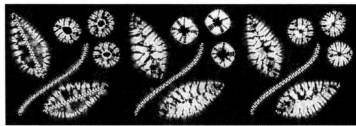

Here I have incorporated a possible solution to eliminate a horizontal stripe. This sets up two opposing diagonals, one of lines, the other of dots.

Three different repeating units have been used again. The stitched line becomes a tendril.

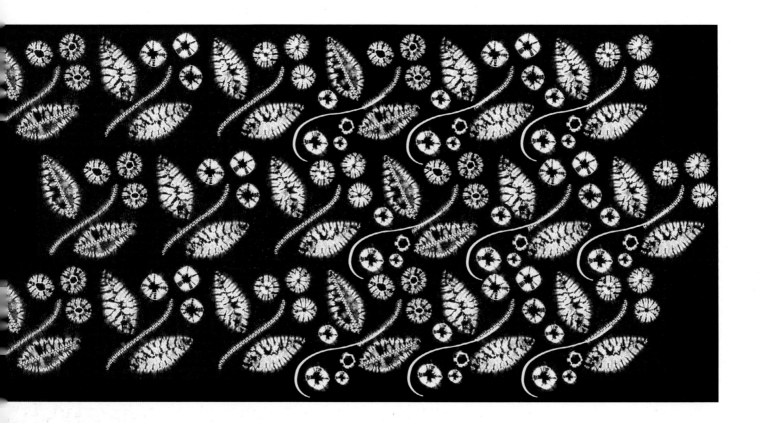

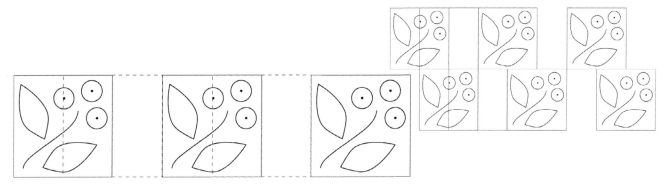

A brick repeat with a built-in space makes a pleasing
diagonal pattern. Again, a tendril could be introduced.

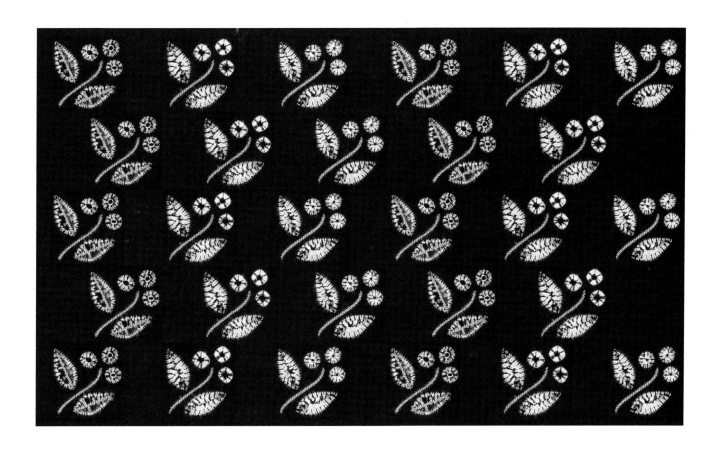

Reflected repeats

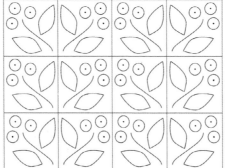

A reflected pair is set up here which is repeated directly underneath itself, a format very useful for creating striped designs.

For a more interlaced look the pair is placed directly underneath but then moved one square along.

Here, alternate rows use the repeated motif from the pair.

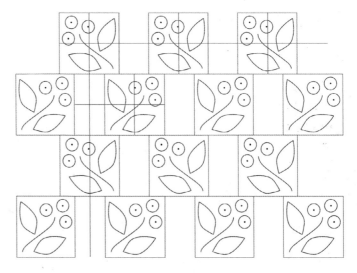

This example has half a square width of space between the horizontal placements. Registration lines enable the placements to be set up accurately.

Full reflected symmetry

Each square is reflected as it is moved round
to form the quartet. Once the shibori is worked
the motifs are not the same (as dye markings
will differ throughout), though in essence the
pattern demonstrates full reflected symmetry.

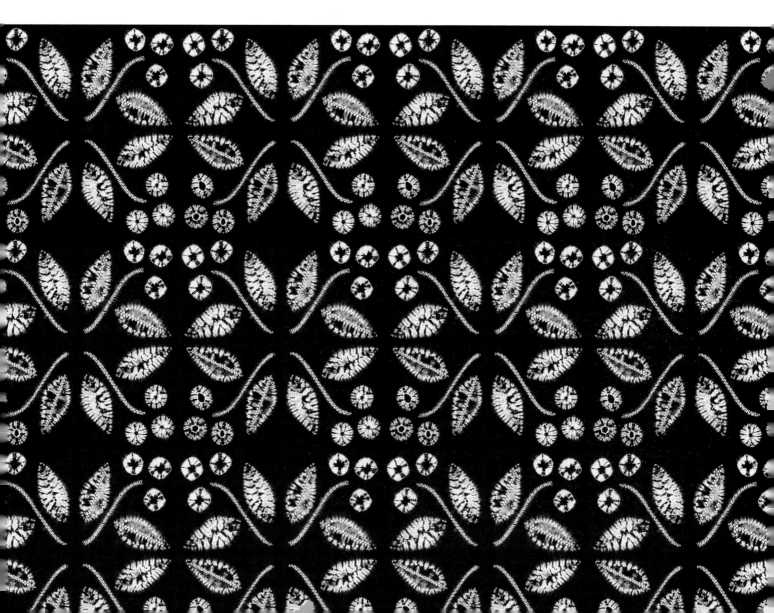

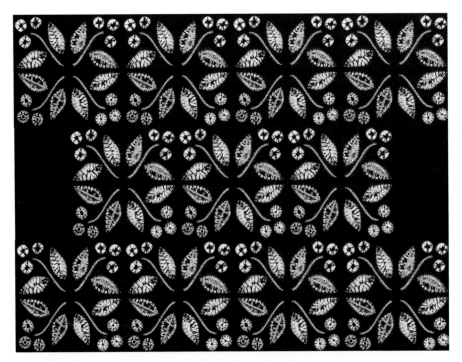

The amount of space the design occupies within the square impacts on the look and ambience of the pattern. Here it is set tightly within the square in a brick repeat.

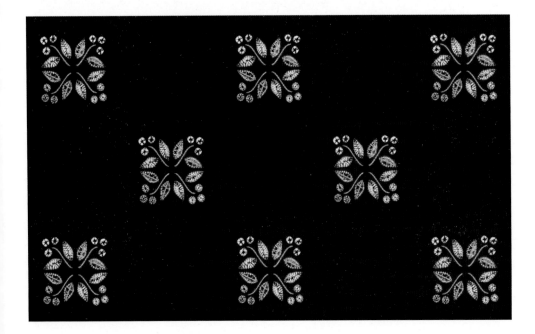

With every other square left out and more space surrounding the design within the box the resulting pattern is airy and spacious and lends itself to subtle interest or a linking detail being added in the plain areas.

The format lends itself to any number of additions in the blank square, be it through further shibori work or another textile technique.

The following pages show a degree of refinement within this standard format.

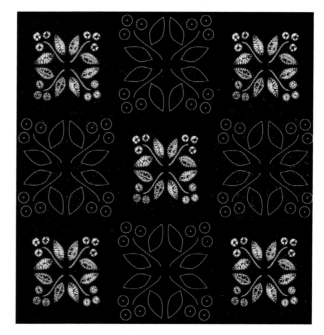

Here is the suggestion of delicate hand quilting using a pale shade.

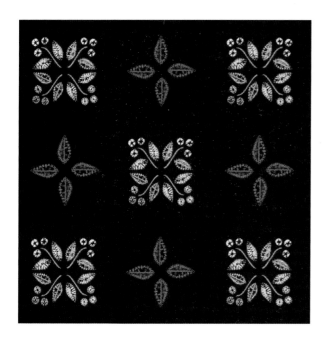

A less obvious shibori pattern can be achieved through specific and controlled dye procedures.

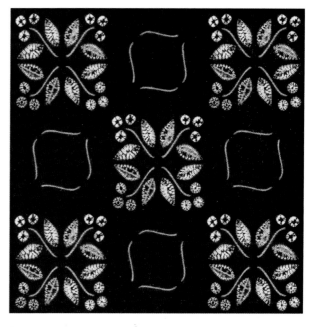

This example shows the use of stems only, which have been placed at 45 degree rotation.

Several different patterns can be built up by separating out the varying design elements.

The wavy lines here are reminiscent of the traditional 'tatewaku' pattern. The stitching here is shown in short lengths, allowing the pattern to be worked as a large whole cloth.

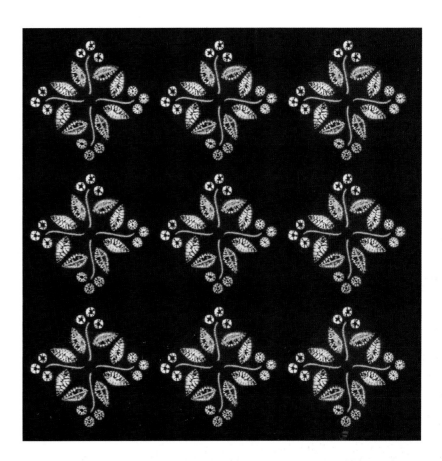

Here the design has been turned 45 degrees, reboxed and repeated in a straightforward grid.

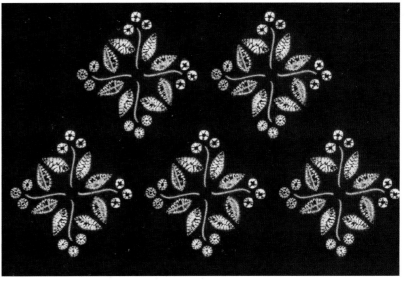

By putting a half drop or brick repeat in place a negative chevron band is formed.

This illustration shows a quarter of the group set at the apex of the vertical arrangement.

Here the quarter has been enlarged and set in the spaces.

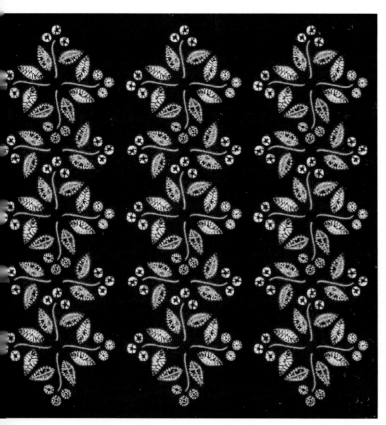

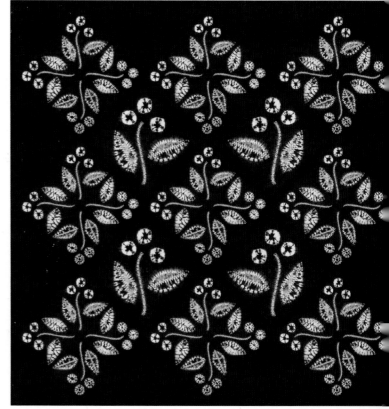

Design development

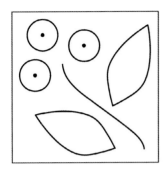
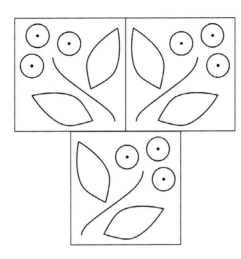
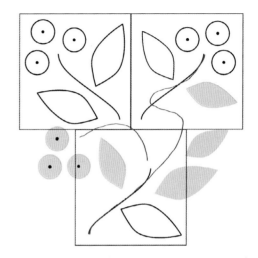

A new cluster of three is made using a reflected image and brick repeat. It is then redrawn. Two leaves are added, others made smaller, lines become more sinuous and dots (flowers) are moved.

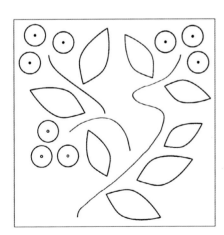
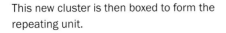

This new cluster is then boxed to form the repeating unit.

Once in repeat we can see where improvements can be made. Here two groups of three dots have been amalgamated into a varied group of seven. In another repeat format they may need to be adjusted yet again.

Step repeat

The dots are squared up. Registration lines are added to help match up their placement with the rest of the pattern. They can set up as a separate stencil.

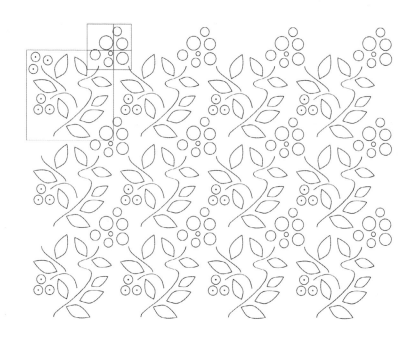

Half drop

The original dots have been replaced with a new grouping.

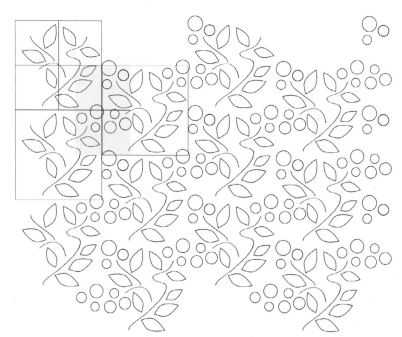

Spacial changes

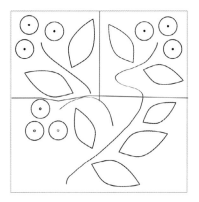

Squares can be separated and moved out if a pattern appears too cramped and intense.

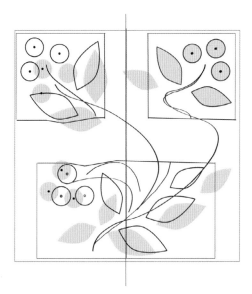

Here, various adjustments to the drawing and placement of existing shapes have been made and two more leaves have been added.

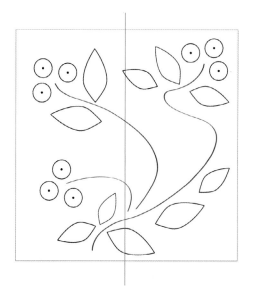

When put into repeat, quite often the square needs to fit tighter to the design or the design may need to extend beyond the square. These judgements are best made when repeats are put in place and the flow of the design assessed.

Step and repeat or block repeat

Tweaks have been made to break the 'block' look by extending the line and moving a group of dots.

Row reflection

The design is reflected on the vertical axis, then placed underneath. The duo becomes the rectangular repeating unit, which is placed as a straightforward block repeat. Essentially, the row is reflected. The line is extended to enhance the flow of the pattern.

Rotation repeat

Alternate rows have been made up of squares that have been rotated 180 degrees, placing the motifs diagonally opposite one another. A horizontal band is evident between the groups of dots. By perceiving this group of four as the repeating unit the changes do not have to be uniform.

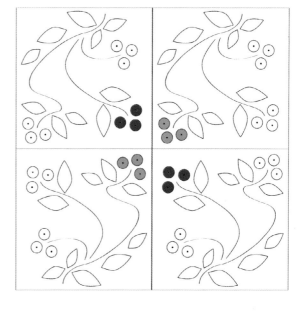

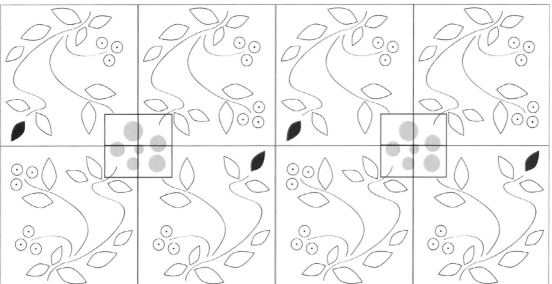

One group of twelve dots has been replaced by a group of six, which can be marked in with a separate stencil. The alternate group of twelve dots has been replaced by repositioning a leaf.

This example shows the placement with the new dots and leaf, keeping the pattern open.

This illustration shows the design with an overlap.

More rotation repeats

Here the pair is placed as a custom brick repeat.

Alternate squares have been rotated 180 degrees. The pair is then placed to form a chequerboard pattern.

This haphazard pattern has been achieved by rotating each square by 90 degrees twice. This gives a multidirectional type of pattern.

Reflected repeats

The image has been reflected and then placed as a pair directly underneath. By removing alternate blocks we find an airy pattern with the directional lines maintaining connection and flow.

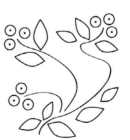

Full reflected symmetry

From this arrangement four separate designs can be extracted,
each with full reflected symmetry.

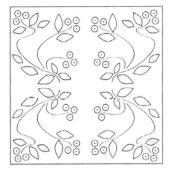 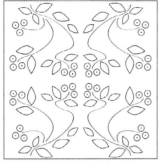 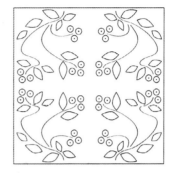

In this half drop, the column on the right has been nudged to the left to tighten the pattern.

In a custom brick the design could be tightened vertically.

As custom brick with alternate squares removed.

And again, with custom placements to lessen the space vertically and horizontally.

Random correlation

A group of three, in this instance, has been used to build up another design. The original square on the left has been reflected, rotated and placed top right. From this orientation

it has been randomly rotated for the third lower square. An existing leaf has been reduced in scale and duplicated. More dots have been added.

These design elements can then be squared up or, as on the right, set into an oblong to keep the placement tight.

Step repeat.

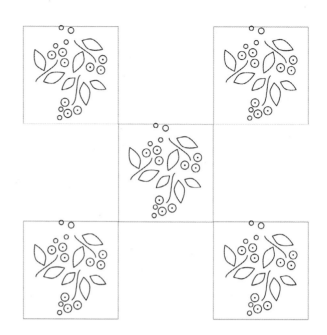

With every other square omitted.

Oblong grid setting as a half drop. It is then set as a half drop through the horizontal placement only. The repeating row is

as a standard placement. Both groupings lend themselves to having linking lines added in developments.

Triangular grids

Triangular grids can also be used for shibori and here the design is adapted to suit. There are many different stitch formats for elliptical shapes and for dots and circles and the unique characteristics of the shibori technique will transform the following graphics. These clear shapes would also suit appliqué.

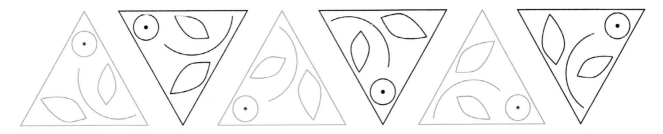

Here is a row of 6 triangles, the result of five 60-degree rotation moves.

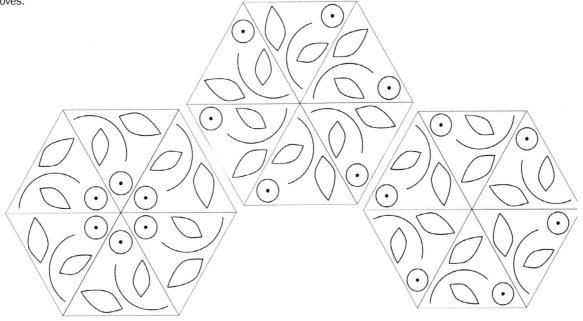

The three resulting roundels.

Here we see the results of bringing those hexagons together. The simplified shapes and lines specifically designed to work shibori have produced some floral patterns which could have many applications.

Further changes can be made by selectively removing some of the design elements.

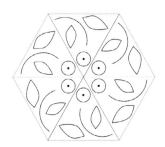

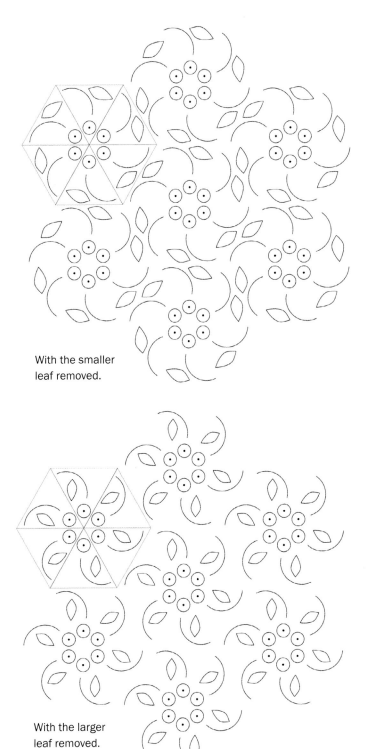

With the smaller
leaf removed.

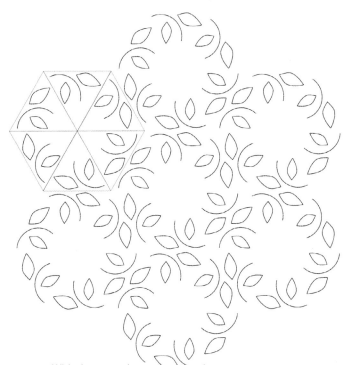

With the central
dots removed.

With the larger
leaf removed.

The same strategy has been applied here,
removing different elements of the design
to create new floral patterns.

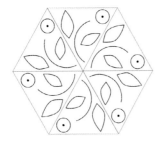

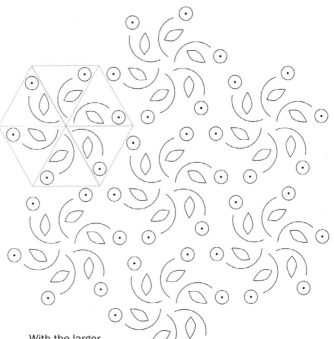

With the larger
leaf removed.

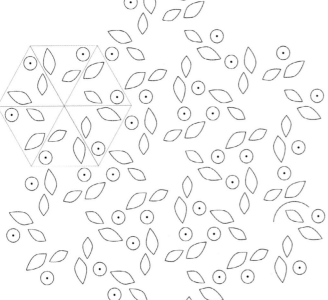

With the line
removed.

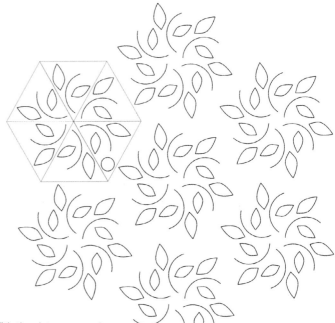

With the dots removed.

And again. The line, the central floret of large leaves and finally the contained small leaves have been removed.

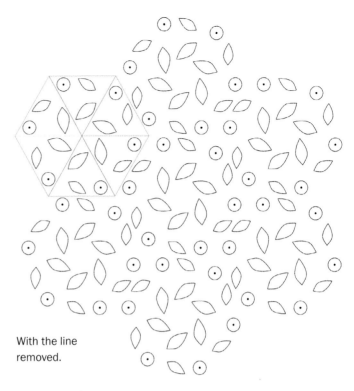

With the line removed.

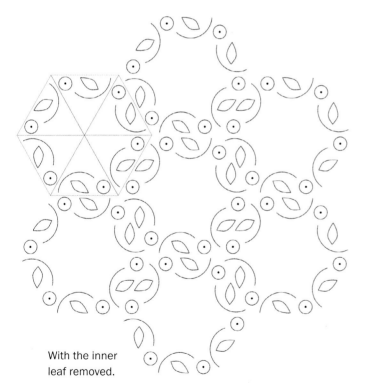

With the inner leaf removed.

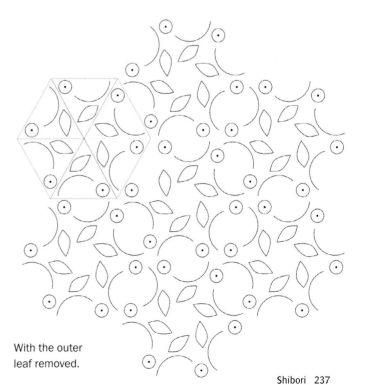

With the outer leaf removed.

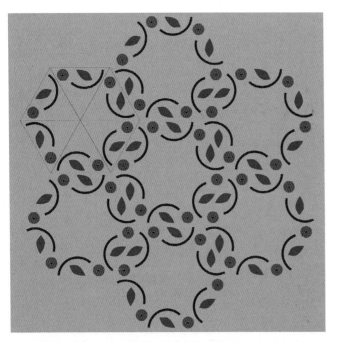
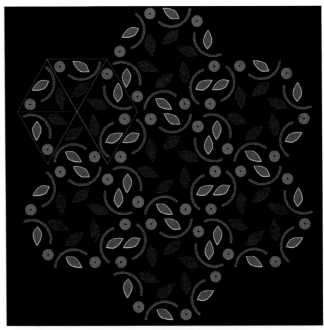
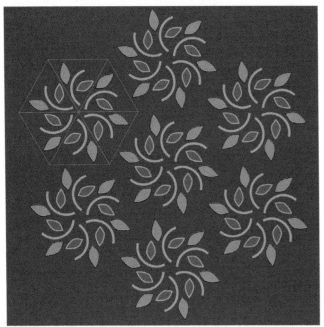
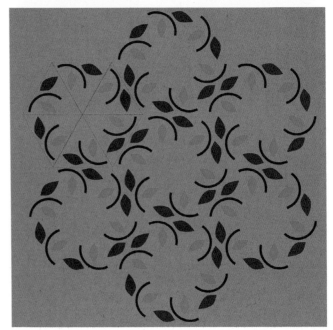

A random selection of four roundels have been given colour.

Introducing new design elements

This group has the addition of fine lines to the central triangle which affects colour, tone and – if interpreted as stitch – texture. The backgrounds become progressively darker in tone, changing contrasting values.

With a pale background. Here the lines add warmth – a darker line creates a break and forms a linking background hexagon when seen complete.

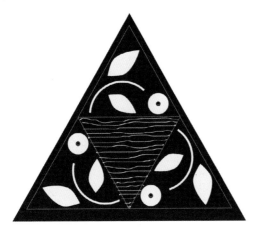

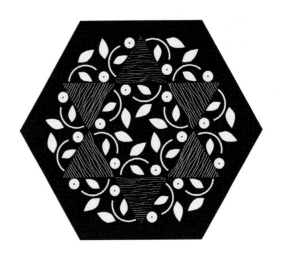

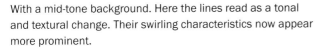

With a mid-tone background. Here the lines read as a tonal and textural change. Their swirling characteristics now appear more prominent.

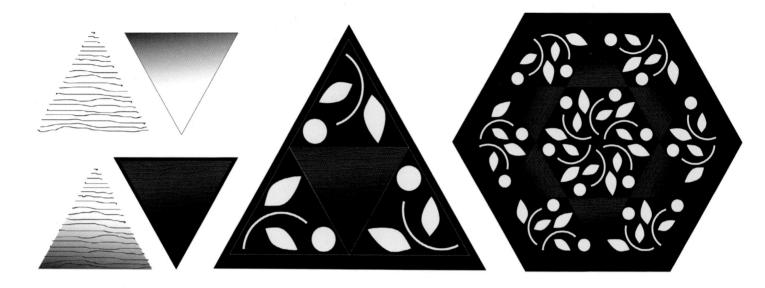

A gradient is set behind the small triangle which adds warmth to the pattern and intensifies the blue.

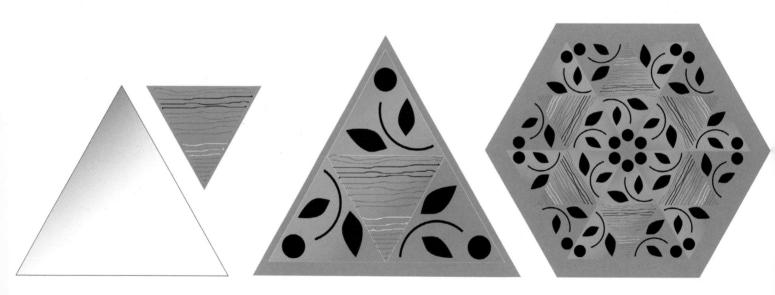

The gradient is set for the large triangle and highlights selective shapes in the overall pattern. Here the lines have been broken up with tonal changes.

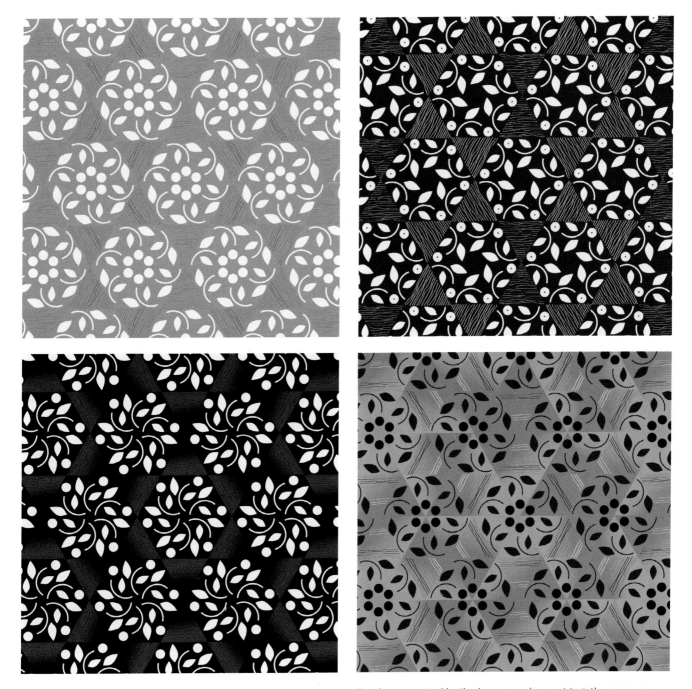

The resulting patterns seem more cohesive when set into squares – the shape created by the hexagon when put together appears complete and resolved, which can limit perception of an overall multidirectional pattern.

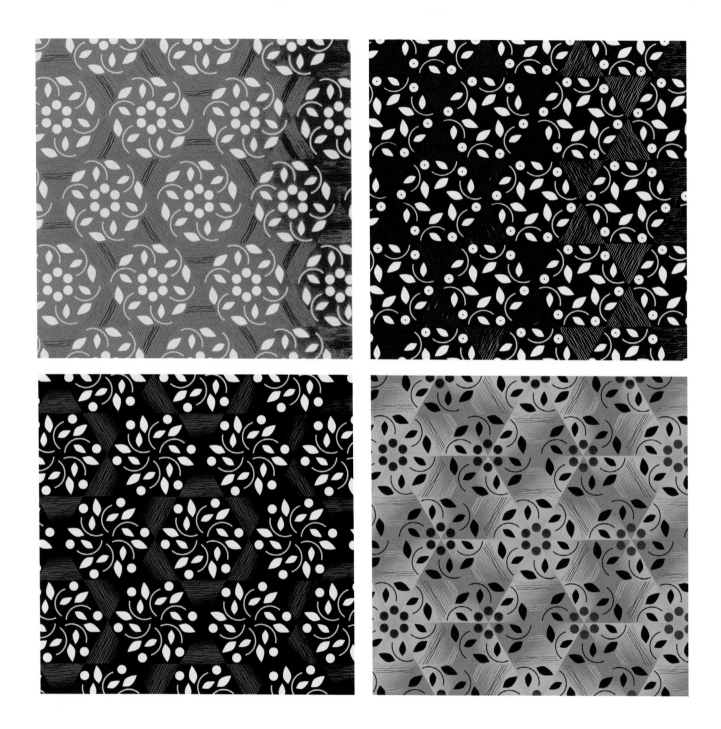

Out of Africa

These wonderful shapes have been taken from aprons and skirts made by the Kuba peoples of the Congo. The applique design would have been of raffia cloth and the colour schemes the result of earth and wood dyes, giving rich palettes of brown, amber, black, ochre and tan.

The designs have a bold simplicity. A soft tan is the only colour used, with black and white in this first section in order to see the difference between the various placements, but it is extraordinary how much variety can be achieved with such a limited palette.

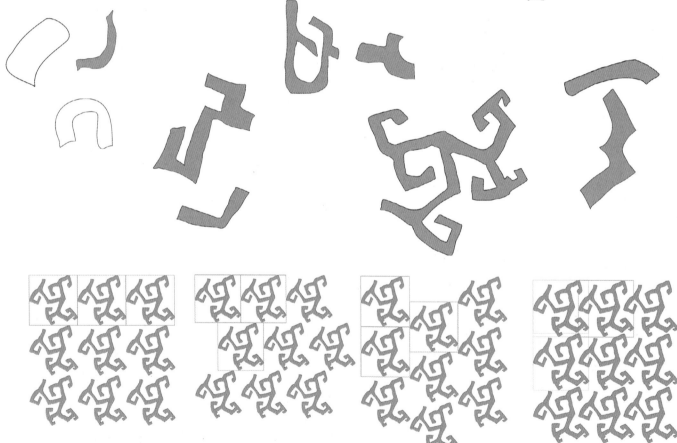

Block repeat.　　　　Brick repeat.　　　　Half drop.　　　　Block repeat with overlaps.

Reflection

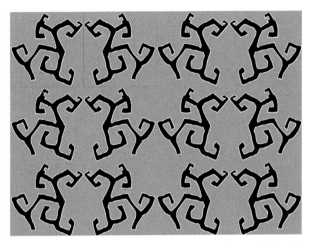

Here the reflected pair is placed directly underneath itself in a block repeat.

A reflected pair is shown as a border pattern.

A half drop tightens the placement.

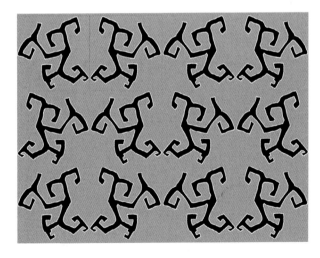

The reflected pair is moved along one square when placed underneath in a brick repeat. The negative space changes.

Again they make for quirky borders.

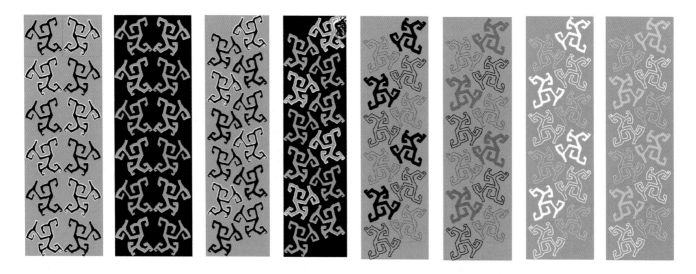

The same two border patterns look very different. The changes that have
a marked effect on the rhythm of the pattern are shape outline widths and
colour, which has an effect on the infill and background. A more delicate effect
is achieved by using a line only for the shape and lessening the contrast of the
solid areas by using a 50 per cent opacity.

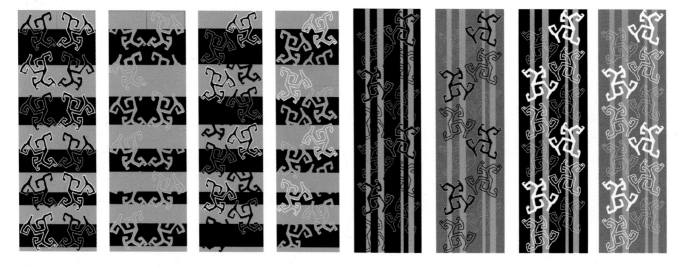

Now the same patterns are placed on a banded background, the shapes
disappear now and then. Again delicacy is achieved by using a drawn outline for
the shape. On the right, the black stripe has been used at 50 per cent opacity.

Rotation

Further patterns and designs are found with the rotated placements.

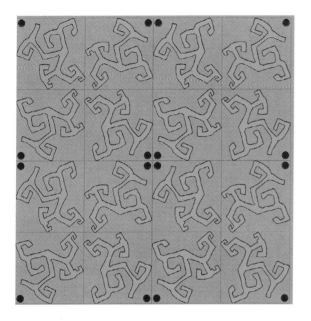

The pink dot highlights the rotation. Here the opacity is 50 per cent.

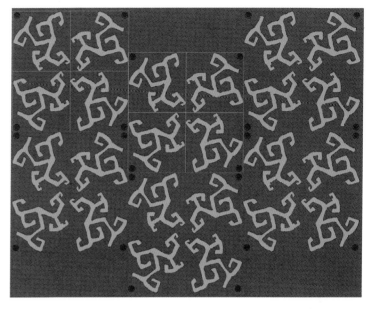

Above the group of four is placed as a custom drop. The opacity of the black is 80 per cent.

Here we see the opacity of the tan infill changing. From left to right, 80 per cent, 50 per cent and 30 per cent.

Full reflected symmetry

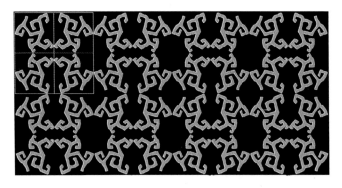 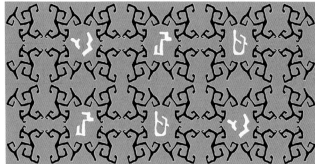

Extracting the four possibilities for one-off pieces and altering
the combinations of tone and colour gives twelve further designs
from this one shape.

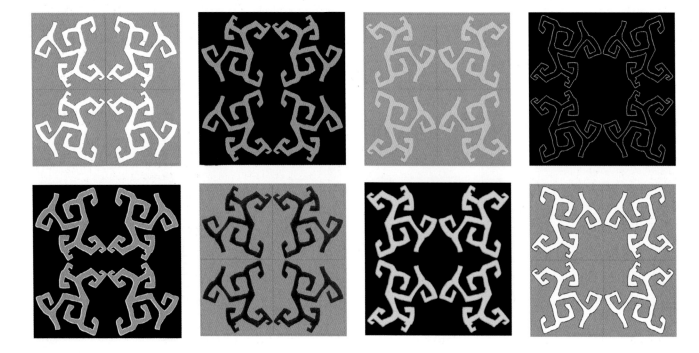

With the design set as full reflected symmetry, diagonals are introduced by progressively changing the opacity of the shapes. Opacity settings are 20, 40, 60 and 80 per cent.

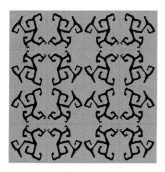 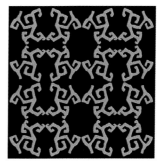

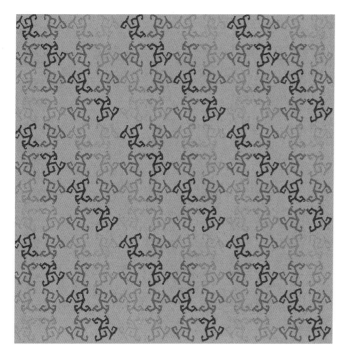

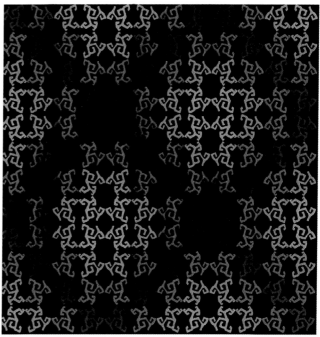

Each square unit of 16 is treated as the repeating block. This black-on-tan example is placed as a straightforward block repeat.

In this tan-on-black example the unit itself is reflected to give the larger diamond shadowing effect.

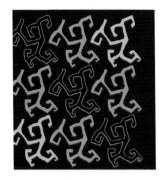
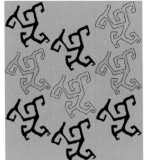
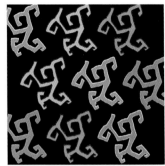

Here, the palette for the background is increased and there is a selective placement of colour for both shape and outline.

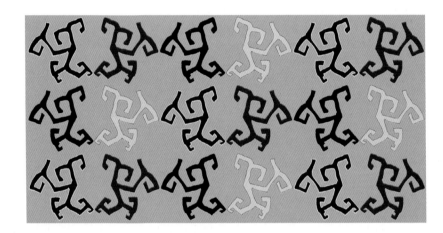

The pattern shown here is a reflected pair with an alternate colour change.

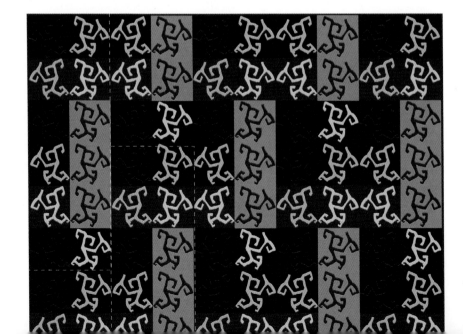

Here, a new 12-unit block is put in a half-drop repeat pattern, which suggests strip weaving. A vertical 12-motif block (outlined) placed as a half drop reveals a horizontal rectangle which reads as a brick repeat. The choice of which repeating unit to use would depend on the technique chosen.

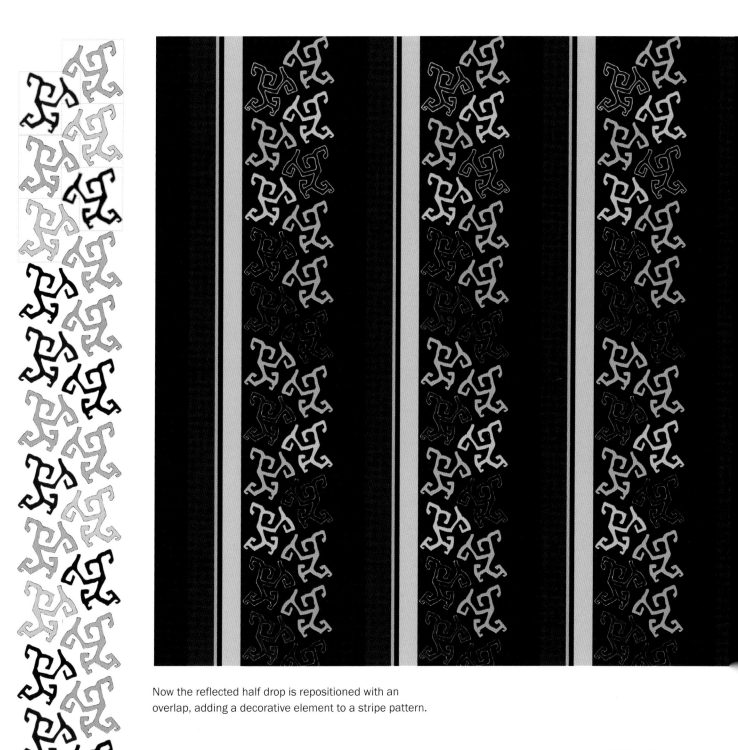

Now the reflected half drop is repositioned with an overlap, adding a decorative element to a stripe pattern.

The reflected pair is moved along. Changing the opacity presents many more colour variants and further opportunity for thinking about placement.

The samples below show the difference in the pattern through using these translucent colours.

100%

50%

60%

40%

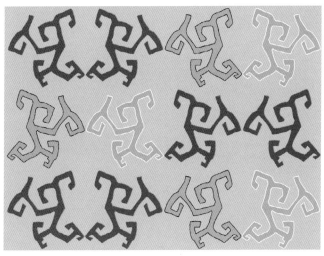

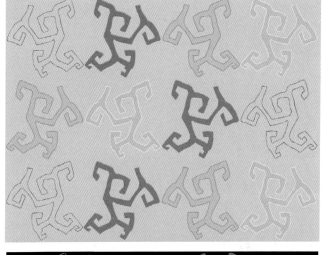

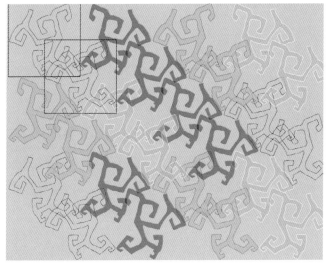

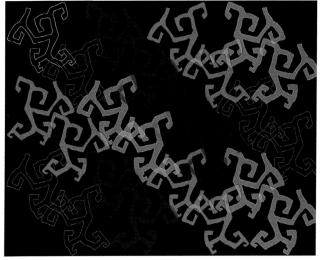

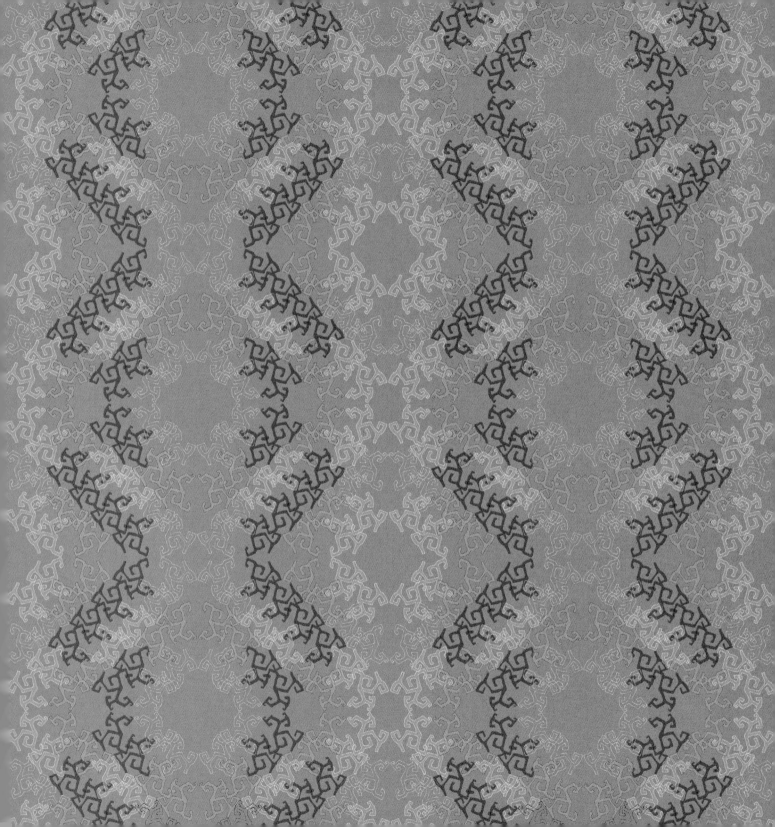

Full reflected symmetry

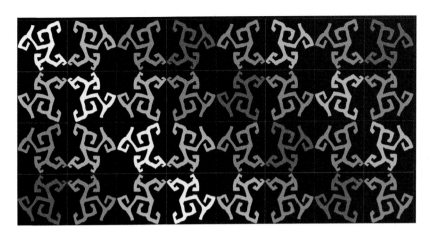

A single unit in full reflected symmetry.

The unit forms a diagonal in repeat, because of the opacity changes.

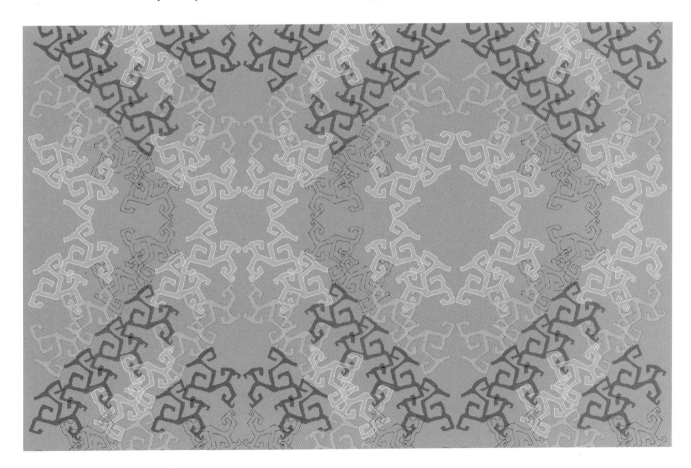

Dots and splodges

These simple shapes and the idea of pattern-making with them is inspired by the *kanoko* shibori styles of Japan, in which shapes are filled with tiny resisted dots placed in a grid sequence.

Below they are put into a block repeat. Each time the square has been rotated anticlockwise. A larger splodge has been added to fill the gap.

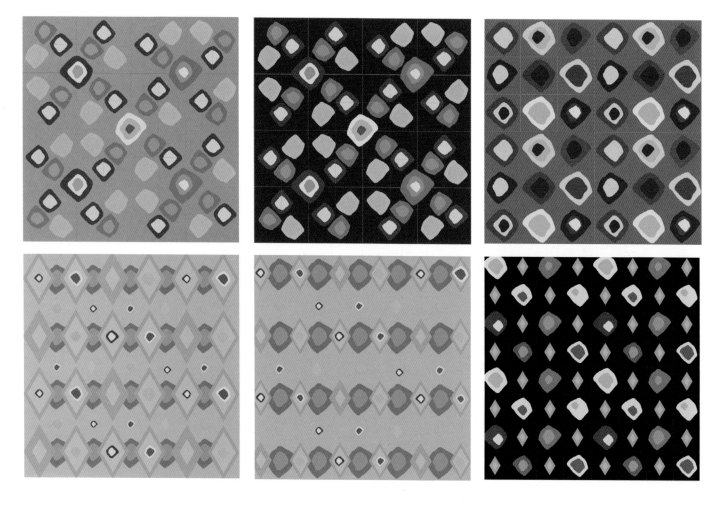

An abstracted floral in
essentially block repeats.

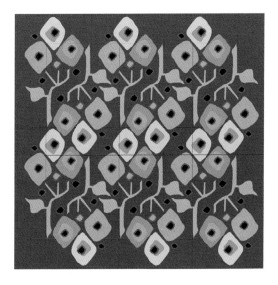

The floral is custom placed to form clumps
of splodge colours.

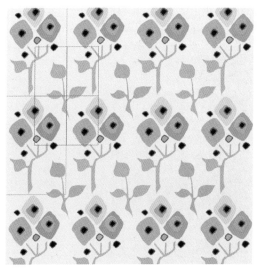

Separate sprigs are added and block placed.

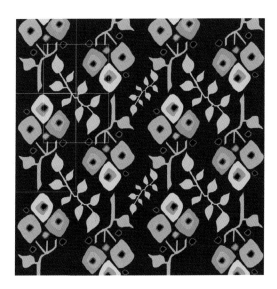

Separate sprigs are added and block
placed (variation).

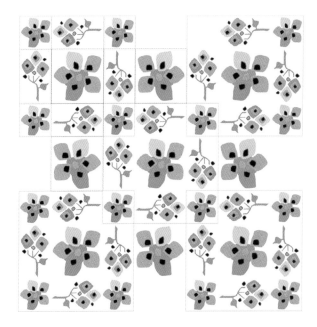

A composite square has been put into block repeat.
The addition of florets intensifies the pattern.

A traditional format can be just as effective with contemporary shapes. Though the overall look speaks very much of Islamic design, its dottiness gives the feel of Maori art.

The triangles are reflected when placed to form the hexagon. The marked changes in tonal value within the design bring about distinctive florets when the hexagons are finally brought together. These are further enhanced by dropping in a local background colour of deep blue. The complete pattern is then placed on a dark background.

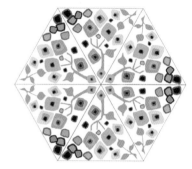

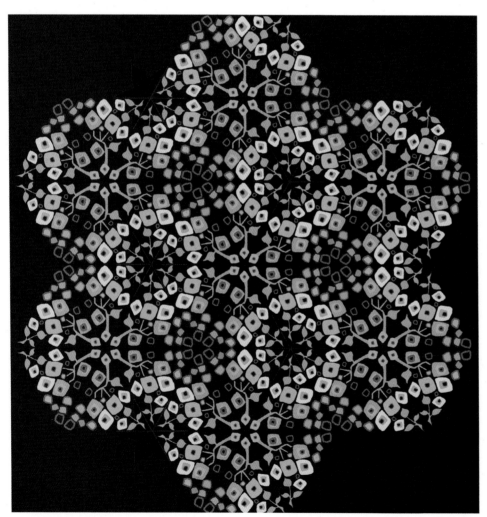

The design elements here are for a one-off quilt project. Reflected repeats are set into an eight-sided polygon set centrally within the piece. The design is set up essentially in a block of nine squares, each containing a large floret within a diamond. The background has been subdivided and in-filled with close colour tones. Extra splodges have been added.

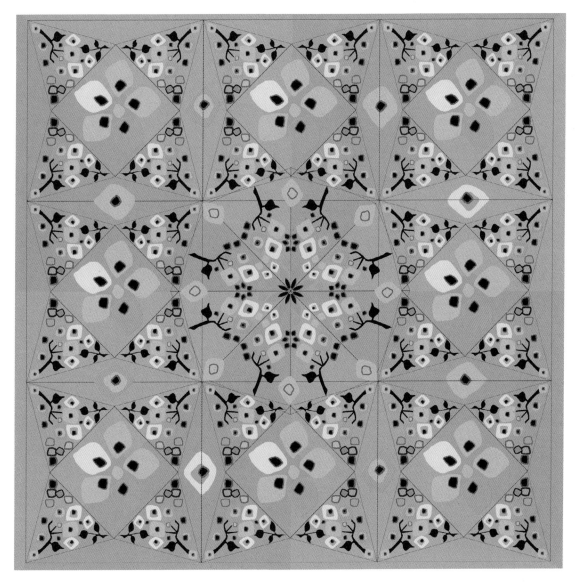

Butterfly

There is a buddleia growing just by the room where I have my computer. Every summer there is a wonderful view of butterflies settling on the flowers to feed and this design is inspired by those transient wings. It is based on full symmetric reflection which I enjoy so much. These designs can be as complex or as minimalist as one likes. Worked large scale much more detail can be included, but minimal surface detail can offer very dynamic results when projected large scale.

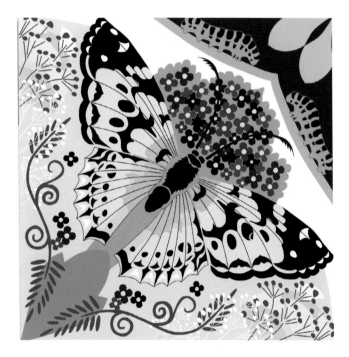

The half image is copied, reflected and turned to form a symmetrical design, the basis for the pattern. Once placed, shapes need to be joined to fill any gaps that appear on the diagonal axis.

Once the four sections are brought together they can be joined to make solid areas. As the repeats multiply, different areas start to appear that will benefit from this procedure. Having said that, of course, it is still useful to have the original quartered design to rearrange.

The shape that forms the base for the blossom florets is drawn as one unit and set at 100 per cent opacity. Similarly the central shape behind the caterpillar is drawn as one shape.

The look of the design changes dramatically when set on a dark background.

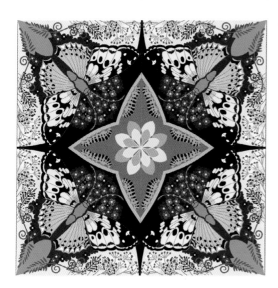

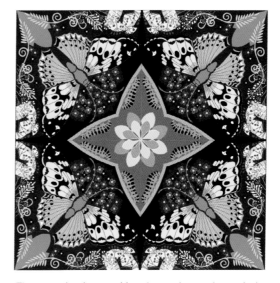

Every other petal of the central star is a different shade, and the floret has been duplicated and set centrally to give a fuller look. The seed heads have been darkened.

The outer background has been changed to a dark, warm tone. The butterfly body has been brightened and the same colour is used for the corner leaves. The fern-type leaves are lightened also.

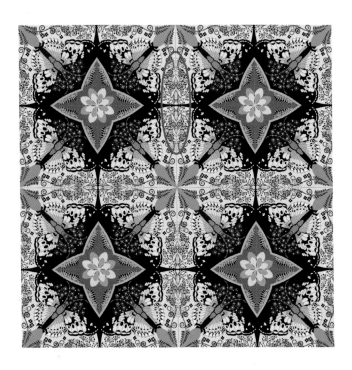

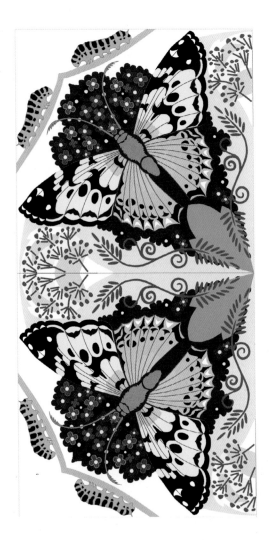

The tile can now be assembled to create the repeating pattern. As the scale of the pattern decreases, the definition of the detailed areas become less clear and would benefit from being redefined where circled.

The smaller background cow parsley detail has been removed and a new shape has been placed behind the top section which leads the eye to the grass head. The following pattern embraces the blousiness of summer days.

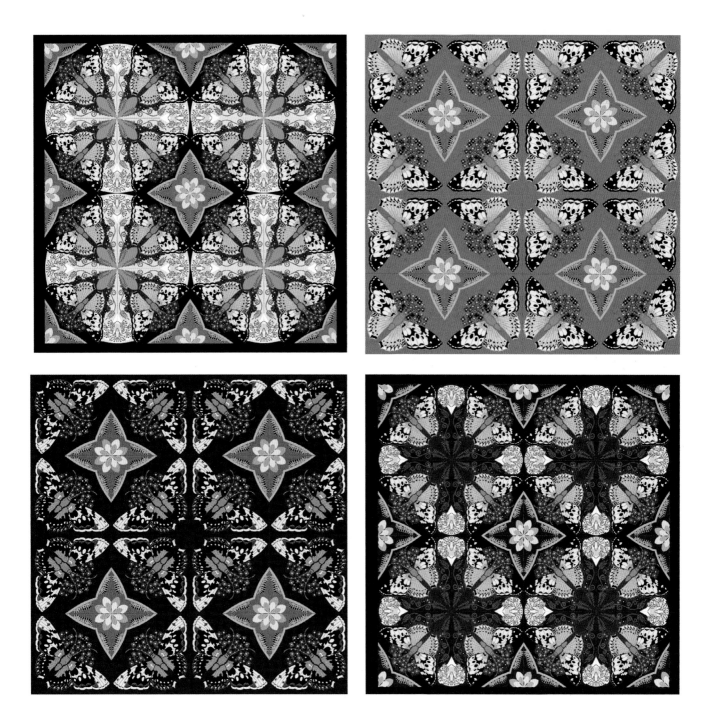

The finished repeat is shown top left. The other examples here show the design with all the detail removed in various colourways.

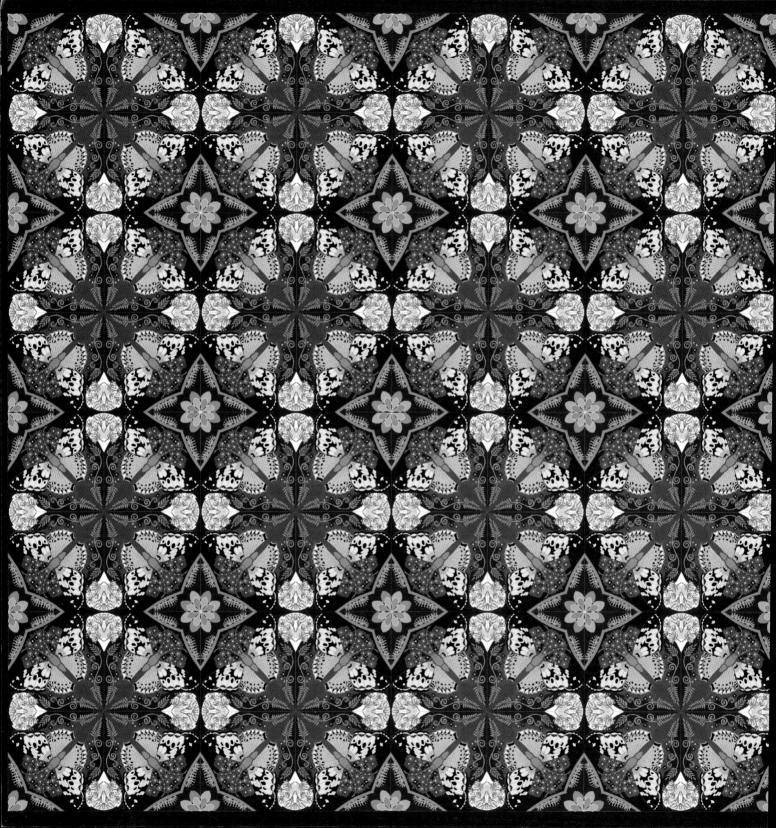

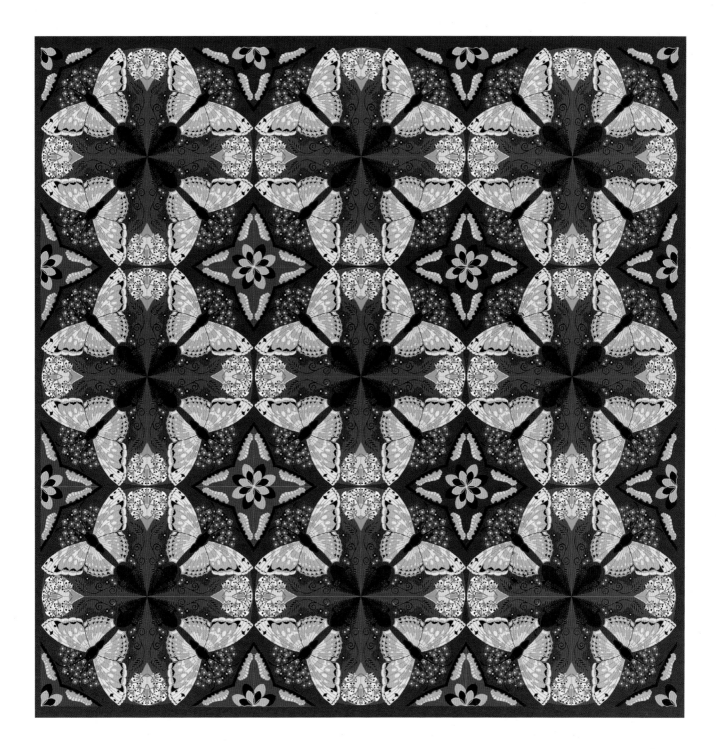

Leafy geometrics

Breaking down the components that go into 'butterfly' and realigning units brings about a whole new selection with which to build up pattern. Composite designs could be used to create new patterns or be incorporated with the existing butterfly design.

The background to the blossom, when repeated, turned and superimposed makes a floret. Double up the placements and reduce the scale for each shade and further options come to light as shown right.

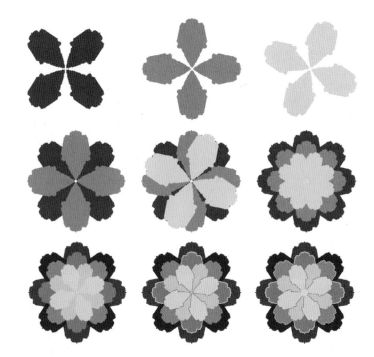

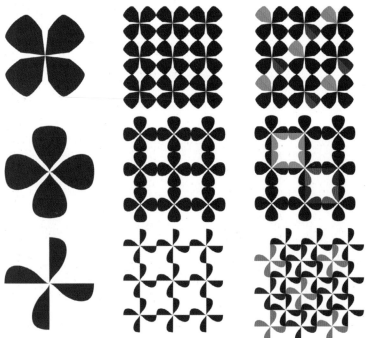

Smoothing out the edge of a different shape gives another unit to use. These placements could be used for any number of petal or leaf forms. The central alignment echoes the linked circle pattern. The following patterns show a range of different colourways.

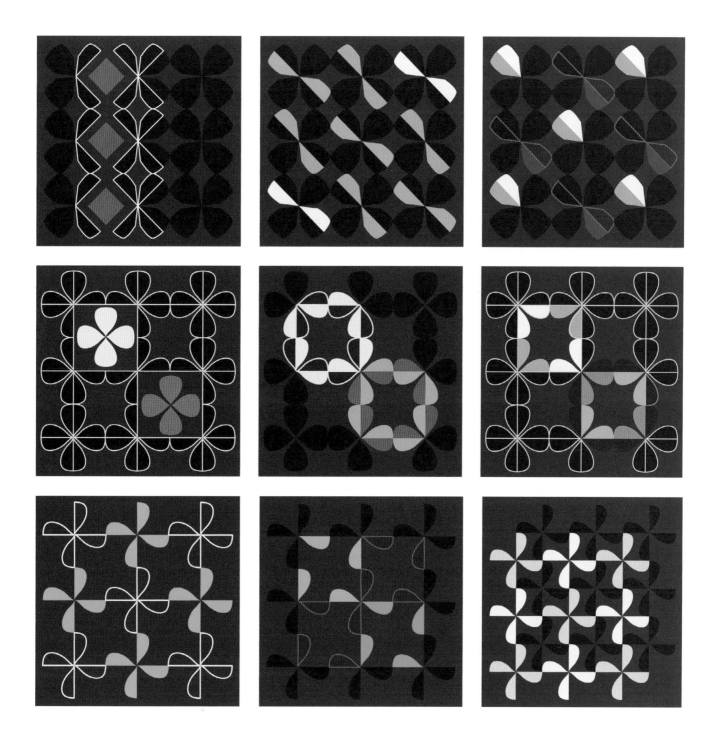

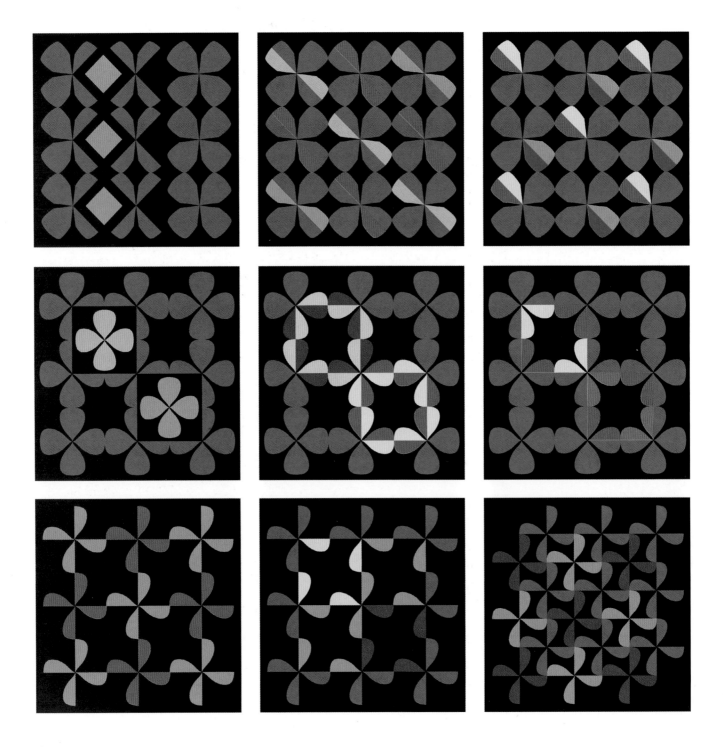

Two of the previous designs are grouped together to form small repeats. Each is tweaked to turn a negative shape into a positive one with the addition of colour.

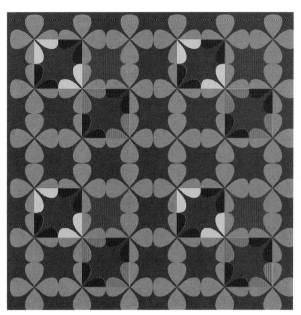

This pattern has the addition of a 'filled in' square.

Removing four petals in this pattern links two negative shapes.

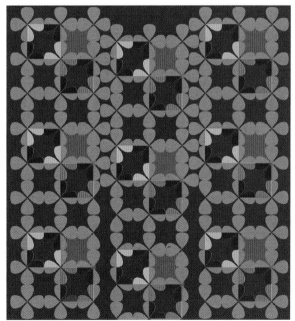

The same pattern as above has the placement of petals tucked in close, which forms an intense stripe. By removing them a negative stripe is made.

Developing the floret

The blossoms have been set into their own square and the outer top edge of the background shape retained, the rest is shaped to form the square's corner. Bringing them together forms a new symmetrical design unit.

The floret is placed with different sizes and colours.

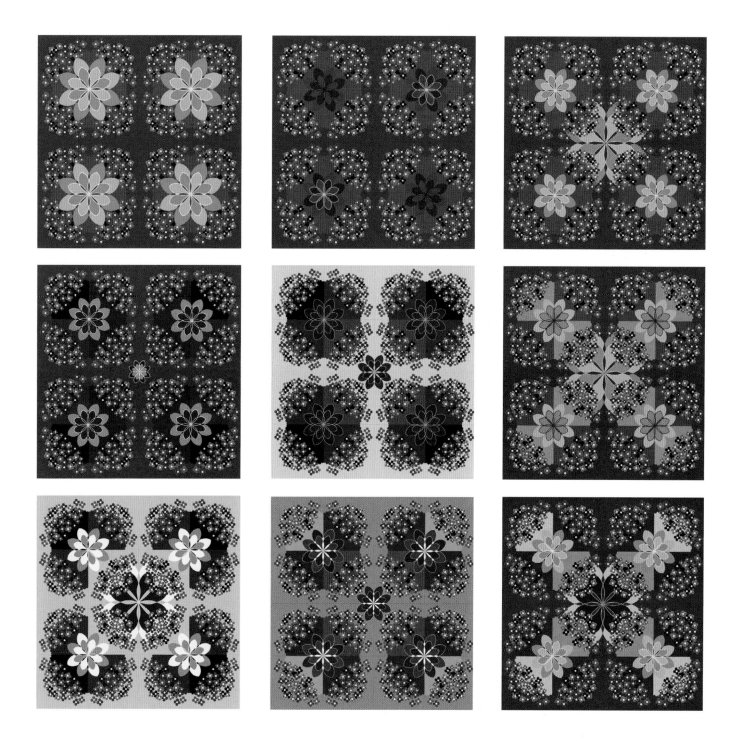

Developing linear detail

By extracting the linear detail that forms part of the border pattern we find a repeating unit that could easily be interpreted in stitch or linocut block print.

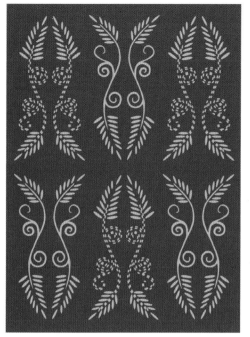
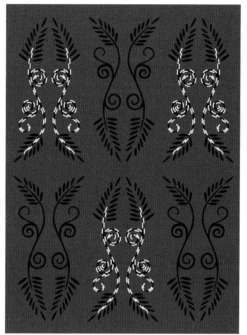
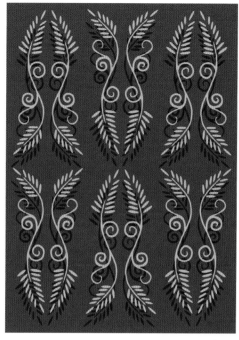
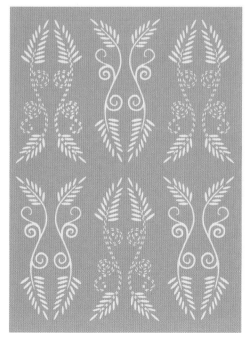

The linear design is also effective in full reflective symmetry. The leaf shape has been included in this collection.

Note how powerful the thin outline in red, complementary to green, is. It gives a touch of warmth and clarifies the shape.

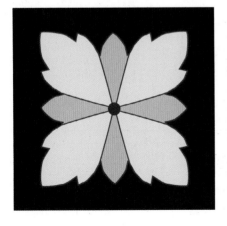
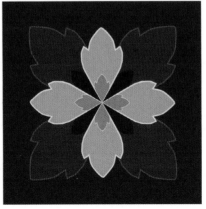

The floret is given four and then eventually eight more leaves – the same shape but reduced and rotated. The deep red sits behind the original group and the smaller green leaves give a shadowing effect. Note what a dramatic effect a tiny dot has.

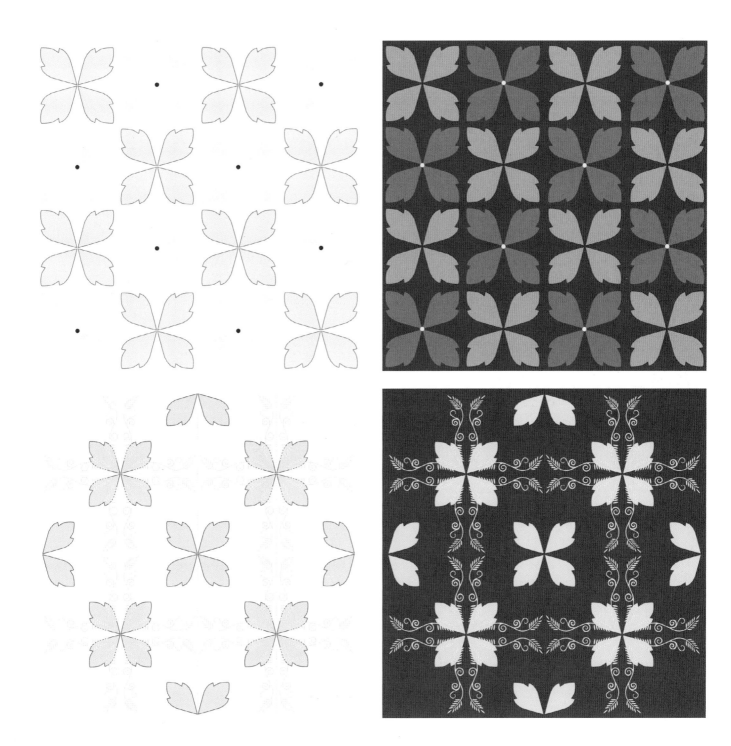

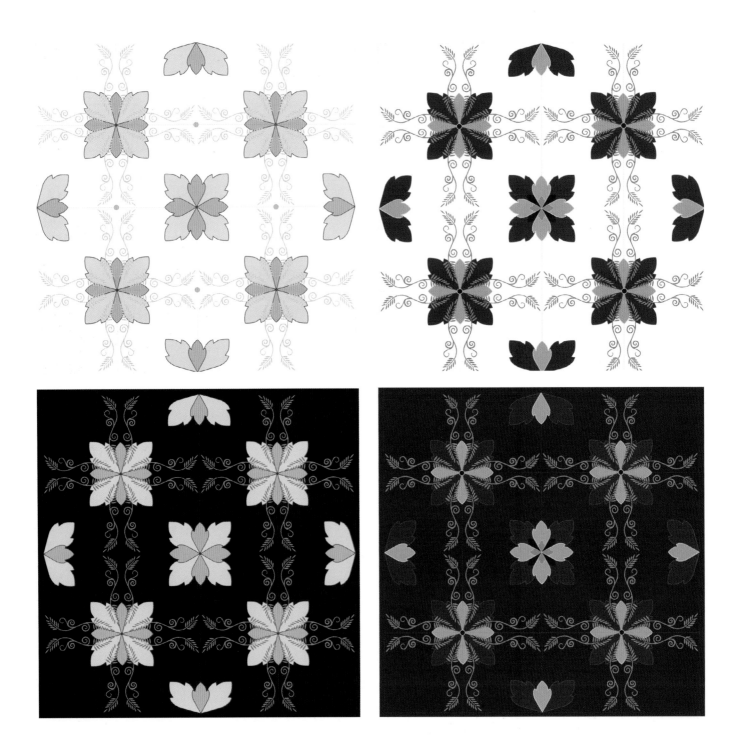

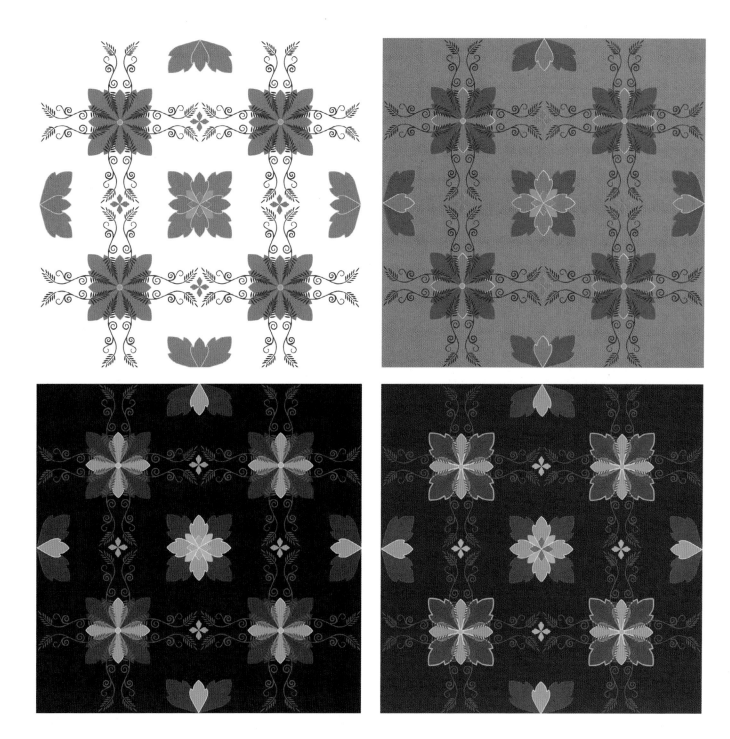

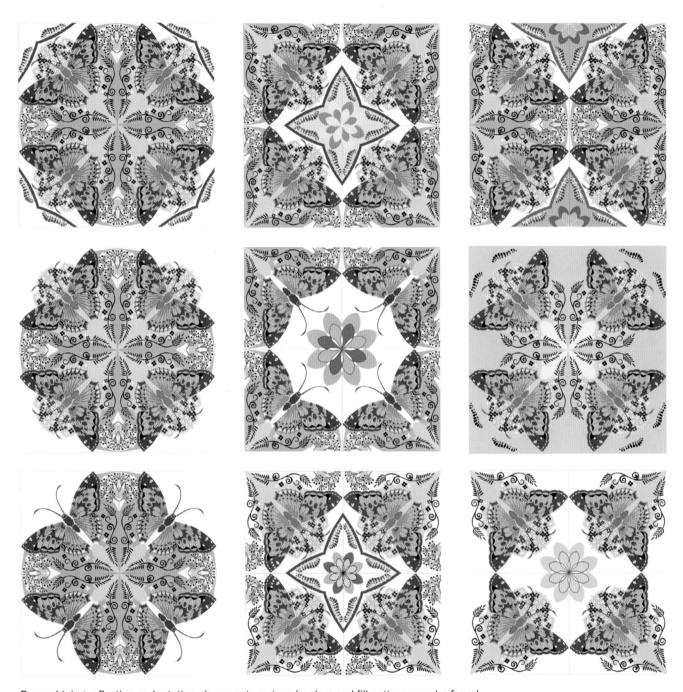

By combining reflection and rotation placements various borders and fill patterns can be found.

Developing the seed head

Originally drawn up as half a design, the posy shapes are redrawn as a whole with solid areas backing the linear and dotty detail. As complete shapes they can now be placed in a square or scale grid.

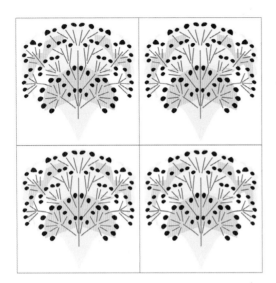

First the posy is put into a square and repeated.

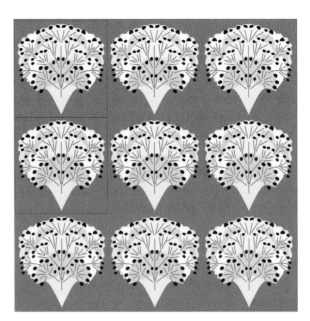

Block repeat.

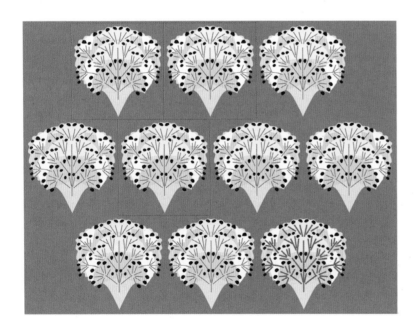

Brick repeat.

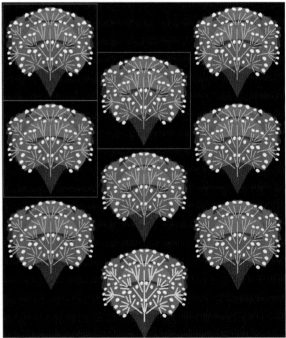

Half drop, in which the contrast of lines and dots is reversed.

Here the posy is tweaked to fit into the scale tessellation. The lower point has been adjusted so that it fits neatly into the shape. Stems and dots (seeds) have been brought within the containment line and others have been added to link the shapes together.

Once the design within the shape has been resolved with additions and subtractions, the blocks can be joined. In this case they have been paired up first and the containment outline is eventually removed.

As with all pattern-making there will be more alterations, additions and subtractions before the flow of the pattern suits the repeat.

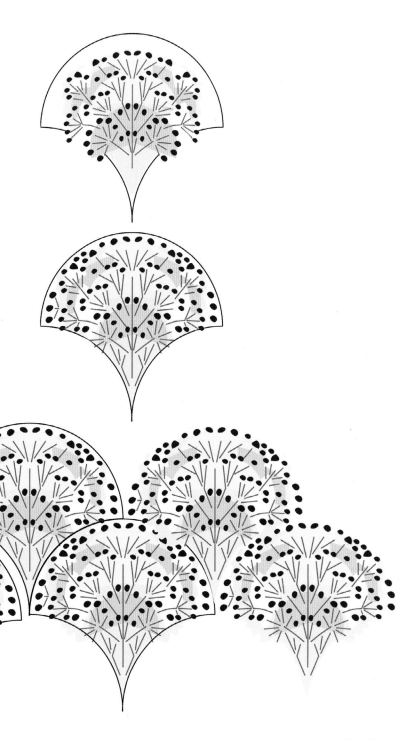

This sample shows the pattern on a mid-tone background but with a changing local background (pink and green) to the posies. These are placed to form a horizontal chevron, a secondary pattern.

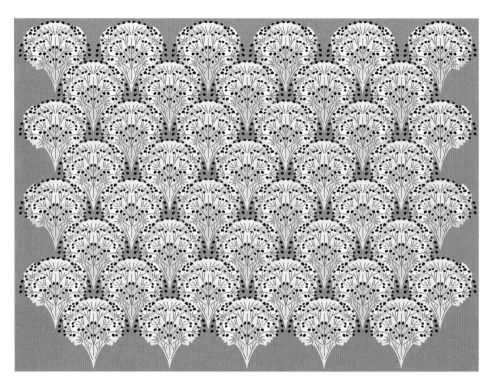

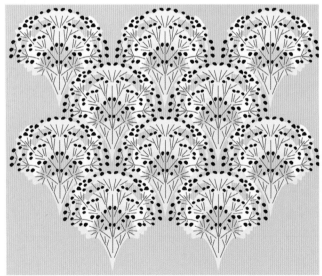

These two examples show the pattern on a background colour which is the same as one of the shapes within the posy.

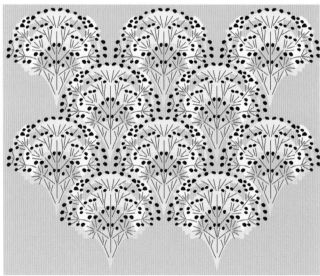

This design shows a cool lilac picking out a diagonal stripe.

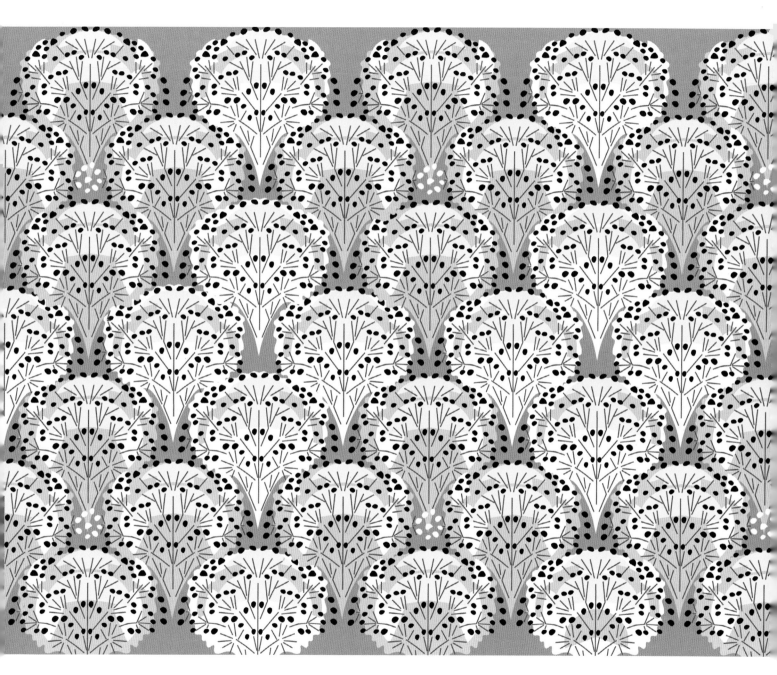

This sample shows the posies being grouped together in fours with local backgrounds of white and lilac picking out a diamond format. The lilac group of four has been given a pale dotty centre; the white has the dots removed.

This diagonal stripe has been inspired by the colours of a winter hedgerow – note the difference that can be made by removing just a few dots and dashes at the base. The soft tertiary colours remain the same on the two local background colours of the posies.

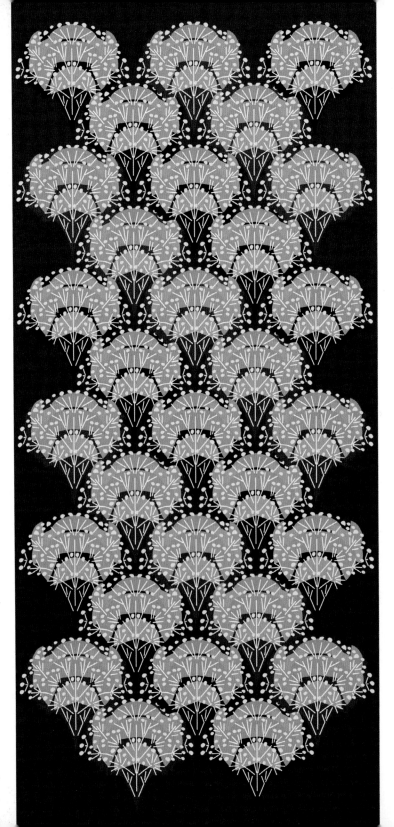

Some posies have been given a mustard local ground while on others the local ground shapes have been removed. In these the warm tone within the posy has been darkened with more red whereas it is set at a paler tone on the mustard.

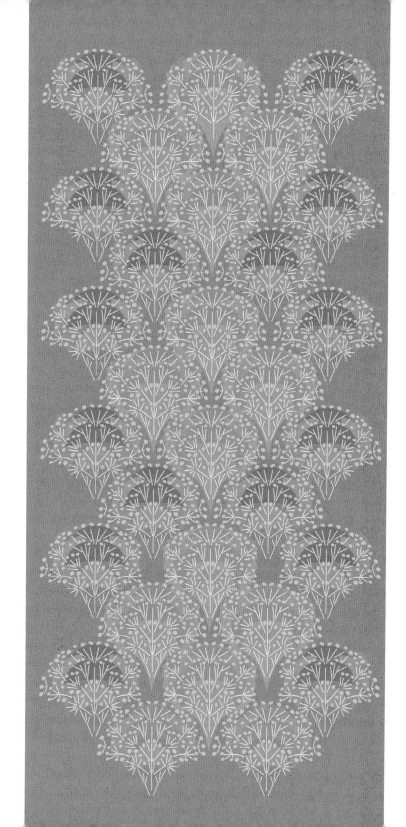

The next few patterns in this group are composed of lines and dots only, and combines 100 per cent opacity with tints.

100 per cent is set on the left, then 15 per cent, 30 per cent and 57 per cent.

This example shows 100 per cent opacity against 30 per cent. The contrast picks out distinct horizontal bands.

Here 50 per cent opacity against 30 per cent lessens the contrast considerably.

15 per cent opacity is used in a horizontal band with 28 per cent and 57 per cent opacity shown selectively.

Various opacity settings have been used here to create subtle variations in emphasis. Some dots have been removed while others are of a stronger colour.

It is the opacity settings and width of line, or the removal of the line, that changes the accent and appearance of the pattern. On larger-scale patterns the negative space made by deleting lines could be the sighting of a new shape.

The only colours used on black to create these six patterns are shown above.

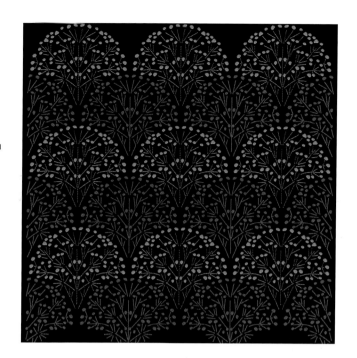

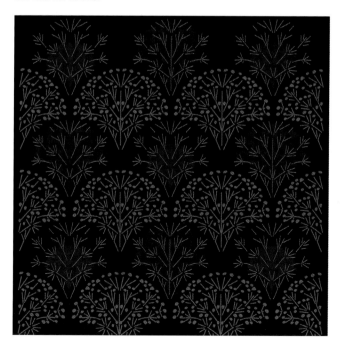

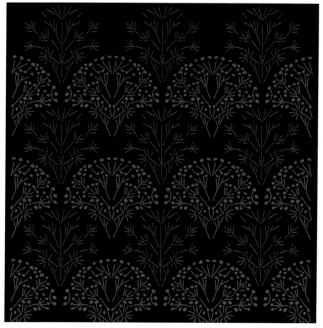

Rotating the scale

The posy design in a new colourway is brought together on a
central point. Each section has been rotated by 90 degrees to
give full reflected symmetry.

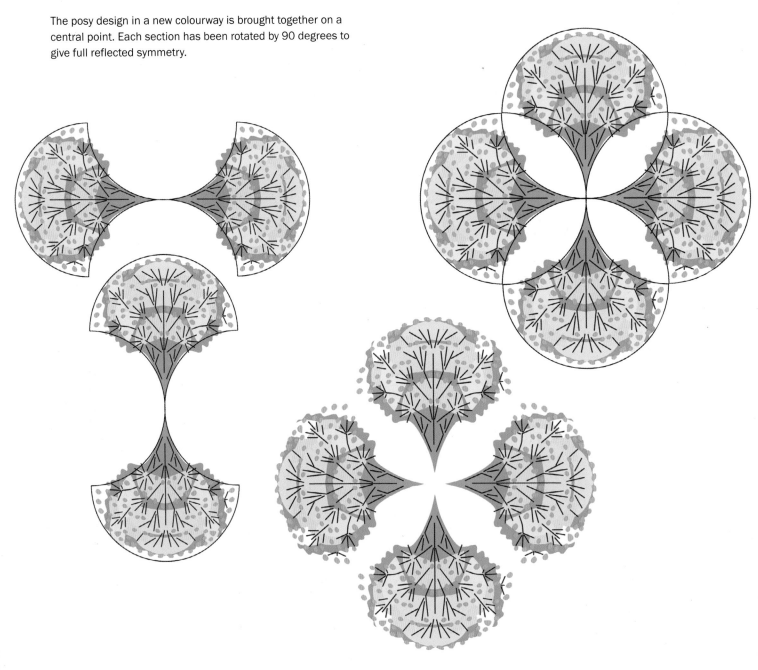

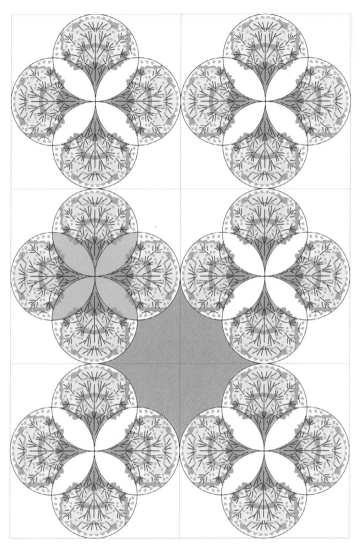

The resulting negative shapes are shown below as positive shapes. These can be combined in different ways with the pattern.

Because the scale grid is based on the circle, this placement forms a unit from the popular linking circles pattern (green). Traditionally used throughout the world in many different surface decoration methods, such as stone and textiles. it has been reinvented many times over.

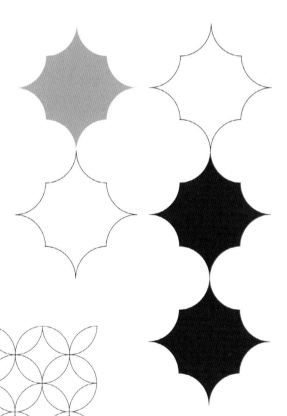

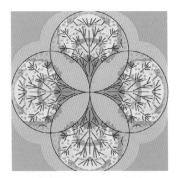

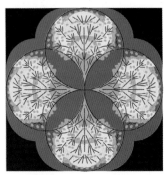

The next 20 examples show different colourways and uses of the additional extracted shapes.

First we see the pattern placed on four bright saturated background colours (opposite). The colours of the pattern itself remain the same. The local background colour is a green blue.

Next softer tertiary colours are used with the local background being a lighter blue. Two inner, echoing shapes have been added. These change in appearance as a result of the adjacent colour and tone, and seem much lighter on the lower pattern.

The third group sees a change in the local background colour, and also the addition of the linked circle in linear and solid form. In the last example it is used as a central petal detail in a smaller scale.

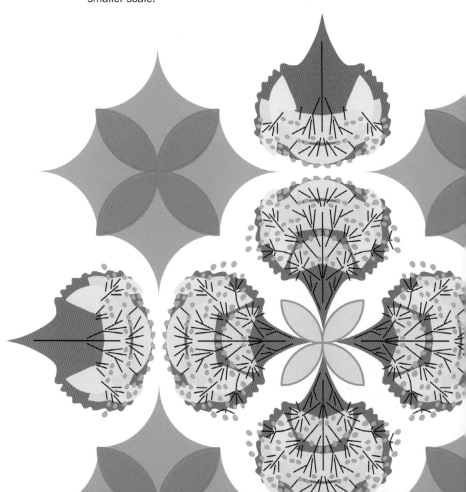

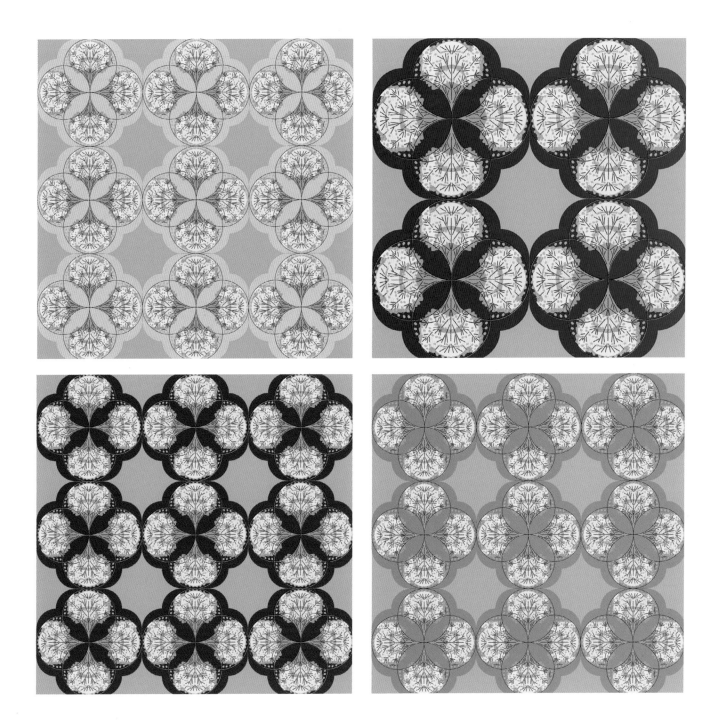

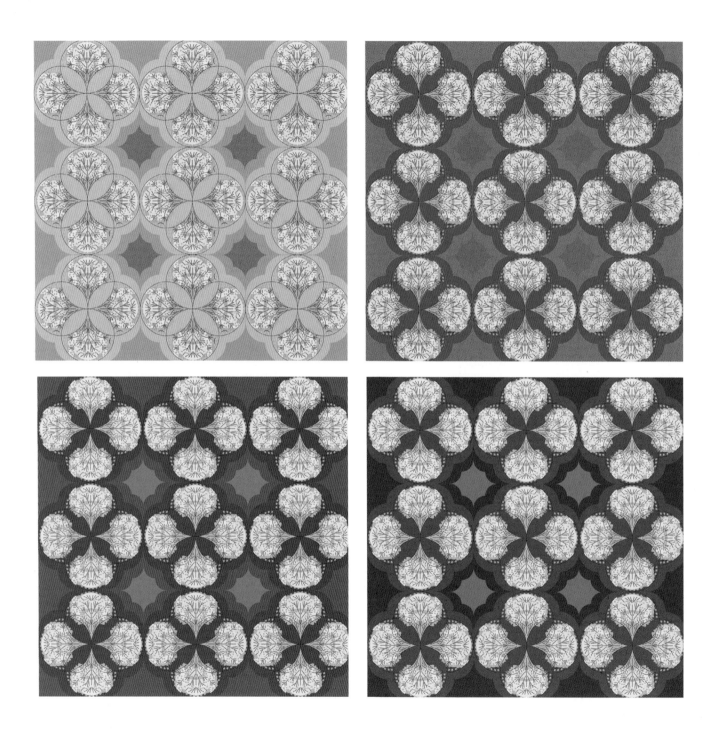

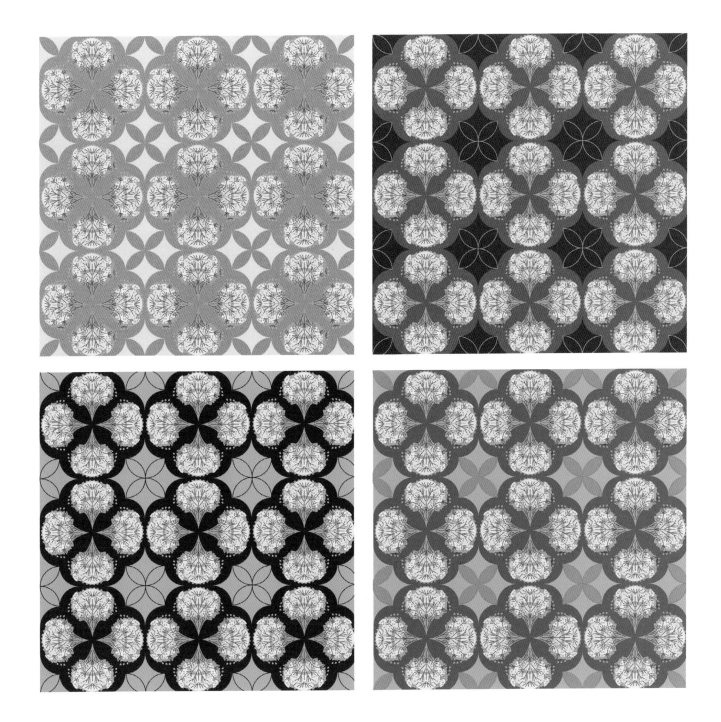

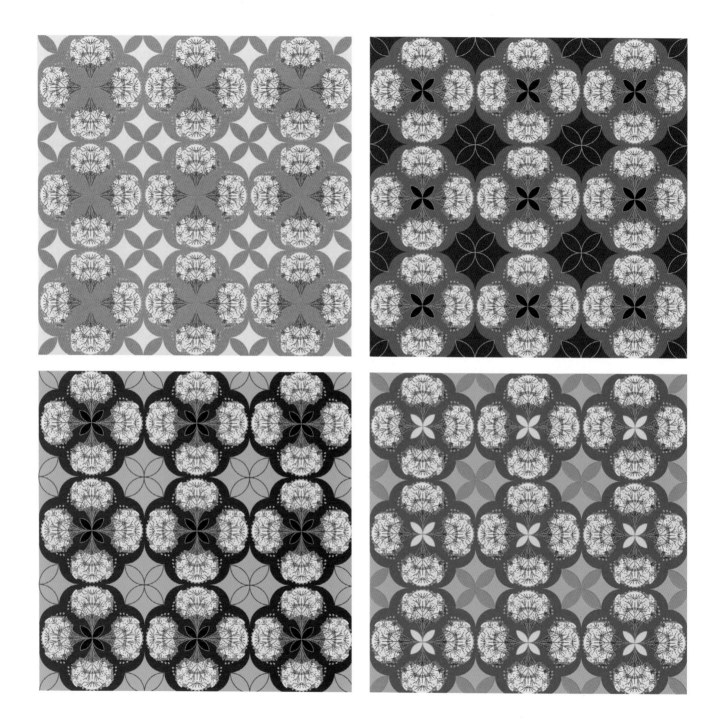

Spot repeats

The 'sateen' or spot repeat is well documented by Lewis F Day. Not only is it especially useful when dealing with smaller units of design, be it a singular motif, a posy, or juxtaposition of lively marks and colour but it also helps lessen the predictability of a simple repeated unit. A pattern can be viewed from any angle when motifs are rotated, and spot repeats can be used in any manner of ways in pattern development. I have included some of my own sequences in this chapter as well as those documented by Day.

The basic repeating unit for the spot repeat is the square. In the textile industry the size of the square would be calculated as an equal division of the width of fabric allowing for selvedge. These days, with all the varying surfaces and their varying widths plus the technical capabilities now at our disposal, the size of the repeating unit depends on many variables – the size you like to work, size of motif, how much detail is involved etc. as well as the final surface it is to be used on.

The main square repeating unit is divided up into a grid. There can be as few as three or as many as eight or more 'containment squares' within the repeating unit as benefits the design. The motif is placed in one of the 'containment squares'. However, the row in which it is placed cannot then be used again either horizontally or vertically.

These squares show the 25 containment squares of a five-spot repeat.

To further disguise a repeat, colour changes and scale differences can be introduced.

The repeats can carry different motifs in each placement.

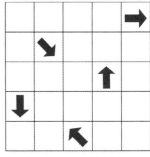

Placing them upside down or sideways ensures that the pattern will be multidirectional.

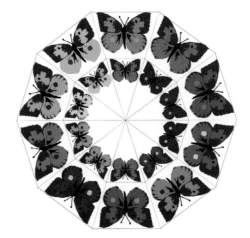

By using a circle and protractor, rotation positions for a spot repeat motif can be identified quickly and easily. Here ten placements are combined with two colour pallets, one with softer hues.

Three spot

LF Day

In this three spot a diagonal is evident, not too steep, which reads more markedly top left to bottom right.

Here we still have the diagonal but the butterflies are set in various rotations giving a multidirectional pattern.

Four spot

LF Day

In this four spot we get a sense of two diagonals.

A custom quarter brick repeat suggests a chevron.

Five spot

LF Day

LF Day's five-spot pattern in a custom brick repeat.

Six spot

LF Day

Seven spot

LF Day

Eight spot

Nine spot

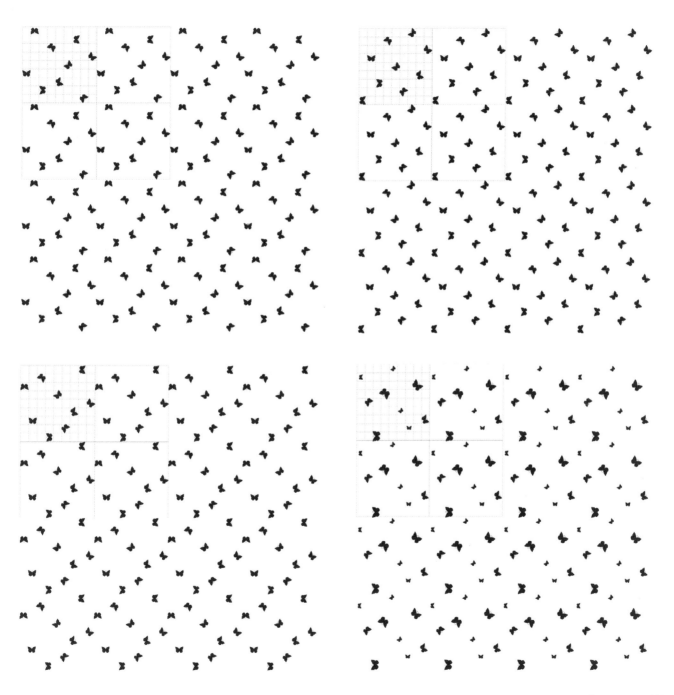

Ten spot

The 'spot' area can also be thought of as points of rest in an all-over pattern. That is, rather than have the allocated space be taken up with a motif, leave it blank. The large square would have a fully designed repeat.

Spot the difference

Spot repeats can be used in a number of ways and this section deals with the variations that can be worked in scale, colour and background when using a simple motif – and here I am indeed using the dot! The resulting patterns look much more complicated than they really are.

For the main part I have chosen a six-spot repeat so that comparisons can be made. I have also removed the defining border though the initial repeating unit is shown top left.

In all cases the spot represents a motif of choice, be it a floral or geometric. By making changes in colour and scale the pattern appears less predictable.

Playing with scale

The motif can spill over the border of the containment square.

The repeat can seem larger by alternating the colours in two or more of the repeating units. In this example two units make for twelve analogous colours. The units have been placed directly underneath each other to form a vertical repeat.

Background changes

Here six analogous colours are set on a background which has its own repeat.

This is the same six spot put on to a striped background, giving a very different look.

Clematis

One observational drawing can inspire further studies in order to develop a pattern. The starting point in this case was a clematis flower head, isolated and stark. The eventual pattern tells the life story of the plant, that is to say, it includes buds, leaf, flower and seed heads from a variety of species. It required trips into the garden to draw a leaf group, or a browse through photographs.

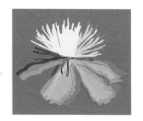

The flower head is put into block repeats and includes shadowing with multiple tints and line placements. Organzas and translucent fabrics come to mind for the embroiderer, combined with hand and machine stitching; the printer could use translucent layers of pastes or inks; and multimedia techniques. Later, using the *en point* placement, a geometric background is straightforward to put in place.

Some linear placements are close and add a sense of depth to the drawing, while others are set a greater distance apart from the solid shapes. Some are tinted while others are set at 100 per cent, giving clarity.

This example (left) has two tinted layers while the example above has three; two cool with a warm tint top layer.

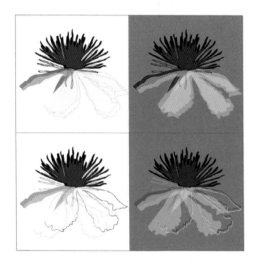

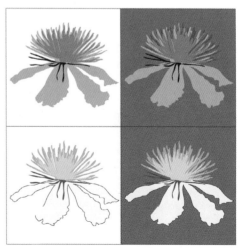

An additional interest has been incorporated by laying a tint in the flower head itself. In the example above it tilts the colour towards a lighter blue or a darker, greeny blue, while in the example right it adds brightness to the flower head when it sits on the darker background colour.

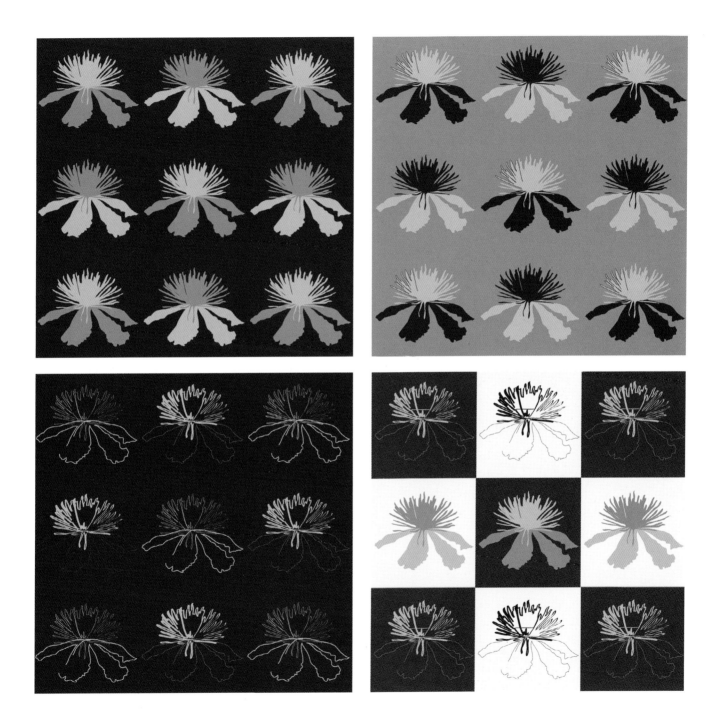

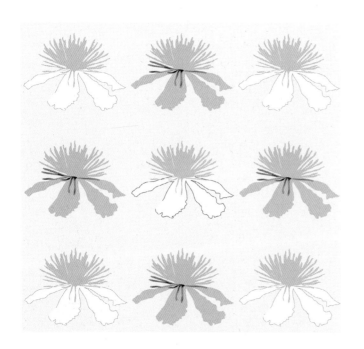
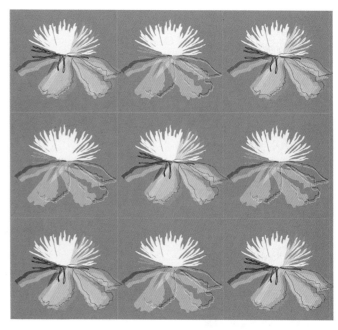
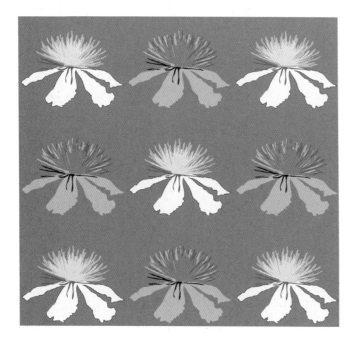
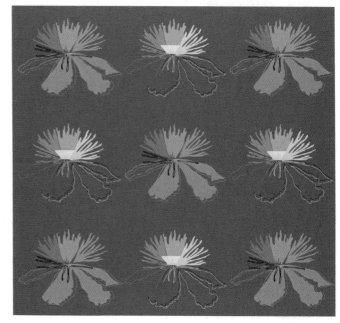

308 Clematis

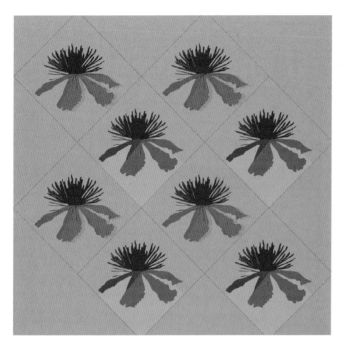
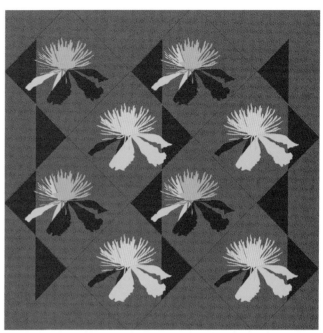
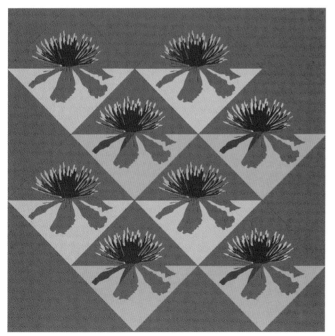
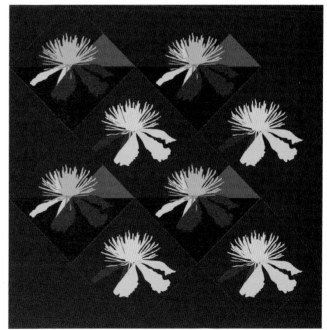

Floral links

Further drawings are made and two main design groups are created, with the ones shown below having been adjusted to form repeat options.

This floral pattern explores the standard block placement (above) and is then used in the scale placement (below).

Every other containment square is used and the design alternates in each row. A diagonal is made.

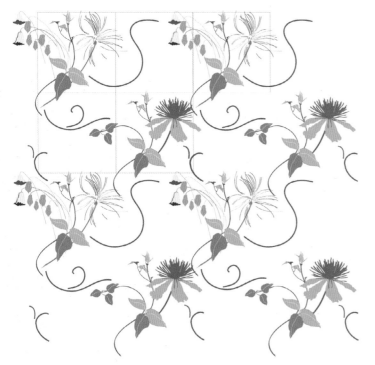 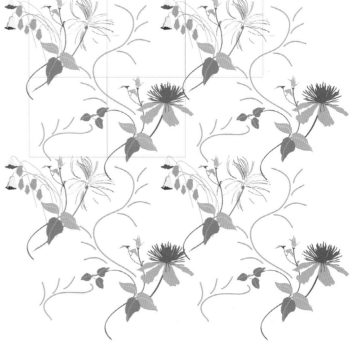

The development of directional movement through the pattern is shown here. These are paths that smaller leaves, dots, flower heads or stems could follow to link the design together, or indeed other shapes.

More complex developments could be set in a paler tone so as not to distract from the main pattern elements as in this exploration above.

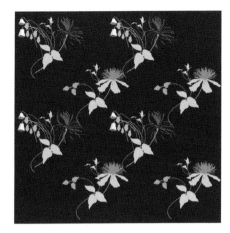

This is how the pattern appears on a darker ground.

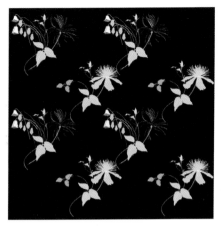

Shown in analogous colours. The bright flower head uses two colours; a smaller shape to the front, which also has an outline, and a larger shape set behind.

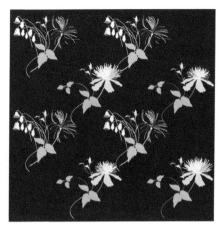

A third colour is added: both are more clearly seen on the darker ground.

The group of three leaves has been superimposed on to the pattern at 35 per cent opacity. This gives a shadowing effect. Here it is set down in a controlled format but would also be effective placed randomly.

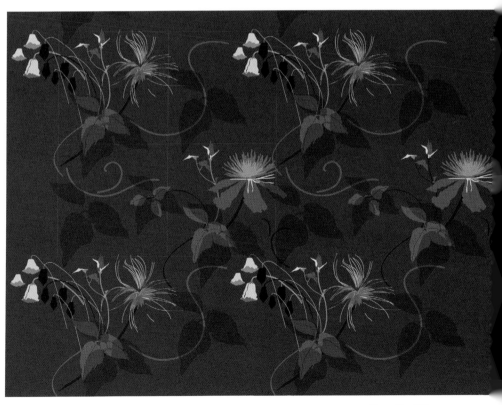

Trellis links

The clematis in the garden grows on a trellis – this provides another idea for the pattern.

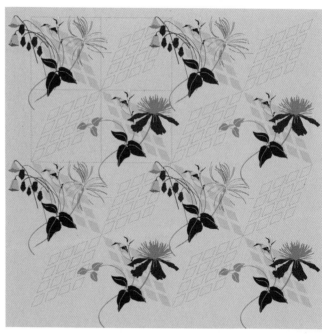

The grid is reduced in size and with an outline only set on the opposing diagonal.

By taking just the outline of the grid we can set it off-kilter to give a three-dimensional effect.

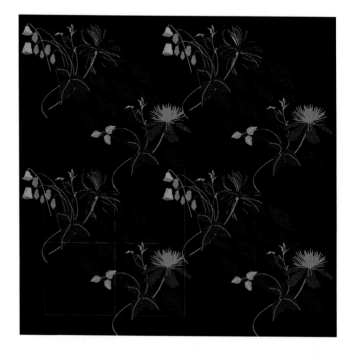

The distorted grid set at 20 per cent stretches across four squares. The colours are autumnal.

The trellis, grey at 100 per cent opacity, uses the same placement as the floral grid but is set in a different sequence. Taking up two square heights, it leaves one square clear before it is repeated vertically. It only takes up part of one square's width; consequently it falls behind the floral differently, creating new gaps as well as fuller areas. Note the pink groups.

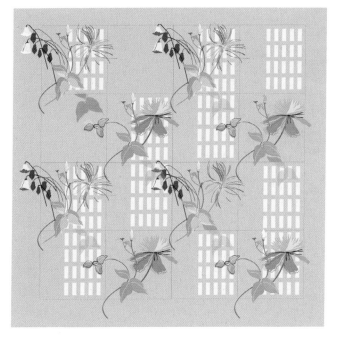

The flower head has been given additional colour with a shadowing of yellow. There is linear outline detail on the leaves. Also the group of leaves has shadowing at a smaller scale. It is also positioned behind the trellis. There are two options as to how the trellis is presented, and it is placed as a lighter tone on the grey background.

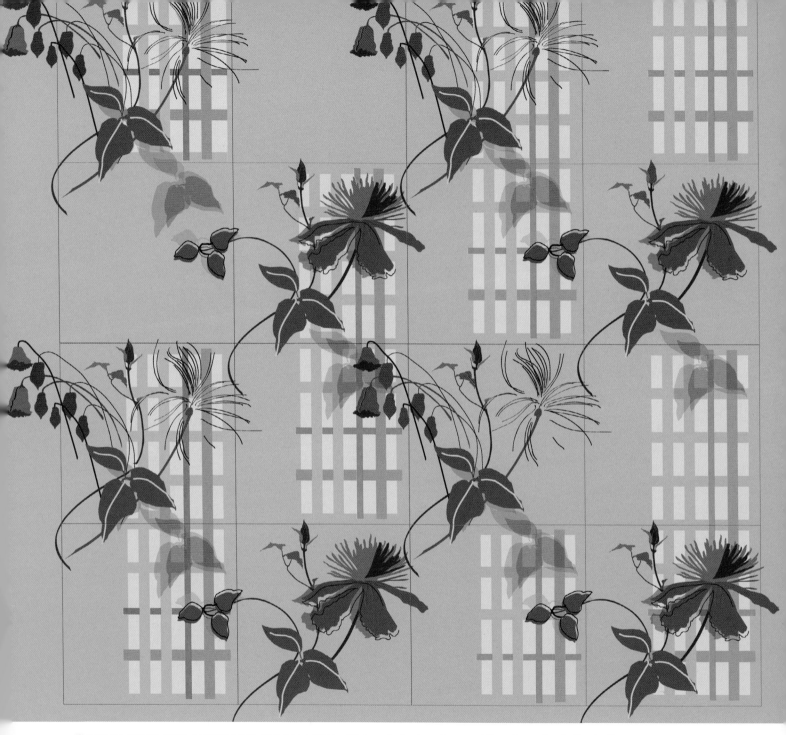

The warm palette gives a tropical feel. There is additional interest of colour, tone and line dimension in the trellis.

This is an exploration of different background grids, with larger shapes having further reduction in opacity.

Diagonal formations

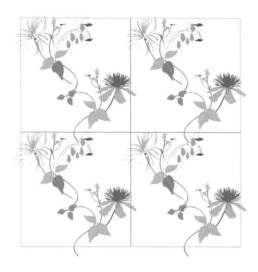

The flow of the pattern is altered by repositioning one of the design squares and the example shows that the square containing the seed head has been reflected. The row with the clematis flower head has been raised so that the group of small leaves (in green) can cover the end of the stem. The bell flowers remain clear of the other group of leaves.

The new repeating square is within the red dotted line.

The design works well when set up for a brick repeat pattern. An alternative positioning of the stem is shown in red, which goes beyond the seed head.

The custom drop sees the seed head and the flower head, the two main components, closer together. An option of reducing the scale of the flower head and/or lightening the tonal value is shown in the last row.

Both the brick and custom drop offer opportunity for additional directional flow. Lightening the tonal value of the flower head makes for a more even all-over pattern.

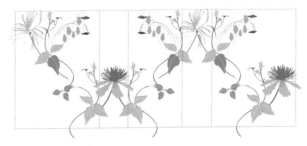

Mirroring the design produces an ogee effect. One flower head and seed head has been removed from each union. These floral mirrored repeats make a good start for patterns developed on the ogee grid.

Here stems have been removed alternately from the flower and seed heads. The space in the middle (in green) could be the sighting of further design.

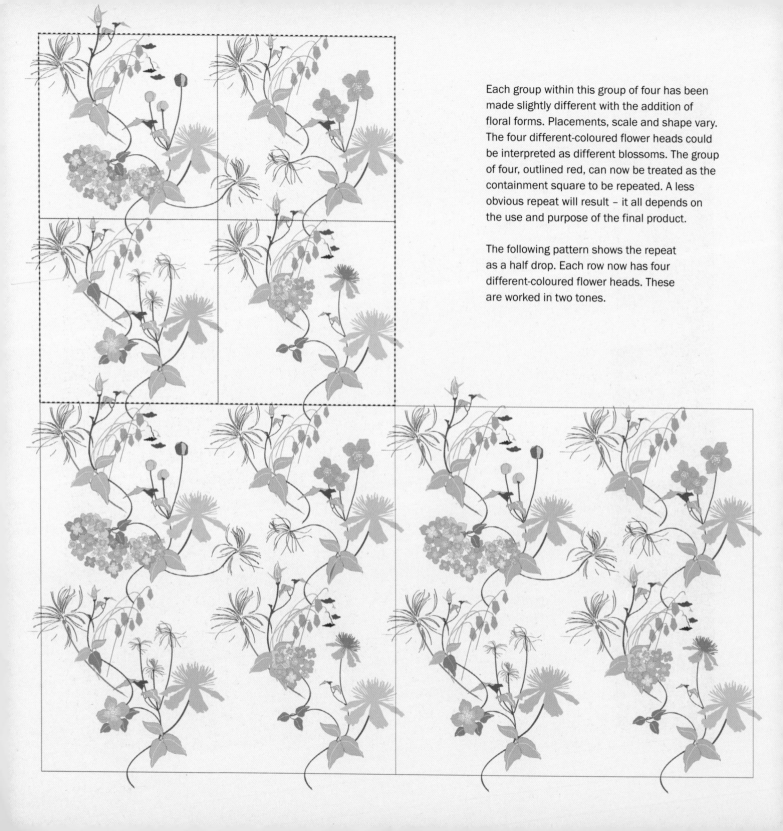

Each group within this group of four has been made slightly different with the addition of floral forms. Placements, scale and shape vary. The four different-coloured flower heads could be interpreted as different blossoms. The group of four, outlined red, can now be treated as the containment square to be repeated. A less obvious repeat will result – it all depends on the use and purpose of the final product.

The following pattern shows the repeat as a half drop. Each row now has four different-coloured flower heads. These are worked in two tones.

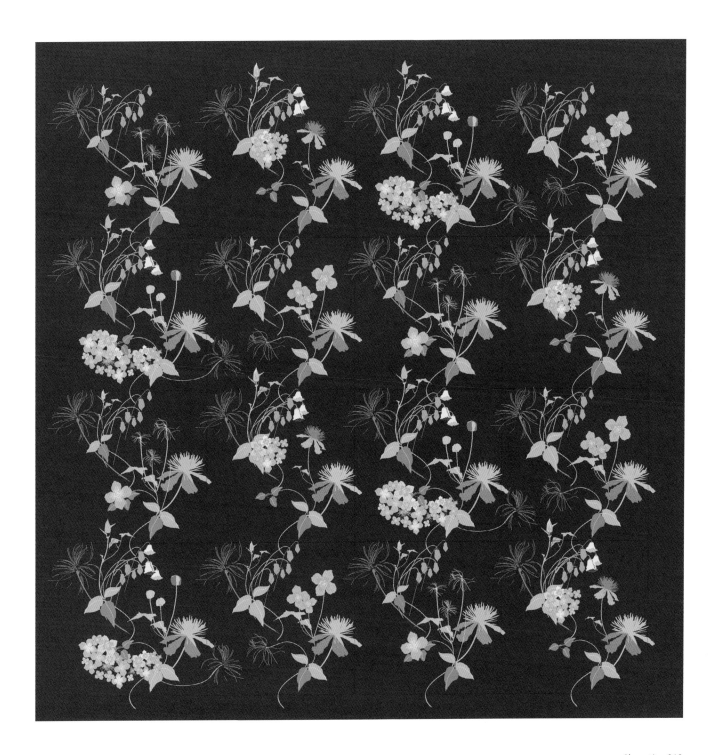

Floral scale

The design components have been selected. New shapes have been added and now are gathered within the confines of the scale format to make a new repeating pattern.

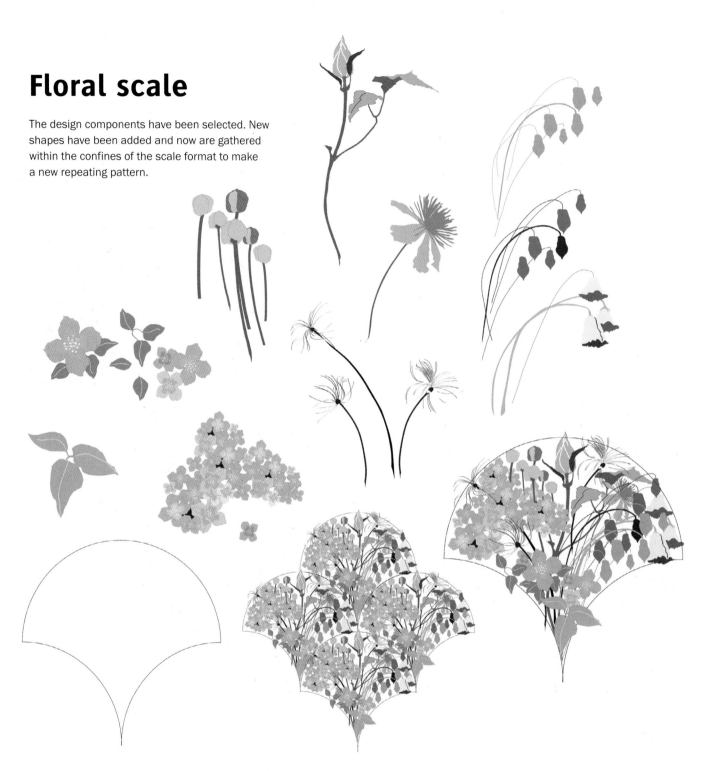

In different line weights, the pattern has the look of a loose garden sketch.

Evocative of lace with translucent layering, these three examples show variety in weight of line and opacity.

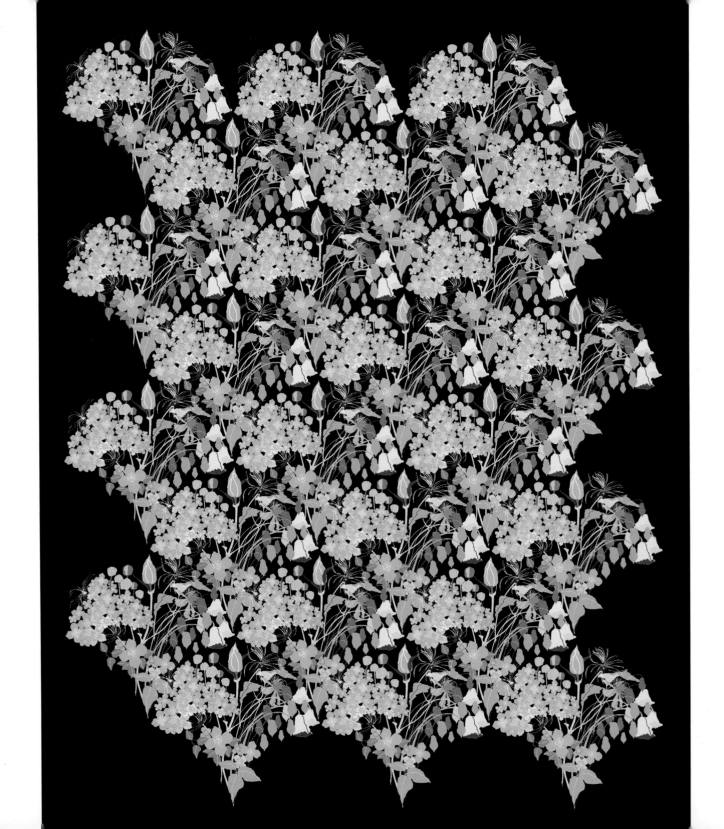

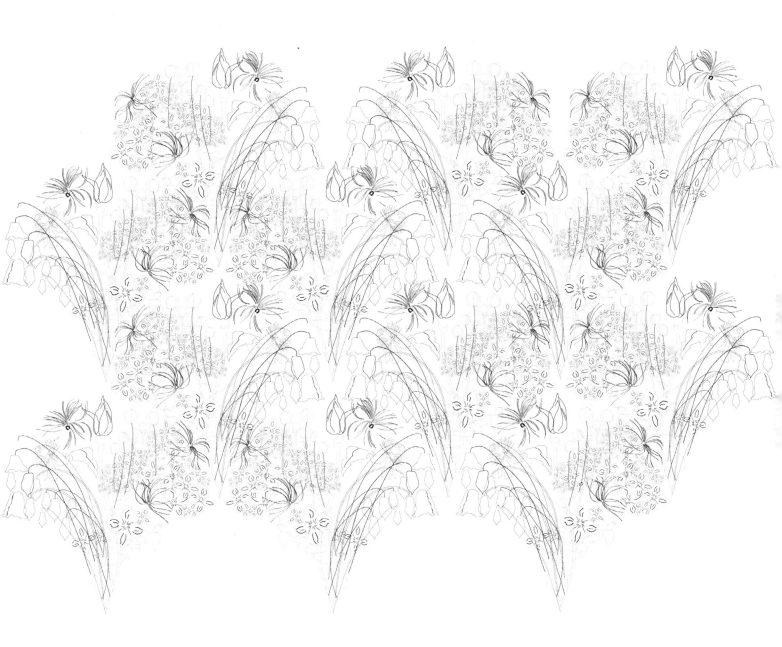

Opposite: The group is brought together in soft colours and set on a dark ground. This is a very intense pattern; the scale of it would need to be considered carefully.

Above: The unit of design has been mirrored here, bringing the dense areas together and creating a darker, textured quality.

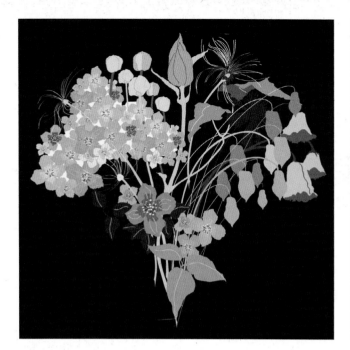
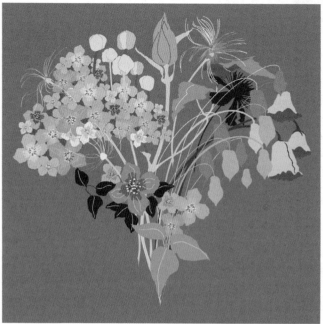

Placing a localized colour behind the clump of flower heads unifies the cluster and can create contrasts with the background.

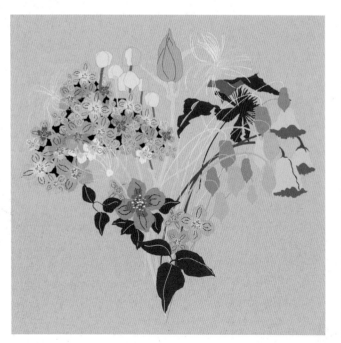
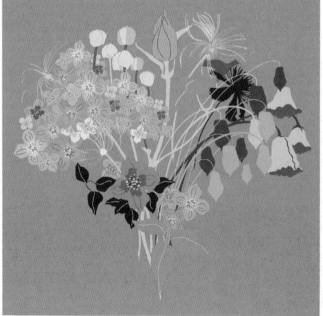

These two examples have the addition of surface tinting, which suggests floral forms.

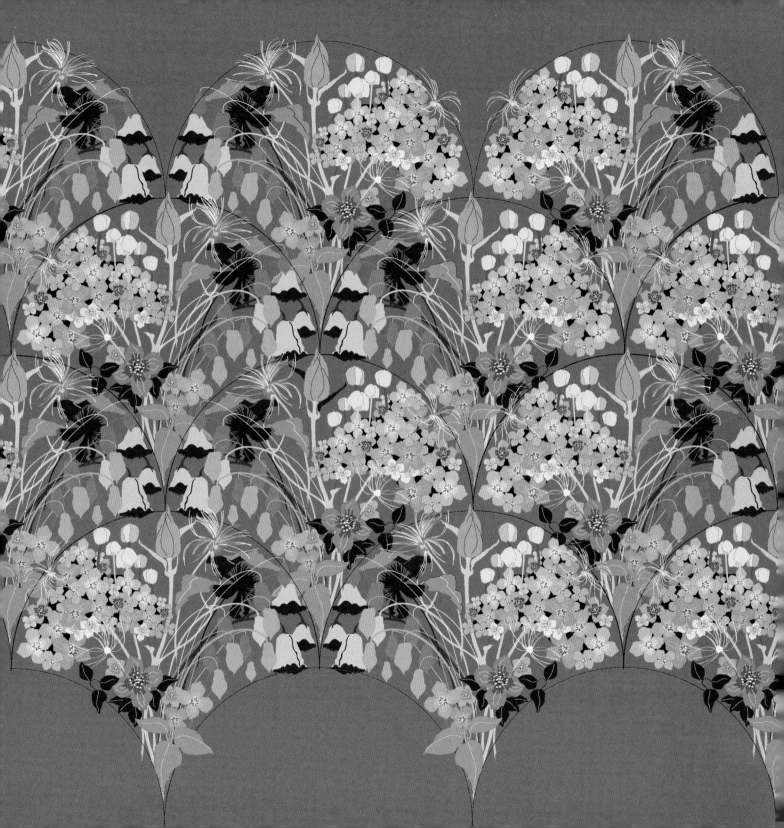

The scale itself becomes part of the pattern here as colours
are introduced to form diagonals.

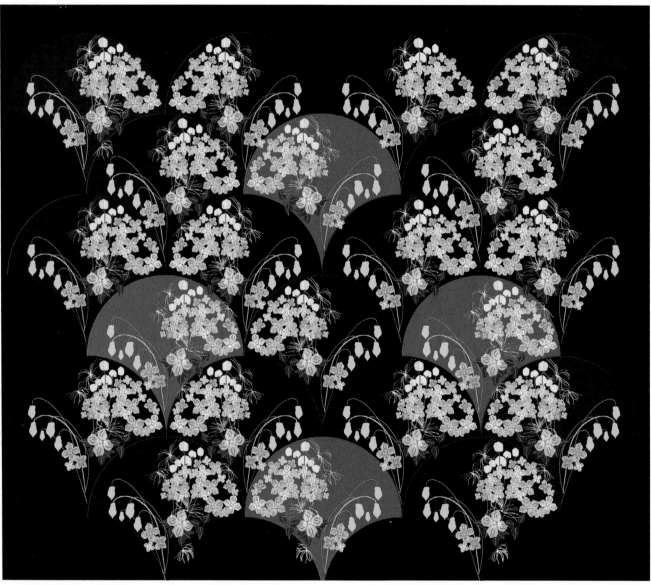

Coloured layers set at 15 pcr cent opacity are set behind the floral.

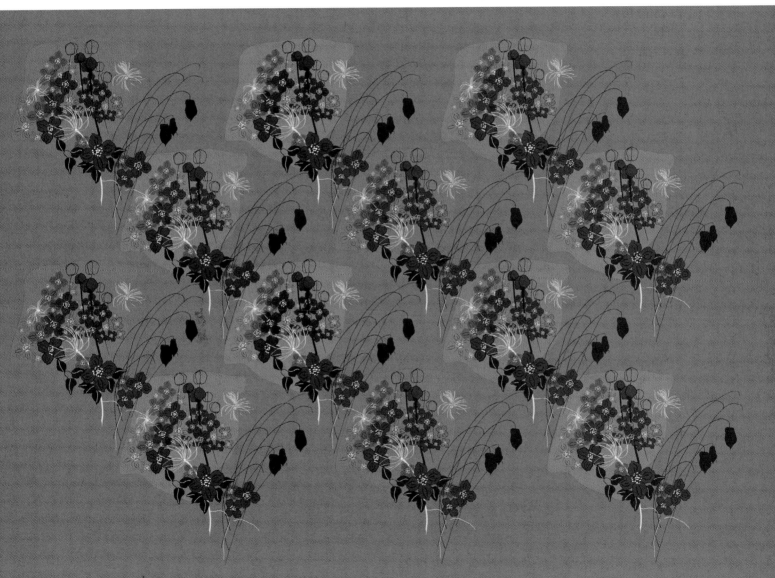

Garden damasks

A damask pattern is one that is traditionally revealed within the woven fabric, the warp and weft threads being of the same colour. Either the warp or weft is favoured to lie on the surface and catch the light. Larger shaped areas appear tonally lighter or darker depending on the movement of the cloth. These effects can be created by considered use of close colour and tone. The three designs shown on pages 330–331, though not strictly damask as more than one colour is used, are the same – but with colours being placed differently and proportions changed they look like three very different patterns.

The pastel shapes used for the underlying colour in the pattern below could be explored for a series of block repeats (shown opposite). The progression shows the systematic removal of selected shapes, which changes the overall impact of the pattern.

This design was created on the diagonal and mirrored.

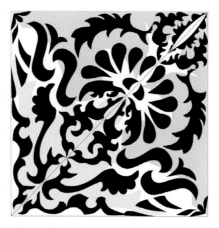

Underlying colour is added.

The underlying pastel shapes.

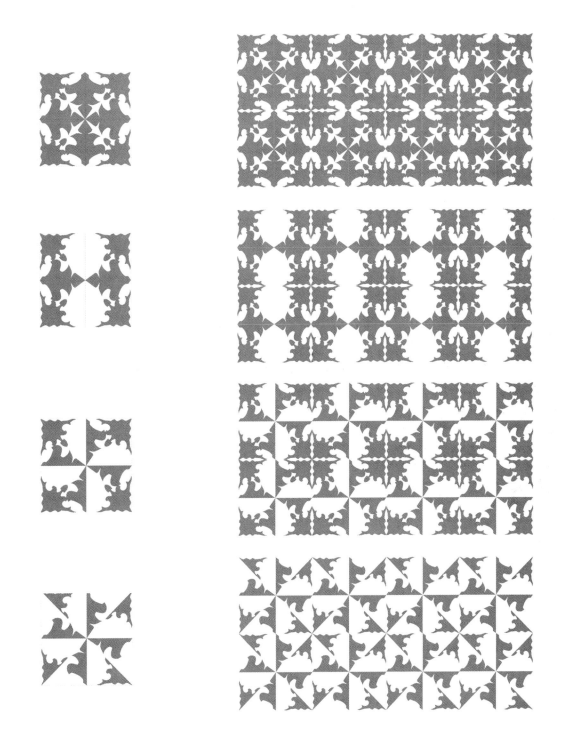

In these three examples the design, now in colour, and the underlying pastel shapes have been combined in the left-hand square. This is then placed on a flat dark ground as reflected symmetry in the right-hand square.

In the larger example, the square is placed as a block repeat and three-quarters of the pattern has been placed on the flat darker background colour. Systematic removal of the pastel shapes through steps 1–3, as explored on the previous page, gradually reveals the full ground colour.

Colourway A.

On darker background.

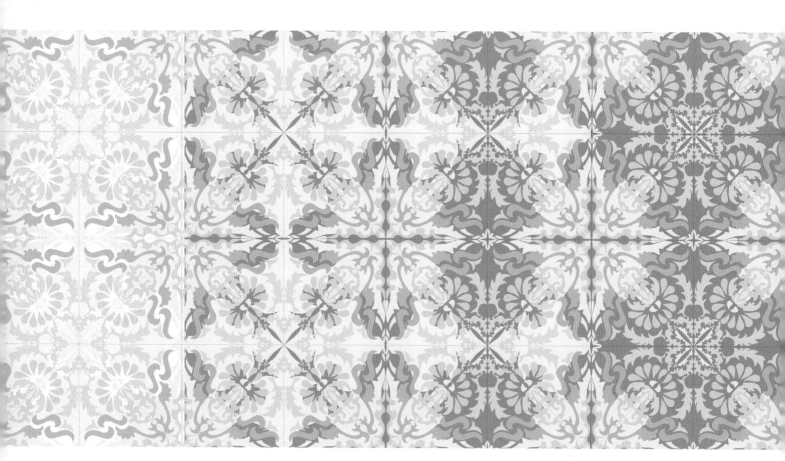

Step 1. Step 2. Step 3.

Colourway B.

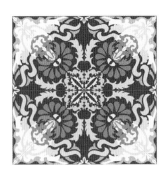

On a darker ground.

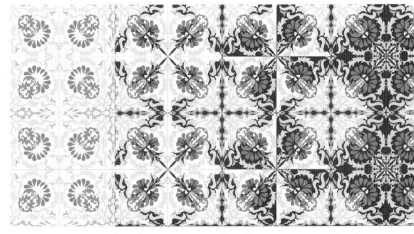

Step 1. Step 2. Step 3.

Colourway C.

On a darker ground.

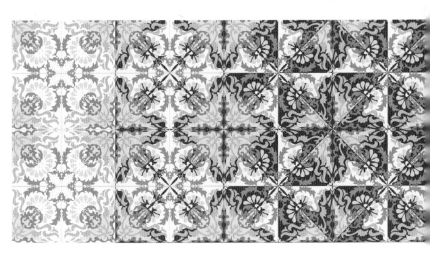

Step 1. Step 2. Step 3.

Garden damasks 331

This group of four shows the garden damask pattern in four seasonal colourways. Spring, summer, autumn, winter. The pattern is placed on a complementary colour and then a much darker background.

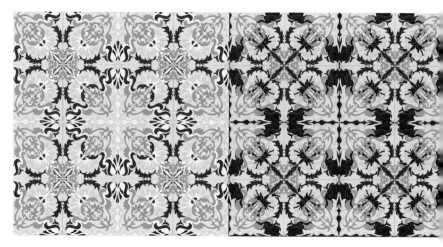

Spring

Summer

Autumn

Winter

Index

Acknowledgements

My sincere thanks go to the entire Batsford team, to Tina Persaud for inviting me to take on this project and calm senior editor Kristy Richardson for her great help and guidance throughout.

In the computer world, my grateful thanks to Kay Rozier at Studica and to Peter Frary of LPD Electronics Ltd. who found everything, when, it seemed, all was lost!

A big thank you goes to Diana Harrison, John Gillow, particularly for the use of visual material for 'Out of Africa', Pauline and Kingsley Lovell and David Page.

I am most privileged to have been supported and encouraged by some wonderful friends, art and textile educators during my creative life. I am indebted to Jo Bacon, an inspiring teacher; the late Susan Bosence for her great encouragement in my shibori ventures, Deryn O'Conner for her extraordinary textile sensibilities; Diana Harrison for her motivation and clear perception; Moira McNeill for her invaluable help and wisdom; Bridgit Sweeney for her unique understanding; Yoshiko Wada for her generous introductions; Noel Dyrenforth for his insightful guidance; Professor Keith Critchlow for his sound direction. I must also mention the late Pam Darlow, a dear mentor and inspirer.

To those who have sustained me in my creative ventures over the years, who have given so graciously of their time, expertise, wisdom and hospitality, shown keen interest in my endeavours, provided opportunity, been an inspiration, kept me focussed and on track, or who have simply listened, my heart felt thanks. Particularly Kathy Bigland, Pauline and Kingsley Lovell, Christina Greathead, Diana and Ian Scott, Dr. Jenny Balfour-Paul, Lucy Goffin, Charlotte Kwon and the Maiwa team, Anna Dolányi, Alison Ellen, Gerry St. Aubyn-Hubbard, Tricia and Richard Gregory, Jayne Wurr, Michelle Griffiths, Ian and Mary-Jane Toulson, Tessie and Philip Waring, Heather Calo, Ann Morgan-Hughes of Black Cat Books, Allan Thomas Designs, and Fran Apperley, also for her marvellous help and support. I am also grateful to all the students with whom I have shared shibori and mixed media surface decoration with over the years, both in the UK and overseas for all they have taught me.

A very special thank you goes to my brother Peter Callender.

Belonging to different centuries, different cultures and far away countries, I shall never meet those artisans that I hold in such great regard. They have mesmerised me with their patterns since childhood, their achievements always an inspiration and motivation. To those makers who worked in clay, plaster and paint, with yarn and thread, cloth and dye, in silver and in gold, in metal, glass, wood and stone, I am deeply indebted.

Bibliography

Allen, Jon, *Drawing Geometry: A Primer of Basic Forms for Artists, Designers and Architects* (Floris Books, 2007)

Askari, Nasreen and Crill, Rosemary, *Colours of the Indus, Costume and Textiles of Pakistan* (Merrell Holberton in association with V&A Museum, 1997)

Bosence, Susan, *Hand Block Printing and Resist Dyeing,* (David and Charles, 1985)

Cole, Drusilla, (Ed.) *1000 Patterns* (A&C Black, 2003)

Critchlow, Keith, *Islamic Patterns: An Analytical and Cosmological Approach* (Inner Traditions International, 1999)

Chijiiwa, Hideaki, *Colour Harmony: A Guide to Creative Colour Combinations (*Rockport Publishers, 1987)

Day, Lewis F, *The Anatomy of Pattern* (Batsford, 1889)

Day, Lewis F, *Pattern Design* (Batsford, 1979)

Faulkner, Robert, *Japanese Stencils* (Webb & Bower and Michael Joseph Ltd in association with V&A Museum, 1988)

Gillow, John and Sentance, Bryan, *World Textiles: A Visual Guide to Traditional Techniques* (Thames & Hudson, 1999)

Gillow, John, *Textiles of the Islamic World* (Thames and Hudson, 2010)

Harris, Jennifer, (Ed.) *5000 years of Textiles* (The British Museum Press in association with the Whitworth Art Gallery, The V&A Museum, 1993)

Hilberg, Birte, *The Patchwork Planner: 350 Original Designs for Traditional Patchwork* (David and Charles, 1993)

Hiroko, Ando, *Japanese Tie-dyeing* (Fujioka Mamoru, Kyoto Shoin's Art Library of Japanese Textiles, 1993)

Jerstorp, Karin and Köhlmark, Eva, *The Textile Design Book: Understanding and Creating Patterns Using Texture, Shape and Colour* (A&C Black, 1988)

Justema, William, *The Pleasures of Pattern* (Reinhold Book Corporation, 1968)

Kafka, Francis J, *Batik, Tie-dyeing, Stencilling, Silk Screen Block Printing* (Dover Publications Inc, 1973)

Lewis, Garth, *2000 Colour Combination for Graphic, Textile and Craft Designers* (Batsford, 2009)

Lundy, Miranda, *Sacred Geometry* (Wooden Books Ltd, 2006)

Naylor, Gillian (Ed.), *William Morris by Himself: Designs and Writings* (Macdonald and Co Ltd, 1988)

Picton, John and Mack, John, *African Textiles* (British Museum Press, 1993)

Powers, Alan, *Modern Block Printed Textiles* (Walker Books, 1992)

Storey, Joyce, *Manuel of Dyes and Fabrics* (Thames and Hudson, 1978)

Storey, Joyce, *Manuel of Textile Printing* (Thames and Hudson, 1992)

Sutton, Daud, *Islamic Design* (Wooden Books Ltd, 2007)

Wada, Y, Kellogg Rice, M, and Barton, J, *Shibori: The Inventive Art of Japanese Shaped Resist Dyeing* (Kodansha International Ltd, 1983)

Wells, Kate, *Fabric Dyeing and Printing* (Conran Octopus, 1997)

Website www.newyorkcarver.com